ART HISTORY

THE BASICS

'... refreshing and realistic ... For those thinking of studying art history in the West today, this guide will serve as an invaluable signpost.' *The Art Book*

Art History: The Basics is a concise and accessible introduction for the general reader and the undergraduate approaching the history of art for the first time. Fully illustrated with an international range of artistic examples, it introduces the key ideas, issues and debates. Questions covered include:

- What is art and art history?
- What are the main methodologies used to understand art?
- How have ideas about form, sex and gender shaped representation?
- What connects art with psychoanalysis, semiotics and Marxism?
- How are globalization and postmodernism changing art and art history?

This informative guide provides information on relevant websites and image archives, helpful subject summaries, suggestions for further reading and a useful glossary for easy reference.

Grant Pooke lectures in the History and Philosophy of Art at the University of Kent. He is co-author of *Teach Yourself Art History* (2003).

Diana Newall is the Konstantinos Leventis Research Fellow in Post-Byzantine Art at The Open University. She is author of *Appreciating Art* (2008) and joint recipient with Grant Pooke of a University of Kent Faculty of Humanities Prize (2009) for *Art History: The Basics*.

ALSO AVAILABLE FROM ROUTLEDGE

ART HISTORY

THE BASICS

Grant Pooke and Diana Newall

LONDON AND NEW YORK

First published 2008
by Routledge
2 Park Square, Milton Park, Abingdon, Oxon OX14 4RN

Simultaneously published in the USA and Canada
by Routledge
711 Third Avenue, New York, NY 10017

Routledge is an imprint of the Taylor & Francis Group, an informa business

© 2008 Grant Pooke and Diana Newall

Typeset in Aldus and Scala Sans by Taylor & Francis Books

British Library Cataloguing in Publication Data
A catalogue record for this book is available from the British Library

Library of Congress Cataloging in Publication Data
A catalog record for this book has been requested

ISBN10: 0–415–37309–3 (hbk)
ISBN10: 0–415–30908–5 (pbk)

ISBN13: 978–0–415–37309–8 (hbk)
ISBN13: 978–0–415–37308–1 (pbk)

In memory of
Professor Graham Clarke
(1948–2007)

The language of contemporary art can be as subtle as calligraphy or the glaze on a vase, except that the materials are ideas, intentions and references.
(Grayson Perry, *The Times*, 1 November 2006)

Understanding art takes time. It is not a catchy pop tune or an addictive soap opera. Art needs a lot of looking and reflection ...
(Grayson Perry, *The Times*, 8 November 2006)

CONTENTS

FIGURES

ACKNOWLEDGEMENTS

Art History: The Basics arose from undergraduate teaching under-taken by its authors at the University of Kent, the Open University and the Courtauld Institute of Art. In a very tangible sense, its content variously reflects seminar and tutorial discussions over several years with full- and part-time students across modules on art historical methodology, aesthetics and contemporary art.

We would like to record our appreciation to Jake and Dinos Chapman, George Dannatt, David Hensel, Roger Hill, Peter Kennard, Jeff Koons, Gerald Laing, Grayson Perry, Tim Noble, Sue Webster and Jago Max Williams for their generosity with permissions and images.

Our thanks to all of the following for their help with illustrations and arranging permissions: Amanda Baker; Sophie Rigg, Artangel; Lucy Adams and Rachel Cockett, Birmingham Museums and Art Gallery; Geoffrey Fisher, Conway Library; Emma Hayes, Courtauld Institute of Art; Christian Zimmerman, DACS; Nina Williams, Florin Press; Anna Johnson, formerly of St Martin's School of Art; Andrew MacLachlan; Rebecca Staffolani, National Gallery Picture Library; Lucy Tyler, Osborne Samuel; Sophie Greig, Saatchi Gallery; Claudia Schmid, Tate Gallery; Bryony McLennan, Victoria Miro Gallery; Derek Whittaker, Peter McMaster, University of Kent; Jay Jopling, White Cube Gallery; and Diana De Froment, Witt Library.

We would also like to express our gratitude to colleagues and friends for their time in offering candid and constructive comments on chapter drafts: Robin Cormack, Jonathan Friday, Richard Hingley, Angus Pryor, Eileen Rubery, Ben Thomas, Christina Unwin and Graham Whitham.

We would especially like to record our thanks to David Avital and Rosie Waters at Routledge for their enthusiasm and support in this venture and to Aimee Foy, Jonathan Jones and Andy Soutter for assistance with the manuscript.

INTRODUCTION

WHO IS THIS BOOK FOR?

Art History: The Basics has been written as an undergraduate primer and for the general reader with an interest in art history and the visual arts. As a university or college student, you may be exploring art history or the contextual studies component of a practice-based fine art or art and design programme for the first time. If you are a regular or even casual visitor to galleries and exhibitions, or peruse art critics' newspaper columns and reviews, *Art History: The Basics* offers an introduction to the subject and to broader debates about the interpretation and meaning of art.

WHAT DOES THIS BOOK OFFER?

In the last few decades art history has developed significantly beyond the stylistic analysis and classification of art works. A number of introductory books or anthologies have been written which open up the subject to the student or general reader. For example, John Berger's collaborative series of essays, *Ways of Seeing* (1972), offered a critical Marxist approach to a canonical art history. Marcia Pointon's *Art History: A Students' Handbook* (since 1980) is a highly successful and popular guide largely aimed at a pre-college

student readership. Books containing selected texts on key art historical issues provide material for more in-depth research, for example Eric Fernie's *Art History and Its Methods: A Critical Anthology* (1995). Michael Hatt and Charlotte Klonk's *Art History: A Critical Introduction to Its Methods* (2006) offers accessible discussions and explanations of methodological debates in art history. *The Methodologies of Art*, by Laurie Schneider Adams (1996), surveys differing approaches to art and some of the assumptions of their use.

Art History: The Basics provides a toolkit of concepts, ideas and methods relevant to understanding art and art history. It will develop reader knowledge and subject-specific skills, enabling the exploration of issues and debates within art histories.

CONTEMPORARY ART HISTORIES

Contemporary approaches to art history recognise its plurality – 'art histories' – rather than a singular and central art historical tradition. For example, as its title suggests, Ernst Gombrich's *The Story of Art*, first published in 1950, asserted particular assumptions and exclusions about the meaning of art and the role of art history, many of which are no longer tenable. Jonathan Harris has described Gombrich's concern with 'The canon of great art, and its confirmation in, and by, art history' as integral to broader humanist values and liberal ideals (2001: 37). Gombrich perceived these connections to be self-evident and unproblematic.

Fast-forward over half a century and the 'picture', so to speak, looks very different although not unrecognisable. The subject boundaries, which broadly characterised the discipline of art history in the 1950s, have been profoundly transformed by the concerns of critical theory – initially from the continent, and increasingly taken up across the world. Today we are faced with a range of art histories rather than a single methodological approach or explanatory model. What one commentator has recently described as an interdisciplinary 'menu' of options concedes the partiality of interpretation, whilst inviting a healthy and timely self-suspicion about the basis on which claims to artistic value and meaning might be sustained. This is not to suggest, however, that older and more conservative 'Gombrichian' approaches to art history do not continue among survey courses or some A-level syllabi – they do.

Parallel to these new perspectives is an increasingly globalised cultural economy of new proximities and perspectives. The contemporary world is one in which past and present asymmetries of power and postcolonial histories are mediated through contemporary art and art history, as they are by other interests and discourses.

ART HISTORY: THE BASICS – HOW HAVE ITS CHAPTERS BEEN ORGANISED?

Chapter 1 considers changing ideas and assumptions about art – what is it and how might it be understood and defined? Its second section offers a selective historical survey of art history – from the origins of the discipline to the impact of the so-called 'New Art History'. The reason for combining a brief exploration of aesthetics – philosophical approaches to art – with a summary account of art history as an academic discipline is twofold. First, although in many respects these subjects retain separate – and sometimes antagonistic – institutional identities and affiliations, they are nevertheless symbiotic (Elkins 2006). For example, to explain early twentieth-century Western abstraction without reference to assumptions about mimesis or formalism, or to discuss the impact of postmodernity without reference to the Institutional Theory of Art, is to misrepresent the context in which these departures were made and theorised.

Second, both art history and critical theory share a well-known point of origin in philosophical aesthetics. These inter-dependencies underline the extent to which critical theory is already 'immanent' – that is, within and part of contemporary art history rather than some supplementary gloss concealing methodological business as usual (Emerling 2005: xii). These interconnections are all the more resonant because many of the insights associated with critical theory have questioned traditional aesthetic categories and the nature of our experience and engagement with art.

Chapter 2 opens by considering how we might use a formalist vocabulary in describing examples of painting, design, sculpture and construction. What do we mean by formalism and its institutionalisation through Modernism as approaches to looking at, and making art? How might we relate these ideas to abstract art and what has

been their legacy for art history? Chapter 3 introduces Marxist perspectives on art and culture and the legacy of such ideas for a social history of art.

Chapter 4 discusses the subject of signs or semiotics and the various contributions of Peirce and Saussure. What issues and concerns do structuralism and poststructuralism raise about art, meaning and authorship? Chapter 5 looks at the impact of psycho-analytic theory as well as considering how more recent interventions might be used to situate aspects of art practice. Chapter 6 explores how issues of gender and sexual identity have been mediated through art. It also considers the perspectives offered by feminist, postfeminist and queer theory in relation to art history.

Chapter 7 explores the postmodern – what does it mean and to what extent have ideas and theories associated with it been used to characterise art and the status of the visual within culture more generally? Chapter 8 looks at theories of globalisation and postcolo-nialism and the context of their increasing centrality to art and art histories.

Some final points about the images used to illustrate this primer. Subject to the usual constraints and permissions, effort has been made to include a range of work spanning ceramics, construction, installation, painting, photomontage and sculpture. These are not of course exhaustive, omitting for example, performance work, video-based installation and film. However, all of these practices, whether contemporary or otherwise, are the subject and focus of art histor-ical study. The various ideas and interventions explored in these chapters consider the specificity of what art is and what it does – or might do.

In the same way that art is not reducible to the theories explored in these chapters, neither is it produced without an awareness of the aesthetic values and presuppositions of its time – whether a Cranach painting or a Gabo construction. If anything, one of the frequently noted characteristics of much recent art practice across all of these genres is the extent to which it is self-referential, demonstrating other traditions of art making and art theory. To give some immediate examples, the work of Jake and Dinos Chapman, Peter Kennard, Barbara Kruger, Gerald Laing, Fiona Rae and Yinka Shonibare registers an acute awareness of the institutional frame-works in which art is made, discussed and historically located. In

this sense, it might not be too great a claim to suggest that art practice and art history increasingly – and reflexively – implicate each other.

GLOSSARY TERMS, CHAPTER SUMMARIES AND FURTHER READING

Each chapter poses questions and includes summaries for reference purposes, in addition to noting resources for further exploration and ideas for additional reading. The aim throughout *Art History: The Basics* has been to support active engagement and to underline what we hope is a discursive and accessible reading experience which will encourage further exploration of both art and art history.

The use of italics indicates a glossary term, which will be *italicised* on first use within any given chapter. For a more wide-ranging and comprehensive glossary of terms see *Art History: The Key Concepts* by Jonathan Harris (2006). All titles of art works discussed in the text are in **bold italics**. A full listing of examples used in this primer, including media, dimensions, date and location, is given in the list of figures on pages xii–xiv. Note that the reference to each illustration includes its page number.

Unless otherwise stated, the views, omissions and assumptions in this book are those of its authors.

Grant Pooke
Diana Newall

ART THEORIES AND ART HISTORIES

WHAT IS ART AND WHAT IS ART HISTORY?

I'm delighted to have made an empty plinth that isn't empty, where the exhibit itself is merely invisible.

(David Hensel 2006)

A British artist sends a sculpture to an internationally prestigious and open art exhibition. However, what the selectors actually accept for exhibition is not the jesmonite laughing head, but its slate plinth and bone-shaped wooden rest which had been accidentally separated from the sculpture during handling. The head, *One Day Closer to Paradise*, 2006 (**Figure 1**, p. 2), was duly returned to the bemused sculptor. The empty plinth (RA exhibit 1201), subsequently re-named *Another Day Closer to Paradise* (**Figure 2**, p. 3), was later auctioned with a donation made to charity. This is not an urban myth, but a widely publicised incident which occurred at the Royal Academy's 2006 Summer Exhibition (Malvern 2006: 4–5). The artist involved, David Hensel (b. 1945), recalled:

the art world itself seems to be engaged in a cultural performance about our times, a parody about duplicity, marketing tactics, and acquiescence.

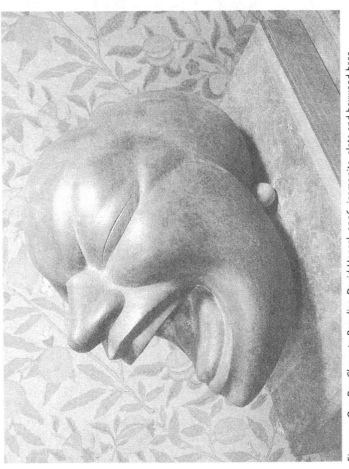

Figure 1 *One Day Closer to Paradise*, David Hensel, 2006, jesmonite, slate and boxwood base, 44 × 33 × 22cm, © the artist.

Figure 2 *Another Day Closer to Paradise*, David Hensel, 2006, slate and boxwood 44 × 33 × 22cm, © the artist.

Presenting this work in public and watching the reactions has produced many fascinating insights into how the arts work, about the need for understanding the broader picture of the dynamics of culture, and particularly the need to study the history of propaganda and patronage, the pursuit of invisible influence, in parallel to the study of a history of art.

(Letter from David Hensel, 1 December 2006)

Unsympathetic critics and commentators claimed that the treatment of Hensel's RA submission demonstrated the 'emperor's new clothes' syndrome, although the jury's selection seemed to suggest just how arbitrary contemporary ideas about art and *aesthetics* seem to be.

Taking Hensel's thoughts on his RA submission and its aftermath as a point of departure, we might reasonably ask what we actually mean by art and art history. These are the two central questions around which this primer has been written. This chapter will consider some of the changing ideas about art and its interpretation. What are the origins of art history as an academic discipline and how has it evolved? What is the purpose of art? And how might we characterise some of the developments of recent decades within the academic discipline of art history?

SO WHAT IS ART?

There really is no such thing as Art. There are only artists.

(Gombrich 1984: 4)

Gombrich's Delphic observation suggests that art is something which artists do. The various examples used to illustrate this primer – ceramics, constructions, paintings, land art, *installations, performance art, photomontage* and sculpture – all have aesthetic status. In other words, the label 'art' connects very disparate objects, practices and processes.

Recognising this diversity, various categorisations have been made within definitions of visual art (including Fernie 1995: 326). Building on these we might propose a general set of guidelines for understanding what art is thought to be:

- Fine art has traditionally been used to distinguish arts promoted by the *academy*, including painting, drawing and

sculpture, from *craft*-based arts. The latter typically refers to those works created for a function – such as ceramics, jewellery, textiles, needlework and glass which are still termed decorative arts. This distinction does not apply so strongly in contemporary art making where a wide variety of *media* are used including, for example, ceramics (Grayson Perry) and embroidery (Tracey Emin). There is, however, still a loose boundary between objects made with a specific function in mind (and therefore where technical and design-related concerns are paramount) and those which are made primarily for display.

- A broader definition of art encompasses those activities which produce works with aesthetic value, including film making, performance and architecture. For example, architecture has always had a close connection to painting, drawing and sculpture, two instances being the *classical revival* in the eighteenth and early nineteenth centuries and the Bauhaus aesthetic of the 1930s which frequently integrated fine art with design, craft and architecture.

- Contemporary definitions of art are not medium specific (as ideas around fine art tended to be) or particularly restrictive about the nature of aesthetic value (as *Modernism* was – see Chapter 2). These ideas are associated with the Institutional Theory of Art which is probably the most widely used definition. It recognises that art can be a term designated by the artist and by the institutions of the art world, rather than by any external process of validation. On the one hand it provides an expansive framework for understanding diverse art practices, but on the other, it is so broad as to be virtually meaningless. We will return to this in Chapter 7.

However, regardless of categorisation, all definitions of art are mediated through *culture*, history and language. To understand these differing concepts of art, we need to look at their social and cultural origin.

THE CLASSICAL CONCEPT OF 'ART'

In a Western context, art understood as a practical, craft-based activity has the longest history. For example, within ancient Greek culture

there was no word or concept approximating to our understanding of 'art' or 'artist'. However, the Greek word 'techne' denoted a skill or craft and 'technites' a craftsman who made objects for particular purposes and occasions (Sörbom 2002: 24). Similarly, within the classical world, examples of craft, such as statues and mosaics, had practical, public and ceremonial roles. The classical sculpture of *Zeus*, copy after a fifth-century BCE original (**Figure 3**, p. 7), would have been judged according to the technical standard demonstrated, and by the extent to which it fulfilled the social and civic roles expected of craft. Foremost of these was the belief that the human form should be represented in its most life-like and vital sense as the union of body and soul (Sörbom 2002: 26). The idea that a sculpture or mosaic should be judged on criteria independent of such purposes was alien to the classical concept of craft.

CE and BCE

In response to concerns over the implied Christian bias of BC (before Christ) and AD (anno domini – in the year of our Lord), contemporary scholars sometimes use CE (common era, equivalent to AD) and BCE (before the common era, equivalent to BC) instead.

Within a Western tradition of art, originating from Greek and Roman practice, the categories of art and craft have become familiar within specific contexts, cultures and in relation to particular audiences. Throughout Europe and North America for example, cultural assumptions about what art customarily was were closely linked to the origins and development of the academic subject of art history itself. Of central importance to this were the social institutions such as academies and museums which were established from the late sixteenth century onwards. Collectively, these interests, and those associated with them, established normative definitions of art, that is, ideas about how art should look and what it should do, variations of which have continued today.

Another point worth making is that to label something as art implies some kind of evaluative judgement about the image, object or process. That is, it recognises the specificity of a range of practices within a broader category or tradition with particular claims

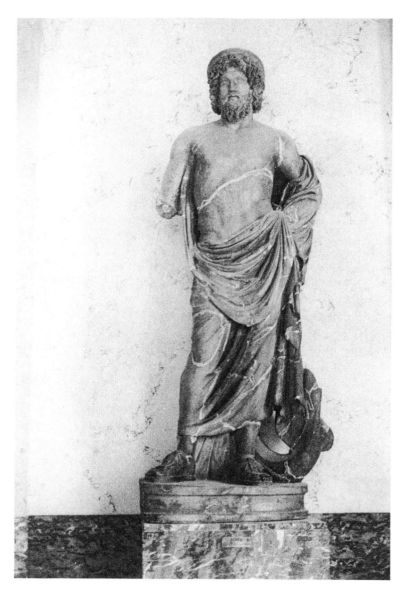

Figure 3 *Zeus*, copy after a fifth-century BCE original, marble, Louvre, Paris,
© photograph Ann Compton, photograph Conway Library, Courtauld Institute of Art,
London.

to aesthetic and/or social value. But it is important to understand that the meaning and attributions of art are particular to different contexts, societies and periods. Whatever the prevalence through time of objects and practices with aesthetic purpose, ideas and definitions of art are neither timeless nor beyond history, but relate to the social and cultural assumptions of the societies and environments which fashion them.

FINE ART AS AN EXCLUSIVE CATEGORY

The academy-based categorisation of fine art and the consensus which underpinned it for several centuries demonstrate how durable and *hegemonic* such interests were. But from the later nineteenth century onwards many *avant-garde* artists began to make work which questioned either the conventional subject matter and primacy of these distinct categories (history paintings and portraiture for example), or the tradition of representation which they *signified*. For example, the work of Paul Cézanne (1839–1906), Pablo Picasso (1881–1973) and Georges Braque (1882–1963) underlined the importance of still-life as a *genre* to the birth of *modernism* (Bryson 1990: 81–86). Similarly, the development of *collage* by Braque and Picasso, and their inclusion of everyday objects such as flyers and tickets, explored the actuality of the flat surface, rather than concealing it through illusionism which had been such a dominant feature of academy-sponsored painting and sculpture.

Academy-based ideas typically marginalised *non-Western* art practices which reflected different ideas about aesthetics, culture and meaning. Overseas trade, colonisation and *imperialism* stimulated interest in tribal masks, carvings, fabrics and *fetish objects* from regions such as Africa, Asia, India and Iberia. These objects, and the indigenous cultures they represented, contributed to major ethnographic collections throughout Europe, stimulating widespread interest in non-Western art and artefacts (Ratnam 2004a: 158–60). Within the avant-garde, various artists like Braque, André Derain (1880–1954), Ernst Kirchner (1880–1938), Henri Matisse (1869–1954), Picasso and Maurice de Vlaminck (1876–1958) popularised the cult of *primitivism*. Whilst such interests frequently reflected romanticised *stereotypes* about what primitive art and culture actually signified,

there was also recognition of the social and political dimensions to such use (Leighten 1990: 609–30).

The legacy of academy-based conventions of art making is such that there is still a tendency by some to rate fine art – painting, drawing and sculpture – as intrinsically superior to installation, performance or conceptual art practices. For example, the sponsoring of a 'Not the Turner Prize' by a national newspaper demonstrates the willingness within parts of the media industry to tap into palpable unease among sections of the general public about the criteria for what is admissible as art and the cultural authority of those who customarily make such judgements. Similarly, the press and public furore over the example of the empty plinth, cited at the start of this chapter, suggests just how deep-seated some of these ideas actually are. In order to understand such categorisations and exclusions, it is useful to consider those aesthetic theories which have been historically influential in shaping values and assumptions about the meaning of art.

ART AS IMITATION

Consider **Adam and Eve**, 1526 (**Figure 20**, p. 142), by Lucas Cranach I (1472–1553), and John Singer Sargent's (1856–1925) portrait of **Mrs Fiske Warren (Gretchen Osgood) and Her Daughter Rachel**, 1903 (**Figure 21**, p. 145). There are appreciable differences between these two paintings in terms of subject, date, genre, origin, materials and meaning. Whereas Cranach attempts to convey the *symbolism* of a Biblical story (the Temptation of Adam), and Sargent seeks to capture the likeness of his sitter, both paintings work on the basis of resemblance – either the circumstances of an imagined event or the features of a particular individual.

The theory of imitation (or *mimesis*), situates art as a mirror to nature and the world around us. Within the history of Western painting, the principle of imitation was associated with the invention and widespread adoption of *single point perspective*, an innovation which, literally and symbolically, underlined the primacy of the artist's viewpoint. This was a major breakthrough which assisted in ever more convincing illusions of depth and space on a flat surface. For example, a *naturalistic* painting, like Masaccio's **Holy Trinity**, 1427–28, in Santa Maria Novella, Florence, became, in

effect, a hole in the wall to another spatial dimension. This example was emblematic of attempts to capture the way things looked, or were believed to be. The success of an art work became, in large part, dependent on the extent and ease with which spectators were seduced into suspending disbelief, forgetting that they were in fact looking at a flat, two-dimensional surface.

> **Artchive online**
> Art works are referenced throughout this book. Although many have been included as illustrations, the reader is encouraged to use the internet to view other works and artists referenced or discussed. One useful source, in addition to the major gallery websites, is the Artchive website: http://artchive.com/ftp_site.htm
> For example, select Masaccio from the list of artists, view the image list and select *Trinity* (1427–28) to view this work.

PLATO'S IDEA OF MIMESIS

The idea of art as imitation can be traced back to book ten of Plato's *The Republic*, c.340 BCE (Sheppard 1987: 5–9). Here, Plato dismissed painting, which he understood in terms of mimesis or imitation, as having limited use. A painting of a table was neither the ideal form of the table (the perfect idea of a table which existed in divine imagination) nor the table made in a carpenter's workshop. According to Plato, a painting of a table was merely a copy and had limited practical value since it could not even be used to actually make or design a real table (Plato 1987: 424–26). Although elsewhere, Plato was more supportive of schematic art (Hyman 1989: 84–88), his comments here suggest that the practice of strongly imitative and illusionistic painting is little short of a fraudulent activity.

Plato's approach to art was framed by the classical world and its values. The principle of imitation makes more sense when we consider the belief, prominent since the *Renaissance*, that artists should attempt as accurate a representation of their subject as possible. Beliefs of this kind shaped much of the Western *canon* of art – those examples judged by the academies to be benchmarks of their kind. In fact, it took nearly 400 years after the birth of Leonardo da Vinci, for an avant-garde challenge to the dominant belief that art was fundamen-

tally about achieving naturalistic effects. But the idea that art should be imitative of things in the world remains widespread, and is not an untypical response by some to aspects of contemporary practice.

PROBLEMS WITH ART AS IMITATION

First, imitation as such is neither a necessary nor a sufficient condition of art. It certainly does not account for the artistic status of music, architecture, imaginative fiction or poetry. Neither does it account for *abstraction* – art which does not have any obvious resemblance to the world around us – or with three-dimensional installations. Consider, for example, one of four versions of Kasimir Malevich's (1878–1935) **Black Square**, *c.*1929 (**Figure 13**, p. 74). Although this image has been interpreted in various ways, naturalism is not among its concerns.

The theory of mimesis is also unhelpful when exploring art which follows differing assumptions about meaning and value. Potentially, this theory marginalises traditions of image making within Byzantine and Islamic art where transcendent considerations are paramount; or art from Asia and China. For example, art from after the Han Dynasty (*c.*206 BCE–220 CE) was understood as an expression of the dao – literally meaning the path or way – which derived from Daoism, a religion indigenous to China (Clunas 1997: 101). Daoism offered personal salvation and the prospect of immortality, beliefs which were conveyed through various ceremonial, ritualistic and alchemical practices. Unlike the Greek and Roman cultural tradition of imitation, art produced in China at this time was concerned with bringing its maker's personality into alignment with the dao – the universe and the natural order.

The emphasis on imitation also excludes a wide range of objects and practices which have characterised more recent avant-garde art. Besides, the idea that imitative art and photography are impartial mirrors of the external world is difficult to justify – we all perceive and experience the world differently. Ultimately, any representation is an interpretation which will not be neutral, but subjective (Foster 1985: 59–64). Lastly, even when we are presented with a naturalistic image, is it really the illusionistic effect that we take to be the ultimate point of interest or value? Whilst we might applaud the painter, or the photographer's naturalistic technique, is imitation really all we look for in art?

FORMALIST THEORIES OF ART – ART AS 'SIGNIFICANT FORM'

In the novel *Brideshead Revisited*, Evelyn Waugh's doomed character, Sebastian Flyte, reads aloud an extract from Clive Bell's *Art*. He quotes:

> Does anyone feel the same kind of emotion for a butterfly or a flower that he feels for a cathedral or a picture?
>
> (Waugh 1982 [1954]: 27)

Bell believed that we respond to instances of natural beauty differently from how we do to examples of art. A British journalist and art critic, Clive Bell (1881–1964) outlined these and similar ideas on *formalist* aesthetics in his treatise *Art* (1914). In outline, formalist approaches to art emphasise the appearance and *composition* of the art work (its form) rather than its narrative or content. Here, discussing 'works of art', Bell asks the question, 'What quality is shared by all objects that provoke our aesthetic emotions?' (Bell 1949: 8).

Bell asserted that our response to certain types of art arose from the impression made by the properties of its form – lines, colours, shapes and tones. He claimed that such an aesthetic response was intuitive and involuntary. That is, we have no control over how we feel in front of, for example, a Cézanne canvas or a Persian tapestry. Represented in a particular way, a configuration of lines, shapes and colours provides the viewer with the experience of significant form which Bell judged to be the benchmark of all great works of art. Similarly, all such examples have in common this quality of significant form.

Bell's theory appears circular and self-justifying. Since it also fails to clearly define either 'form' or 'significant' it is impossible to evaluate more clearly what criteria he actually envisaged. It is suggested that the spectator will know when they have experienced such a compelling response to an object, even if it cannot be clearly explained.

Bell's theory was also *essentialist* – it asserted that great art shared, or had in common, essential and consistent visual qualities which enabled its recognition as such. Refreshingly, for the Edwardian times in which his ideas were expressed, Bell judged

such attributes to be as applicable to fine art as they were to examples of design, craft or architecture, all of which were given comparable status (Edwards 1999: 9). The idea of significant form, even if deliberately vague, proved attractive to a new generation because it seemed to account for the apparently simple, sensual pleasure derived from actually looking at aesthetic objects, regardless of their purpose, previous categorisation or status.

BELL AND AVANT-GARDE ABSTRACTION

Although Bell's theory was simplistic, it underlined a shift of sensibility away from making evaluative judgements about art arising from criteria of resemblance or academic naturalism which had previously defined mainstream British, European and American painting. The increasing prevalence of photography, which provided mechanical reproductions of images, underlined the importance of identifying those features and attributes which were unique to other forms of aesthetic practice (Gould 2003: 37–38).

Like his colleague and contemporary Roger Fry (1886–1934), Bell was an advocate of the work of Cézanne (see for example **Figure 11**, p. 49) and the Post-Impressionists, exhibitions of which he had supported in London in 1910 and 1912 (Gaiger and Wood 2003: 4). More provocatively, Bell also argued that the narrative content of art was at best irrelevant, and at worst actually negated an object's aesthetic status. Appealingly for some of his Edwardian contemporaries, he effectively wrote off much of the Western canon of art since the Renaissance! These ideas were important because they anticipated some of the critical responses to avant-garde abstraction which subsequently became widespread.

THE THEORY OF ART AS EXPRESSION

> Art is the community's medicine for the worst disease of mind, the corruption of soul.
>
> (Collingwood 1975)

According to the theory of expression, art should clarify and refine ideas and feelings which are shared with the spectator. Among its

most influential exponents was the British historian and aesthetician R. G. Collingwood (1889–1943). In *The Principles of Art* (1943), Collingwood argued that art proper is distinguished by a particular and unique emotion, not possessed by either craft or art as amusement, which he describes as lesser forms of technical art. As he eloquently put it, art's place is to tell the audience 'the secrets of their own hearts' (Collingwood 1975: 336). By communicating authentic thought or a state of mind, art enabled both the artist and viewer to gain self-knowledge and so lead a better life. As Graham notes:

> It is through imaginative construction that the artist transforms vague and uncertain emotion into an articulate expression.
>
> (1997: 32)

The idea that art should have a broadly communicative role is not new, but what Collingwood seems to be suggesting is more ambitious: art should convey fundamental truths and insight about what it means to be human and in the world. This theory is regarded as normative; its concern is less with a definition of art as such, but with how art should be valued and understood (Graham 1997: 176). Insofar as Collingwood's theory disregards resemblance as a criterion of art proper, it shares similarities with Bell's idea of significant form and other formalist theories.

OBJECTIONS TO COLLINGWOOD'S THEORY

Few might argue with the generality of Collingwood's suggestion, but the moral tone which underpins his idea of art as a form of self-knowledge is used to justify various exclusions to its definition. First, there seems to be no recognition of the authentic pleasures and enjoyment which looking at and engaging with art can bring. Second, Collingwood does not recognise craft – those objects executed for a purpose – as art proper (Ridley 1998: 10). He continues by suggesting that whilst art may have an element of planning, it may equally be undertaken without a final idea or conception of the finished form. By contrast, any example of craft, such as the making of a table or chair, necessarily requires that its maker has a clear plan of how it will be constructed and what it will look like (Collingwood 1975: 20–22).

Written in the 1940s, Collingwood's qualitative distinction between art and craft now looks dated, particularly because the art paradigm which he seems to have had in mind is that of painting. But since the 1960s, much art has explored other media or has *hybridised* existing forms. For example, Grayson Perry (**Figure 28**, p. 209) has combined the craft associations of ceramics with some of the expressive and iconographical concerns previously associated with painting. The making of much bespoke Renaissance painting and sculpture was not just planned in the general sense conceded by Collingwood's definition, but was highly codified by stipulations regarding size, composition, execution and quality of materials (Baxandall 1988). Whilst it could be argued that such work was still understood and regarded by fifteenth-century contemporaries as indeed a form of craft, by the seventeenth and eighteenth centuries it had been recognised and given 'fine art' status.

As Warburton observes (2003: 60–61), if Collingwood's ideas are taken at face value, religious art, including the *St George Icon* (**Figure 26**, p. 200) and Cranach's ***Adam and Eve*** (**Figure 20**, p. 142), created to arouse devotional feeling, would be relegated to a form of magic or non-art. Collingwood also discounts representational art, suggesting that since it too is undertaken according to a plan of capturing a likeness, it should be understood as a technical or lesser form of art or craft (Collingwood 1975: 42–43).

ART AS ABSTRACTION OR IDEA

These exclusions seem to suggest that authentic art might typically include examples of abstraction like Malevich's ***Black Square*** (**Figure 13**, p. 74) or that it remains an unrealised concept. One of the striking features of Collingwood's *The Principles of Art* is just how few references are made to contemporary (i.e. 1930s) visual art; only the sculptor John Skeaping (1901–80) is noted in passing (1975: 10). The positive mention of the semi-abstract painting of Cézanne and the ideas of the art historian Bernard Berenson (1865–1959) implies a preference for art which conveys meaning through form and imaginative association.

As in Plato's theory of ideal forms, Collingwood suggests that the actual making of the art object is inherently inferior to its conception as an ideal form. Seeing or otherwise encountering for

ourselves the forms, ideas and associations of art is fundamental to the sensory experience it offers. Unless art is reproduced and shared with the viewer in some way, it remains invisible, known only to the artist's mind.

Although there are clearly problems with Collingwood's theory of expression, what it does acknowledge is the extent to which visual art, like music, can and does provide insights and perspectives which are not automatically those arising from mere resemblance, or which are necessarily reducible to form. Although a cliché, the idea that an image or object can convey a thousand words at least recognises that art can be uniquely expressive of ideas and associations – sensuous, intellectual or experiential – more easily felt than explained.

ART UNDERSTOOD AS 'FAMILY RESEMBLANCE'

Faced with such diversity, some philosophers have argued that there is little point in looking for a common denominator in art, be it resemblance or expression, which will give a comprehensive and catch-all definition. Instead they have used the idea of 'family resemblance' (Warburton 2004: 149–50). Whilst members of a family will share some genetic and physical characteristics from one generation to another, these will suggest resemblance rather than exact similarity. Therefore, the best that we can hope for is that types of art such as paintings, film or installations will have particular qualities in common which will enable us to recognise them all as art.

This approach offers the possibility that new and innovative art forms and movements can be incorporated into the existing 'family' on the basis of sharing some characteristics. In this sense, art can be understood as an open concept which is subject to development. A major problem with the concept of family resemblance is that it makes no distinction between exhibited and non-exhibited properties. So, whilst we might identify stylistic similarities in examples of *mimetic* art, there may be other cases where otherwise diverse and visually different art practices do have an underlying connection which is not apparent to the eye (Warburton 2003: 84). For instance, several examples of art with no evident visual similarities may have non-exhibited but relational aspects in

common. The example used by one commentator is that such images may have been undertaken for a similar audience or context, although of course this would not necessarily be an exhibited property (Mandelbaum 1995: 193–210). However, the example cited falls short of providing a definitive relational feature (Neill and Ridley 1995: 193). It was partly this perceived limitation in the concept of resemblance that the next theory we consider attempts to avoid.

THE INSTITUTIONAL THEORY OF ART

As mentioned earlier, the Institutional Theory of Art suggests that art can be what the artist and the art world say it is. Typical examples would include Marcel Duchamp's (1887–1968) **Fountain**, 1917, or Tracey Emin's (b. 1963) **My Bed**, 1999. Although the most flexible and accommodating of the art theories so far outlined, it runs the risk of overlooking the very specificities and attributes of art (whatever they might be), which makes it such an important and differentiated human activity. Besides, upon what criteria does the art world make its selection of those objects designated as art? This theory is discussed further in Chapter 7.

AESTHETIC THEORIES OF ART

All the theories of art considered so far have limitations. Acknowledging these, philosophers have looked at the nature of aesthetic appreciation itself. In other words, is there something that our response to art has in common with the pleasure that we take in a landscape, the cadence of a sentence or simply in listening to the morning chorus? Instead of attempting to define art, should we simply attempt a definition of beauty? If we can successfully agree on this, perhaps we can base our judgements about art on surer footings?

The definition of beauty and the character of our response to it have proved a challenging philosophical and aesthetic problem, the nature of which cannot be fully explored here. In short, there is no agreement on what beauty is, or what it might be. As Sheppard notes, a satisfactory account of the aesthetic experience must explain what makes it so powerfully intuitive and, at the same time, explain why its opposite – detachment, or even disgust or horror – might also be compelling (1987: 64–65). The German philosopher

Immanuel Kant (1724–1804) claimed that aesthetic judgements are disinterested, that is we respond to an object simply on the basis of how it appears to us, rather than us having any particular need or use for it. Although he claimed that aesthetic judgements claim universal validity, Kant remained vague on what the particular criteria of such aesthetic judgements might be, or how differing aesthetic judgements are possible (Sheppard 1987: 74–75).

DIFFERING DEFINITIONS OF ART: FROM PLATO TO THE POSTMODERN

So far, we have considered definitions of art as imitation; significant form; expression; as an activity understood in terms of the metaphor of 'family resemblance'; or as something which is institutionally created. We have noted inconclusive claims as to what constitutes beauty and how it might be justified. These approaches provide a theoretical context for understanding some of the differing historical approaches to, and contexts of, artistic production. Although this is a sweeping generalisation, in a Western context the first theory, or variations of it, was prevalent until the late eighteenth and early nineteenth centuries, explaining as it did the belief that art should principally be concerned with naturalistic representation.

The late eighteenth- and early nineteenth-century cult of *Romanticism* encouraged exploration of the subjective or expressive human response to nature. For example, the oil-based landscapes by the German painter Caspar David Friedrich (1774–1840), or those of the British artist J.M.W. Turner (1775–1851), were not simply concerned with achieving topographical accuracy, but were attempts to express the experience of the landscape upon human sense-perception.

The origins of abstraction in painting and sculpture in the late nineteenth century, and its adoption among the European avant-gardes in the initial decades of the twentieth century, were concerned with art's expressive potential independent of representation. For example, having completed a version of his **Black Square** (**Figure 13**, p. 74), Malevich proclaimed 'I have transfigured myself in the zero of forms' – an aspiration which defied the traditions of naturalistic representation (Néret 2003: 50).

Of the aesthetic theories discussed, the institutional definition of art is widely referenced in relation to the contexts of *postmodern*

culture of the later twentieth century. However, within Western traditions of art making, particular aesthetic ideas and theories have been fashionable at particular times and in particular contexts. Such ideas were (and remain) part of a broader cultural, political and economic framework in which various types and kinds of art were commissioned, produced and evaluated.

ART HISTORIES – THE ACADEMIC STUDY OF ART

The academic subject of art history, with its origins in the eighteenth century, was no less embedded within the ideas, assumptions and institutions of its time. The aesthetic theories outlined here have been variously used or privileged by particular methodological approaches which in turn have underpinned the ideas of art historians, critics and other cultural commentators. The chapters in this primer have been organised to reflect some of these interconnections and inter-dependencies.

For example, Greenberg's Modernist theory, explored in Chapter 2, can be seen as a belief which privileges the best art on the basis of judgements about form. The interpretative framework offered by more orthodox and pragmatic forms of Marxism (Chapter 3) has typically, although not exclusively, endorsed art in terms of resemblance and imitation. The institutional reading of art is evident within formulations of the postmodern (Chapter 7).

More recent critiques offered by *semiotics* (Chapter 4), *psychoanalysis* (Chapter 5), *feminism* (Chapter 6) and *postcolonialism* (Chapter 8) have explored issues, themes and exclusions arising from past and present methodological traditions which have their origins both within and beyond the academic study of art history. The collective impact of these critiques, appreciable from the late 1960s onwards, resulted in claims of a 'New Art History'. However, as several commentators noted at the time, it was by no means clear if there had been agreement on what the old art history had been (Bann 1986: 19–31).

In this chapter's second section, we will explore aspects of the development of art history. Understood in its very broadest sense, art history is the academic study concerned with exploring the making and meaning of those objects and practices judged to have aesthetic value. As you read the brief survey of the development of

art history, keep in mind the ideas about what art was generally assumed to be through these successive historical periods. Whilst art is not a static category, similarly, the assumptions and practices of art historians have also changed through time. In this sense, the actual production of art and its academic study are symbiotic.

WHAT ART HISTORIANS DO

Art history has been described as the 'discipline that examines the history of art and artefacts' (Pointon 1997: 21). Like many definitions, it verges on the tautological, but Pointon succinctly registers the expansive scope of study which typifies the discipline – those objects and practices arising from human agency which are judged to have aesthetic value. Fernie (1995: 326–27) defines art history as the 'historical study of those made objects which are presumed to have a visual content', with the task of the art historian being to explain 'why such objects look as they do'. He elaborates various examples and concludes:

> These objects can be treated as, among other things, conveyors of aesthetic and intellectual pleasure, as abstract form, as social products, and as expressions of cultures and ideologies.
>
> (Fernie 1995: 327)

These definitions underline the extent to which art can sustain a multiplicity of meanings, and that in attempting to interpret details of form and content, the art historian is inevitably concerned with broader issues of social context, causation and value. Exploring how art looks or appears is just part of a wider interpretative framework, within which there are various methodological approaches which are neither value-free nor impartial. Although these will be discussed in the following chapters, we should start by considering the origins of art history as an academic discipline.

VASARI AND THE ORIGINS OF ART HISTORY

So where does art history as the academic study of art making actually begin? Depending on your perspective, there are various points

of departure. Many art historians and *historiographers* (those concerned with the history of the academic discipline) date it to the appearance of Vasari's *The Lives of the Artists* (1550 and 1568). Giorgio Vasari (1511–74), painter, architect and courtier, chronicled the work of Italian artists, describing their painting styles and patrons, leaving thumbnail sketches of their personalities and behaviour. A keen self-publicist, Vasari's account promoted its author's native Tuscany as a centre of artistic excellence to rival Greece and Rome. Its author ranked the artists he listed according to the alleged quality and standard of their work. This reflected Vasari's belief that art passed from primitive, through good to excellent, or what has been described as a 'single narrative of evolutionary progress' (Edwards 1999: 3). In other words, the development of art was perceived as qualitative – from the Middle Ages it got better and better until it reached a peak of perfection in the work of Michelangelo Buonarroti (1475–1564) and Raphael (1483–1520).

EARLY INSTRUCTION MANUALS IN MAKING ART

There were other and earlier accounts of what artists did. Cennino Cennini's (*c.*1370–*c.*1440) instruction manual *The Craftman's Handbook* (*c.*1390) looked at the physical process of actually making a *fresco* or panel painting, including mixing the pigments and preparing the ground. Taking an architectural example and using a biological model of growth and decay, Antonio Manetti (1423–91) traced its history from early Greece and Rome to its supposed decline in the late Roman period (Kultermann 1993: 11).

Some of these early ideas and manuals were relevant for later art historians and philosophers, who revisited issues of artistic meaning and value. For example, the Italian art historian and antiquarian Giovanni Bellori (1615–96) applied Plato's idea of the existence of perfect or pure forms as a basis for his theory of artistic beauty. For Bellori, to capture an ideal form, the artist should observe and select the best examples from nature. These could then be combined to create a composite whole which was based on neither the inventions of fantasy nor the imperfections of nature. Other classical writers provided a source for Renaissance commentaries on art; for example, Leone Battista Alberti (1404–72) drew upon the Roman architect Vitruvius' (*c.*80/70 BCE?–*c.*25 BCE) book *De Architectura;*

and the writings of Pliny the Elder (CE 23–79) provided a source for *Classical* Greek artists such as Praxiteles (fourth century BCE).

Although Italian writers and artists dominated the early historiography of art, there were exceptions. The Flemish painter and writer Karel van Mander (1548–1606) published his *Book on Picturing* in 1604. His treatise was instrumental in establishing the canon for Dutch and Flemish painting from the fifteenth century, central to which was Jan van Eyck's (c.1385–1441) use of oil-based pigments. In addition to painting, Mander recognised the contribution of printing and drawing, including both within his categorisations.

WINCKELMANN, ART HISTORY AND THE ENLIGHTENMENT

The origins of art history with claims to being an empirical and rational discipline can be dated to the eighteenth century. Like archaeology, art history arose in part from the cultural politics of the *Enlightenment* and antiquarian interests promoted by the *Grand Tour*. The many *objets d'art* and, in some cases, fragments of entire classical ruins such as the Athenian Parthenon brought home by European travellers provided the impetus for study, comparison and classification. The excavations at Herculaneum and Pompeii provided antiquarians like Johann Joachim Winckelmann (1717–68) with the opportunity for detailed, object-based study.

Winckelmann is generally regarded as the founder of modern art history in recognition of his attempts to apply scientific methodology to the study of sculpture and architecture (Heyer and Norton 1987: xxi; Potts 1994). His first book, *Reflections on the Painting and Sculpture of the Greeks* (1755) established the Greek cultural ideal, and his study *The History of the Art of Antiquity* (1764) became central to the *neo-classical* movement. Winckelmann underlined the importance of direct study of the object and sensitivity to the actual process and skill of its creation. His attempt to link art with the ideas and values of its period provided the basis for his recognition as the first cultural historian (Fernie 1995: 71). Although based for much of his later life in Rome where he converted to Roman Catholicism, Winckelmann's contribution to art history was formative in another sense. His work established a German language-based tradition in art history which remained dominant well into the twentieth century.

ART AS AN EXPRESSION OF THE WILL TO CREATE

How did the style of aesthetic objects – whether sculpture, painting or architecture – actually come about? This was a central concern for the Austrian art historian and art conservationist Aloïs Riegl (1858–1905). Riegl's answer was to formulate the idea of 'kunst-wollen' – understood as the 'immanent artistic drive' (Ostrow 2001: 7). This artistic impulse defined the ideas, practices and styles of art, but it was also culturally specific and not readily transferable in its original form to other societies. Riegl believed that artistic style could not simply be reduced to technological cause and effect, but that it conveyed the actual world-view and attitudes of those who made it. This idea was initially used to account for changes in decorative motifs (*Problems of Style: Foundations for a History of Ornament* (1893)), but was later extended in scope in Riegl's second book, *Late Roman Art Industry* (1901).

The principle of 'kunstwollen' was subsequently adapted by the German art historian Wilhelm Worringer (1881–1965). In his polemical study *Abstraction and Empathy* (1908), Worringer argued that stylised and geometric art was part of an *alienated* response by the people of older civilisations and cultures to their surroundings. By contrast, naturalistic-looking or classical art, such as Greek or Roman sculpture, was symptomatic of a relatively harmonious or empathetic relationship between peoples and their environment. Worringer's thesis was widely circulated among the German and British avant-garde, and was of particular influence on the ideas of T.E. Hulme (1883–1917), Percy Wyndham Lewis (1882–1957) and Henri Gaudier-Brzeska (1891–1915).

AESTHETIC COMPARISON AND CONTRAST

Although Worringer's ideas were highly generalised and subsequently fell out of fashion, his thesis had attempted to account for stylistic difference and contrast. Among the art historians who is generally regarded as having made the most significant and durable contribution to the discipline's methodology was Heinrich Wölfflin (1864–1944).

In his major work, *Principles of Art History* (1915) Wölfflin expounded a basis for comparative visual analysis which followed

the opposition of the linear and the painterly. From this he set out five pairs of concepts which are as follows:

- linear versus painterly
- plane versus recession
- closed form versus open form
- multiplicity versus unity
- absolute clarity versus clarity.

Although these terms were devised to characterise successive periods of High Renaissance and *Baroque* art, they have since become widely used in the description and comparison of art outside Wölfflin's original formulation. For instance, we might describe Jacques-Louis David's (1748–1825) painting **Oath of the Horatii**, 1784 (**Figure 12**, p. 63) as highly linear because the entire composition is so clearly dominated by the use of outline and the picking out of individual objects or detail, rather than the use of painterly and tonal effect which is largely limited to the *female* figures on the right margin. By contrast, we might describe Sargent's portrait (**Figure 21**, p. 145) as painterly for the opposite reason. Or to take the third descriptive pair, the painting by Agnolo Bronzino (1503–72) (**Figure 15**, p. 91) is an example of an open form in which the arrangement and gestures of the figure grouping deliberately point out to us and beyond the picture frame. By contrast, David's painting is framed around the central figure grouping which is the principal focus of our *gaze*.

Such comparisons and orderings only make sense in relation to each other. Although these opposing pairs have a general descriptive value, they were established for a distinct tradition of mimetic or naturalistic art – Renaissance and Baroque. Similarly, they follow particular assumptions about the extent to which artistic and cultural styles evolve in disaffinity or contrast with what went before. Wölfflin emphasised the importance of actually looking at specifics rather than mapping out highly generalised schemas like Worringer, and to a lesser extent Riegl. His comparative model and a belief in an empirically based art history which necessitated wide-ranging, interdisciplinary knowledge set the benchmark for European art history in the first half of the twentieth century.

ART HISTORY IN THE LATE NINETEENTH AND EARLY TWENTIETH CENTURIES

From this brief and necessarily selective overview, various points can be made about the origins and general character of later nineteenth- and early twentieth-century art history. First, it was a discipline dominated by continental thinkers (Austrian, German and Swiss), who in turn drew upon a broader intellectual tradition rooted in *idealist philosophy*. In practice, this meant that the study of art and the wider realm of the aesthetic – how we respond to what we see – was based on particular assumptions concerning value and meaning. For example, aside from its intrinsic interest, art was valued because it was considered to be a universal and humanistic expression of our central place and unique identity within nature and the world, a sentiment re-stated by the German-born art historian Erwin Panofsky (1892–1968) (1993: 3–31).

Second, the category of objects accorded artistic status reflected a general consensus about the central importance of a Western and broadly Mediterranean canon of art making, with its origins in classical Greek and Roman culture. In turn, these examples were regarded as the 'height of artistic value and aesthetic excellence' (Edwards 1999: 3). Typically, the areas of study or those objects presumed to have aesthetic interest included architecture, sculpture, painting, print-making and decorative design – an ordering little changed from Vasari's day. Despite differing areas of emphasis, the category of art was understood as a relatively bounded and unproblematic term – it was broadly something which different cultures and people did. A central aspect to an art historian's role was therefore to describe, categorise and place such artefacts in relation to the established (Western) canon determined by the various European academies throughout the preceding centuries.

Third, there was a central and recognisable art historical tradition. In other words, it was a case of 'art history' rather than 'art histories'. As we shall see, these overall characteristics were important since they established an academic orthodoxy with broadly shared assumptions and values. Among these shared assumptions was a belief that art history was primarily concerned with stylistic analysis ('connoisseurship') whether situated in relation to the

artist, the broader culture or an even more generalised sense of the *zeitgeist* – the spirit of the time.

This characterisation of art history as a broadly formalist discipline was to be revised and disputed in the early 1930s by a politicised generation of émigré art historians for whom art was a profoundly *ideological* phenomenon which mediated particular social and economic relationships.

BRITISH ART HISTORY, THE COURTAULD AND WARBURG INSTITUTES

In Great Britain the origins of art history as an academic discipline are closely bound up with private philanthropy and the founding of the Courtauld Institute in 1932. Its initial sponsors were the Anglo-American grandee and former Tory minister Lord Arthur Lee of Fareham, the art collector Sir Robert Witt and the millionaire textile magnate Samuel Courtauld. The Courtauld Institute's early curriculum was survey based and linear – 'from the pyramids to Picasso' (Carter 2002: 86) and broadly formalist – concerned with the object itself and its broader place within the classical canon. Such an ethos was to some extent a reflection of the more empirical character of British cultural life – sceptical of abstract theory and lacking the continental legacy of a classical sociology associated with figures like Émile Durkheim (1858–1917), Karl Marx (1818–83) and Max Weber (1864–1920) (Anderson 1969: 218–29).

The other major base for art historical study in London was the Warburg Library (and subsequently research institute) established in 1933 and named after the independent scholar and polymath Aby Warburg (1866–1929). Of the two institutions, the Warburg was more directly indebted to some of the ideas of the continental thinkers outlined here, but like the Courtauld, it became one of the major destinations for émigré art historians arriving in the country and seeking relevant employment.

CONNOISSEURSHIP AND ATTRIBUTION

Connoisseurship – a belief in good taste and judgement gained through extensive experience and contact with works of art – was central to the ethos of both institutes and to the overall character of

nineteenth- and early twentieth-century art history. Typically it is a concern for stylistic analysis (how the object looks) and identifying its date, authorship and record of ownership (or provenance), in order to establish claims to authenticity. Connoisseurship explores the 'quality' of the art under consideration and how it relates to other 'pictorial traditions to which it belongs' (Fernie 1995: 330–31). Influential exponents of this approach included the American scholar Bernard Berenson, Giovanni Cavalcaselle (1820–97) and Giovanni Morelli (1816–91). Connoisseurship emphasised the importance of correctly ordering works of art and their proper attribution – the identification of an original work from a *copy* or *fake*.

Whilst it may seem self-evident that art history is crucially concerned with looking, connoisseurship established stylistic analysis and attribution as central to the discipline, frequently excluding broader considerations of context and social meaning. Before the widespread use of X-ray technology and more sophisticated methods for accurately dating wood panels and stretchers, connoisseurship necessarily depended upon the acuity of visual judgement. For example, at various times in their careers art historians like Anthony Blunt (1907–89) and John Pope-Hennessy (1913–98) staked their reputations on making correct attributions within their respective areas of expertise. Blunt was famously involved in what became a very bitter dispute with another connoisseur, Sir Denis Mahon (b. 1910), initially over the dating of Poussin's (1594–1665) work and subsequently over the interpretation of the artist's entire career (Carter 2002: 421–34).

The legacy of connoisseurship was also apparent in the display and collecting of art works. Throughout the nineteenth century, the development of art historical research had been influenced by the museums which relied upon experts for the classification and dating of their collections. Given the vogue for formalist analysis, the gallery visitor of the day was customarily given little more than the name of the artist or school and the date. In some cases, even the titles of works exhibited were omitted (Holly 1984: 25).

THE LIMITS OF CONNOISSEURSHIP

One of the principal assumptions of connoisseurship is that, within certain variations, artistic styles remain essentially distinctive (Hatt

and Klonk 2006: 60). However, meaning and interpretation are as context-bound as the production and composition of art. Also, allowing for the various purposes which commissioned works were required to serve, artistic styles vary over time. For these reasons, it has become increasingly rare for attributions based purely on stylistic appearance to be made without other forms of corroboration. Additionally, in what is a largely unregulated international market, there are issues of commercial liability for both vendor and purchaser and for the safeguarding of professional reputations against misattribution. That said, in these cases, there are philosophical arguments which question the tendency to immediately identify a high-quality copy or forgery as automatically inferior to the original. Some commentators have also questioned the apparent fetish for verifiable originals, particularly in a culture based upon visual reproduction and re-presentation.

More generally, innovations in dating technology, the accumulation of more evidence and research, routine cleaning and restoration programmes within collections and museums, as well as a less deferential social culture, have all tended to question the principle of uncorroborated attributions. For example, the ongoing Rembrandt Research Project established by the Dutch government in the 1980s has made a considerable number of high-profile de-attributions from the artist's *oeuvre* with repercussions for individual collectors, museums and, most importantly, for the art historical understanding of Rembrandt's (1606–69) own studio practice (http://www.rembrandtresearchproject.org).

ART HISTORY AND THE 1930s DIASPORA

British art history was radicalised and in one sense professionalised throughout the 1930s by the influx of émigré talent seeking refuge from the Nazi threat in Germany and from totalitarian regimes in Soviet Russia and elsewhere. This diaspora provided some of the most eminent and distinguished contributors not just to art history, but to British culture overall (Snowman 2002). Some of the most well known figures included Walter Friedländer (1873–1966), Sir Ernst Gombrich (1909–2001), Erwin Panofsky, Nikolaus Pevsner (1902–83), Karl Popper (1902–94) and Aby Warburg. No less influential were Marxist art historians such as Frederick (Frigyes) Antal

(1887–1954), Arnold Hauser (1892–1978), Francis Klingender (1907–55) and Meyer Schapiro (1904–96), whose concept of a social history of art challenged the formalist orientation of British and American art history which typified the period.

Such an influx of talent irrevocably changed the intellectual perspectives and aspirations of art history and other humanities disciplines from the 1930s onwards. Whilst Marxist art historians stressed art's enmeshed, ideological role within social relations, others such as Gombrich explored the contribution of perceptual psychology to aesthetics and stylistic analysis, or like Panofsky, attempted to situate art within a humanistic framework. However, all acknowledged the philosophical tradition of art history mentioned earlier, even if they were critical of its assumptions and premises.

Whilst the hiatus of the Cold War period revised the political and military map, it also retrenched other ideas and values, marking the period from the later 1940s through to the early 1960s as one of relative social conservatism. In art history, this was reflected by the dominance and institutionalisation of abstract art and a prevailing and supportive critical practice derived from the ideas of the American art critics Clement Greenberg (1909–94) and Michael Fried (b. 1939) (Harris 1994: 62–63). Aspects of this will be discussed in Chapter 2.

THE NEW ART HISTORY?

This was the collective name given to the radicalising impact of a range of *critical theory* – from structuralism to anthropology, psychoanalysis, feminism, Marxism and postcolonial critiques – evident across art history from the early 1970s (Rees and Borzello 1986: 1–10). In both direct and more nuanced ways, these perspectives arose from the very different social and political ethos of the late 1960s which witnessed student revolt, the war in Vietnam and the American civil rights movement.

Any attempt at briefly characterising such a significant reorientation in art history risks homogenising the very plurality which typified the work and approaches undertaken by its proponents. Among the shifts in approach was a greater awareness of the materiality of art and visual culture as commodity and object, within broader social, economic and psychoanalytic frameworks. Dawn Ades, among the contributors to the first anthology, which explicitly

addressed the impact of these new trends, characterised the re-definition of art this way:

> It is taken that art is not hermetic and autonomous, but bound up with the social and economic movements of the time, as well as conditioned by both artistic tradition and aesthetic ideology.
>
> (Ades 1986: 13)

As various art historians have noted, the New Art History appellation proved misleading in various ways. On one level, it suggested that what was being replaced was in some sense without all or any of the intellectual insights then being discussed. Additionally, the inference was that new perspectives had seamlessly superseded a singular and unitary academic discipline called art history. However, what the label did attempt to register was the extent to which many of the traditional presuppositions of art history and the scope of its academic focus was no longer representative – of either the changed contexts of artistic production or the impact of different intellectual paradigms then being felt across the humanities disciplines.

. . . AND SINCE THE 'NEW ART HISTORY'?

How can we characterise the art histories of today? What of the legacy of the radicalising insights and challenges of the 1970s, 1980s and 1990s? Have they too become part of a new orthodoxy?

There is no longer, and has not been since the 1930s, a recognisably homogeneous art historical discipline, although the distinction became more explicit from the 1970s onwards. There is instead what Andrew Hemingway has recently characterised as a 'liberal pluralism, an attitude that fosters tolerance of a range of different perspectives' (2006a: 1). The scope and range of objects, practices and issues addressed by art and cultural historians have never been wider or more inclusive.

In recent decades, art history has demonstrated a tangible sense of renewal and self-criticism which has accompanied record levels of public interest and engagement in the work of artists and the institutions of the art world. The subjects and themes of contemporary art history suggest an awareness and reflexivity about the asymmetries of cultural power, *gender*, ethnicities and the value-forming role of

museums and art-related institutions. At its best, much contemporary art theory and practice has also been galvanised by an awareness of the imperatives of the global village and the new issues, dislocations and diasporas of our own times. Although the academic *discourse* of art history has frequently been bound up with the preoccupations of Western culture, the global economic and cultural shifts of recent decades underline the extent to which art and art history are not the preserves of the first or even of the developing world.

SUMMARY

Art is an evaluative term which derives from specific cultural histories, conventions and linguistic usages. Both the Western concept of fine art and the academic discipline of art history which arose from it, have their origins in the assumptions, values and aspirations of the European Enlightenment. Theories of aesthetics – what art was generally considered to be and what it should set out to do – whether understood as mimetic representation, expression, significant form, aesthetic response or situated as a pragmatic institutional category – are closely and necessarily interwoven with the history, institutionalisation, and avant-garde practices of art itself. This symbiotic relationship stretches from the eighteenth century to the postmodern, and its legacy is still very much with us. Hegemonic within America and Europe, these ideas and their related institutions typically marginalised the aesthetic practices of non-Western countries and peoples, whilst frequently appropriating the art of the colonised to a pre-existing template of the primitive.

A largely formalist and connoisseurial pursuit throughout much of the nineteenth and early twentieth centuries, the academic discipline of art history was radicalised in the 1970s, registering the impact of various continental theories, including gender, psychoanalytic, Marxist and post-structuralist critiques which systematically interrogated and challenged extant assumptions and biases. In some cases, these ideas reconnected, albeit in new contexts, with earlier social and political art histories which had been all but erased by formalism, or marginalised by intervening Cold War priorities.

It follows that art historical debates about the status, meaning and value of what artists actually do (or have done) invariably implicate these histories and pre-suppositions, even when they do not acknowledge doing so. Although a truism, all art histories mediate the interests and agendas, concealed or apparent, of those who articulate them. Like the making of art, it is a realm which is neither value free nor transcendent of human culture.

FURTHER READING

The New Art History: A Critical Introduction, by Jonathan Harris (London and New York, 2001), is a comprehensive guide to the developments and changes which have characterised the academic discipline of art history over the last thirty years or so. It explores in considerable detail, and in relation to key texts, the impact and interaction of Marxist, feminist and psychoanalytic ideas and the various contributions made by contemporary art historians and critics.

For those interested in finding out more detail on some of the art historians mentioned in this chapter, the companion volumes by Chris Murray, *Key Writers on Art: From Antiquity to the Nineteenth Century* (London and New York, 2002) and *Key Writers on Art: The Twentieth Century* (London and New York, 2003) offer succinct and very helpful bibliographic entries with guides to further reading.

This chapter has considered art history as an academic discipline as well as issues in aesthetics – theories and attempts to define art. *Art History Versus Aesthetics*, edited by James Elkins (London and New York, 2006), provides new perspectives on both areas by presenting in conversation the views of ten art historians and ten aestheticians. The book's unusual structure and approach are very useful in teasing out points of agreement, tension and symbiosis between both disciplines.

A recent glossary of essential terms and ideas is *Art History: The Key Concepts*, by Jonathan Harris (London and New York, 2006),

This chapter touches upon historic differences of emphasis (as well as points of similarity) between art history as an academic discipline and the institution of the museum. For a further and wide-ranging discussion of the subject see *The Two Art Histories: The Museum and the University*, edited by Charles W. Haxthausen (New Haven CT and London, 2002).

FORMALISM, MODERNISM
AND MODERNITY

INTRODUCTION

I've seen things you people wouldn't believe: attack ships on fire off the shoulder of Orion. I watched C-beams glitter in the dark near the Tannhauser gate. All those moments will be lost in time, like tears in rain.

> (Roy Batty's valedictory speech, from the film *Blade Runner* (1982) adapted from Philip K. Dick's book, *Do Androids Dream of Electric Sheep?* (1968))

The things we see and remember are among the most durable of human experiences. This chapter explores aspects of *formalism* – the concern with *composition* and *medium* in art, rather than with subject matter – as the basis upon which we should respond to and value art. How might we relate formalist ideas, and what became their powerful institutionalisation through Modernist theory, to the art of the last century or so? What has been their legacy for the development of art history and for the actual exhibition and display of art works? To what extent were such ideas representative of the *avant-garde* art produced under the conditions of *modernity*?

THE FORMAL COMPONENTS OF PAINTING AND DESIGN

Before we look at some of the broader aspects of formalist theory, what exactly do we mean by the 'form' of a painting, sculpture or *installation*? How might we set about describing, in formal terms, examples taken from these very different media?

The formal parts of a painting include line, tone, shape, texture and colour (Pooke and Whitham 2003: 23–29). Single point perspective and the illusion of space and recession on a two-dimensional surface provide depth. When these attributes are combined they provide various compositional effects such as balance, rhythm and harmony. For example, in describing the style of a painting, we consider the ways in which its visual and technical qualities blend in order to give a particular look or appearance.

Consider David's painting, ***Oath of the Horatii***, 1784 (**Figure 12**, p. 63). Disregard, if possible, the painting's subject matter, but consider instead how the scene has been organised and presented, using some of the visual components just mentioned. You may find it helpful to reference some of the linear and painterly terms associated with Wölfflin which we mentioned in Chapter 1. However, even from a casual glance, a brief listing of formal details and devices might include:

- The left-hand figures are linear and almost sculptural in presentation.
- Tonal values (the contrast between light and shade) are used to model and define the figures – both those in the centre of the composition and those to the right. David has used tonal variation to highlight or accent the composition's dramatic focus, encouraging the eye to move from left to right.
- Although colour is used within the composition to highlight the central figures (such as the patriarch's red cloak), it is otherwise secondary to line and tone.
- The relatively shallow depth and spatial recession underscores the relationship between the figures and the *classical* architectural background.
- Although the central grouping of figures initially looks asymmetrical, the overall composition is balanced. The trio to

the left is counterpoised by the three *female* figures in the right foreground, one of whom envelops the two children. The central figure provides the dramatic focus whilst compositionally linking the painting's left and right sections. Each arch provides a backdrop to specific sections of the painting, whilst collectively framing the entire scene.

- The overall composition is defined by strong intersecting vertical, diagonal and horizontal lines, variously suggested by the architectural background, the opposing angles of the figures, the positioning and direction of the weaponry and the floor's rectilinear and square patterning.

We might also mention some of the stylistic features of David's example, such as the defined musculature of the men and his attempt to depict the folds, weight and texture of the garments worn by the women. One commentator has noted the 'anatomical precision of the father's outstretched calf, or the gauzy sheerness of the mother's headdress' (Rawlinson 2006: 31).

The extent to which David has taken some of the compositional features used to depict his figures from classical treatments of the body is apparent if we consider a Greek representation of **Zeus**, *copy* after a fifth-century BCE original (**Figure 3**, p. 7). The sculpture depicts a partially robed deity. The sculpture is in the round – i.e. sculpted around 360° of its surface rather than just on one plane as a relief sculpture would be. The classical sculpture represents an older, bearded man, comparable to the patriarch in David's painting. Particularly notable in both figures is their stylised, tightly curled hair and emphasised physical form. Other comparative features include the linear folds of the robes suggesting the texture of the fabric, and the positioning of the over-garment or cloak over the arm. Also note the similarities in the design of the sandals in both works, again a traditional Roman motif. The raised arms of the *male* figures in David's painting suggest a dramatic focus which can be compared to classical sculptures depicting heroes and standing gods, especially the **Tyrannicides**, fifth century BCE (heroes of *Classical* Athens, Museo Archeologico, Naples) and the **Belvedere Apollo**, fourth century BCE (Vatican Museum, Rome). David visited Naples in 1779, claiming the experience changed him radically (Lee 1999: 46–47). The costume of the women in the painting also

conforms to classical forms, comparable for instance to the depiction of women and goddesses on the **Parthenon Marbles**, fifth century BCE (British Museum, London).

VISUAL RESOURCES

The websites of the British Museum Compass, the Metropolitan Museum of Art, New York, and the Paris Louvre allow access to their collections for study. Search the collections for Greek and Roman art at:

http://www.thebritishmuseum.ac.uk/compass
http://www.metmuseum.org
http://www.louvre.fr/llv/commun/home_flash.jsp

Many other museums and galleries have their collections online. Use these to gain quick access to studying works of art.

These examples of classical sculpture attempt a highly naturalistic treatment of their subject matter. However, because the emphasis is on capturing a classical story or a mythological deity, we tend to look through the use of the chosen medium – oil on canvas and marble respectively – to the subject or narrative, before considering the technical means used to achieve it. In other words, we are asked to suspend our disbelief, and forget that what we are actually looking at is pigment on canvas or a piece of elaborately carved stone. As noted in the last chapter, among the consequences of Western art's increasing academicisation throughout the eighteenth and nineteenth centuries was an emphasis on defining pictorial space illusionistically, rather than on registering the materiality of the medium through which it was achieved (Brettell 1999: 14). This distinction was to inform one of the most influential *aesthetic* theories of the twentieth century – but more of this later.

ABSTRACTION AS A PROCESS

When looking and thinking about these examples, we should not forget that the actual planning and execution of a painting, sculpture or installation is both a physical and a conceptual process, rather than just an outcome. That is, the artist might work through

the formal and compositional possibilities offered by the subject or thematic they wish to pursue. Similarly, various options and limitations may arise from the choice of a particular medium, the exploration of the idea and the institutional context in which the work is to be exhibited or displayed.

To illustrate the idea of *abstraction* as process, consider the oil on canvas paintings **War Memorial I** and **War Memorial II**, 2006 (**Figure 4** and **Figure 5**, p. 38) by Roger Hill (b. 1942) and the photograph of the same subject (**Figure 6**, p. 39). In **War Memorial I**, Hill has selected key compositional motifs and forms: the trees in the front left foreground, the white weatherboarded cottages with their ochre tile roofs and the clearly delineated contours of the war memorial. These motifs are tonally and texturally differentiated, with depth and space provided by the curved and receding line of the road.

Now look at **War Memorial II**. Stylistically, although these compositional motifs are still apparent they are less defined and in some cases fragmented. The specific features which were clearly apparent in the first painting meld into each other to form a mosaic of shapes across and around the canvas, with foreground, background and horizon line less differentiated. Although there is a suggestion of depth, the pigment texture or impasto in **War Memorial II** makes the materiality of the painted surface even more explicit. Describing the ideas and processes behind these works, the painter notes:

> Every subject offers reasons for colour, shape and texture . . . I can explore in paint, think in terms of paint as an alternative to a purely representational view.

> (Hill 2006)

If we compare both these paintings with a photograph of the subject, we can see the extent to which the alternative to a highly naturalistic treatment inevitably involves a process of simplification and the privileging of particular formal and textual effects. These examples remind us that abstraction is a process involving aesthetic judgements about arrangement and composition which are made visible by the work and through the use of the medium. Also, we can make discriminations between art which is semi-figurative (**War Memorial I**) and that which we might describe as semi-abstract

Figure 4 *War Memorial I*, Roger Hill, 2006, oil on canvas, 55.9 × 45.7cm (artist's collection), © the artist.

Figure 5 *War Memorial II*, Roger Hill, 2006, oil on canvas, 61 × 45.7cm (artist's collection), © the artist.

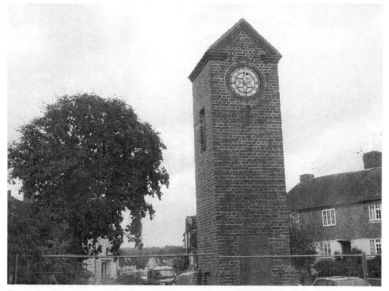

Figure 6 *War Memorial*, Robertsbridge, East Sussex, 2006, © photograph Diana Newall.

(*War Memorial II*). In doing so, we recognise a spectrum of formal and technical practice within and across various kinds of art making, which extends from *naturalism* through to the semi-figurative, the semi-abstract and then on to total abstraction.

To close this section, consider **Construction in Black and White**, 1989 (**Figure 7**, p. 40) by George Dannatt (b. 1915). This relief construction is made of wood and card and is painted in flat black and white. Dannatt follows a particular tradition of geometric construction which typified aspects of avant-garde art practice from the 1920s and 1930s onwards. Originally trained as a chartered surveyor, Dannatt also worked as a professional music critic for several years, before turning seriously to painting. The close observational concerns of both former careers are apparent in his work, much of which combines geometric precision with a frequently lyrical approach to form, balance and harmony. His stylistic allegiance was to the West Penwith (St Ives) post-war abstract school, especially the work of the painter John Wells (1907–2000) and the sculptor Denis Mitchell (1912–93).

Construction in Black and White explores spatial and formal asymmetries in which the raking shadows created by the construction's shallow relief combine to give depth and a sense of enhanced volume. Unlike the paintings just considered, we are presented with an entirely abstract arrangement which depends upon the formal and spatial inter-relationship of black and white squares and rectangles for its aesthetic effects.

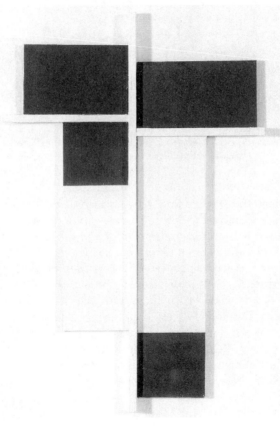

Figure 7 *Construction in Black and White*, George Dannatt, 1989, relief construction, wood, card, flat black and white paint, 18.5 × 14.8cm (private collection), © the artist.

Figure 8 *Birthday greeting card design for John Wells,* George Dannatt, 1977, oils on card, 13.3 × 10.1cm (private collection), © the artist.

Another example of Dannatt's approach to abstraction can be seen in a 1977 birthday greeting design and related preparatory studies for his friend, the painter John Wells (**Figure 8**, p. 41). Choosing a powerful visual contrast between a yellow background and black shapes and lines, Dannatt combines irregular geometric forms with three asymmetrically positioned circles, the largest of which dominates the composition. The interior space of the largest circle is bisected with angular shapes and lines, some of which suggest movement and direction like vectors on a map. The interconnection of the various compositional forms and the considerable care taken with their positioning are especially evident in the two preparatory pencil studies for the completed design.

In this example, and probably stemming from his close interest in music studies, Dannatt explores variations on original themes. The birthday greetings card evolved from a number of earlier and more experimental drawings and paintings which reflected aspects of Wells' own painterly approach and interest in 'texture' (Dannatt 2006).

Looking carefully at these abstract examples and attempting to describe what hits our retina, helps us to understand how these works were made and what aesthetic effects they produce. Regardless of what other meanings or connotations they may have, when we first encounter entirely abstract works of art, we primarily rely upon our visual response to the juxtaposition of forms and colours and to the other compositional elements mentioned at the start of this chapter.

FORMAL LANGUAGE, DESIGN AND SCULPTURE

The various artistic examples just discussed underline the primary experience of looking, through which we register the particularities of media, texture, composition, dimension and, in the case of constructions and sculpture, judgements about weight and volume. Consider for example the abstract cubist design for a tray (**Figure 9**, p. 43) completed under the auspices of the London-based Omega Workshop *c.*1913–19. Like many Omega products, it does not have an attributed designer, reflecting a belief that much of the best pre-modern artisanship was collaborative and anonymous.

Figure 9 *Cubist design for a tray*, Omega Workshop, c.1913–19, graphite, watercolour, body colour on paper, 28.2 × 20cm, © The Samuel Courtauld Trust, Courtauld Institute of Art, London.

Composed using graphite, watercolour and bodycolour on paper, the tray design uses a limited colour range mostly comprising muted greys, and a beige-pink background with blue highlights which recalls the monochromatic palette of early cubist paintings. However, the systematic re-thinking of space and volume undertaken by Picasso and Braque in c.1909–12 is decoratively adapted with a broad, irregular mosaic of interconnecting and intersecting shapes. Here the concern is less with spatial and formal analysis than with a pleasing, *modern*-looking pattern for a functional and practical object.

The stylistic influence of Cubism is also apparent in **Sailor with Guitar**, 1917–18 (http://www.artandarchitecture.org.uk/images/conway/6f53bb72.html), made by the Lithuanian-born sculptor Jacques Lipchitz (1891–1973). Lipchitz moved to Paris in 1909 and subsequently to America as the Nazi threat to Europe increased. Whilst in Paris, Lipchitz met, and was heavily influenced by, Picasso and Juan Gris (1887–1927), with the inspiration for many of his sculptures arising from specific cubist paintings, themes and collages. Fascinated by its analytical and spatial possibilities, Lipchitz subsequently became the most consistent practitioner of a cubist idiom within the medium of sculpture (Pütz 2002: 7–8).

Keeping in mind some of these influences, we might consider the formal composition of this cubist-orientated sculpture. In bronze, **Sailor with Guitar** is an abstract sculpture, comprising a series of interlocking planes which provide volume and mass. It has a largely closed rather than open form – that is with the exception of the elbow angle on the right. We cannot see through the composition which stands self-enclosed and totem-like on its base. The vertical axis along which Lipchitz has made his sculpture reminds us that its inspiration, at least, is the static human form, but the angularity of its intersecting planes renders it dynamic and mobile, with its spatial inter-relationships seemingly unresolved and fluid.

Describing one of the shifts which occurred in sculptural practice in the twentieth century, the art historian Rosalind Krauss has written:

> The logic of sculpture, it would seem is inseparable from the logic of the monument. By virtue of this logic a sculpture is a commemorative representation. It sits in a particular place.
>
> (Krauss 1988: 279)

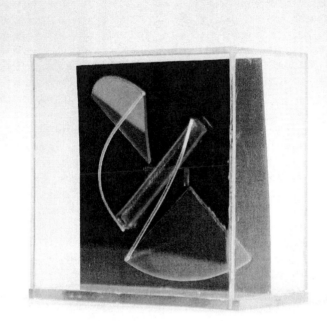

Figure 10 *Square Relief*, Naum Gabo, c.1920–21/1937–38, Perspex, in Perspex box 11.7 × 11.6 × 6.8cm, courtesy Annely Juda Fine Art, the works of Naum Gabo, © Nina Williams.

This characterisation relates to academic sculpture, public and monumental examples of which we can see along London's Thames Embankment or the Seine in Paris. But Krauss goes on to describe the effects of 'modernity' – that is the experience of living in the twentieth century which is registered sculpturally as a:

> loss of site, producing the monument as abstraction, the monument as pure maker or base, functionally placeless and largely self-referential.
>
> (Krauss 1988: 280)

Although a sculpture rather than a monument, the form and appearance of **Sailor with Guitar** mediates this onset of modernity.

Although the title indicates its subject matter, the only real visual clues appear to be the raised ribs which suggest a sailor's striped chemise and the rounded base of the guitar. For practical reasons it has a base, but the absence of a plinth renders it placeless – it could be exhibited or shown anywhere. The near-total abstraction of *Sailor with Guitar* asserts its self-referentiality – the sculpture is primarily an exploration of form for its own sake. Its medium has not been fashioned to be seen through as the technical means to a narrative end, as in David's *Oath of the Horatii* (**Figure 12**, p. 63).

To take one final example in this section, consider *Square Relief*, *c.*1921 (**Figure 10**, p. 45), by the Russian-born sculptor Naum Gabo (1890–1977). Gabo's frequently small-scale works are termed 'constructions' – a reference to the ethos of their making and an underpinning conviction in the socially recuperative powers of art at a time of war and revolution.

The original version of *Square Relief* no longer exists, although there are two other extant versions from the 1930s (Sanderson and Lodder 1985: 208). This 1937 replica of Gabo's earlier construction is made from perspex on an anodised aluminium base – modern materials for a new age.

Compared to the Lipchitz piece, it is slight, delicate and elegantly insubstantial. Both artists claimed Cubism as a point of inspiration for their work. Gabo's conception of sculpture arose from a belief in 'light, time and space as sculptural elements' – considerations which are present in cubist paintings and collages of the time (Nash 1985: 9). Discoveries in science and physics provided Gabo and innovators like him with an entirely new range of geometries. However, Gabo combined these ideas with an intuitive and subjective approach to form, through which his constructions appear to defy gravity and the traditionally vertical and static conception of sculpture.

SOME ISSUES ARISING FROM FORMAL ANALYSIS

From these diverse examples we can make some general points about the use and value of formal analysis and description. It:

- underlines the materiality of the art object – in the case of a painting it typically reminds us that we are looking at a

particular use of a medium (oils, acrylic, gouache, etc.) on a flat surface;

- explores the specificity of an object – how the various compositional and stylistic features noted earlier have been used and combined in a given example;
- provides a language or shorthand which can be used to consider aesthetic effects and our response to them. In doing so, we attempt to convey the particularity of what we see and experience – what is it within the composition and texture of a painting, sculpture, design or installation, etc., which engages interest? As noted in Chapter 1, is narrative or *mimesis* the only thing that we expect from art?
- privileges style – the appearance of the object.

FORMALISM AS ART PRACTICE AND ART THEORY

We have considered how exploring the look of art works can provide a useful basis for teasing out how a particular medium, technique or approach has been used or adapted. Formalist vocabulary can also help in attempts to make judgements about aesthetic value or quality – how might we place the object in relation to other examples or perhaps different genres which use the same medium? Close attention to the particularities of any aesthetic object provides an initial point from which we might discuss broader issues of context, meaning and value.

By the latter part of the nineteenth century, avant-garde artists and critics were increasingly looking to formalist ideas as part of a broader rejection of academic naturalism and narrative content. The pictorial illusionism and classical subject matter associated with the various *academies* was ill equipped to mediate the experiences of modernity – the perceived actuality and social conditions of late nineteenth- and early twentieth-century life. This altered consciousness in turn arose from the processes of modernisation – accelerating technological and industrial changes initiated by the Industrial Revolution (Harrison 1997: 6).

Formalism was not just an aesthetic consequence of social modernity, far-reaching as these effects were. The backward looking art of the academies traded on artifice; it concealed the materiality of painting, rather than exploring the problems inherent in the use

of particular media, or which arose when artists attempted to approximate the shapes, colours and structures of their work to the experience of seeing objects in the world around them.

Concerns over opticality – how things actually appear to the senses – and structure – how such experiences could be intelligibly orchestrated on a flat surface without resorting to illusionism – typified the work of successive avant-gardes and those associated with them. Artists such as Claude Monet (1840–1926), Édouard Manet (1832–83), Cézanne, Picasso, Derain and Matisse elaborated the semi-abstract and non-representational aspects of art practice. Their work suggested that meaning and value could be achieved in relation to the formal and expressive components and effects of the art work, rather than simply being a judgement which arose from narrative or representational qualities. In other words, formalism as a descriptive and observational technique was elaborated into a broader, if disparate, aesthetic theory. As noted in Chapter 1, there were precedents for this thinking in the connoisseurial tradition associated with art historians like Wölfflin and with collectors such as Berenson. Formalist ideas also underpinned the classificatory ethos of museums and ethnographic collections contemporary with these avant-gardes (Holly 1984: 25).

ROGER FRY AND A BRITISH FORMALIST TRADITION

In England, Clive Bell, Roger Fry and Desmond MacCarthy (1877–1952) played major roles in sponsoring and introducing the avant-garde art of Manet and the Post-Impressionists to an Edwardian British public more accustomed to academic painting and illusionism. We might also point to Sidney Colvin (1845–1927), an early advocate of 'art for art's sake', or formalism, which he associated with, among others, the work of the American expatriate artist James McNeill Whistler (1834–1903). Colvin subsequently became Slade Professor and founder of the Cambridge Fine Arts Society. Colvin's presence at Cambridge has been cited as an early influence on the formalist ideas of Roger Fry (Prettejohn 2005: 159).

Fry was an art historian, amateur painter, founding editor of the *Burlington Magazine* and curator of paintings at New York's Metropolitan Museum. Fry's 'Essay in Aesthetics' (1909) was his first major statement on the philosophy of art and is generally

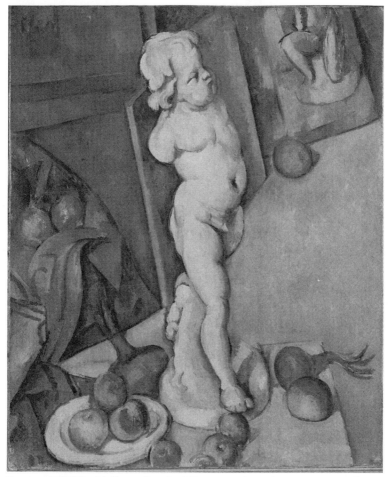

Figure 11 *Still Life with Plaster Cast*, Paul Cézanne, *c.*1894, oil on paper mounted on panel, 70.6 × 57.3cm, © The Samuel Courtauld Trust, Courtauld Institute of Art, London.

regarded as one of the most sophisticated statements of a formalist position for its time. For Fry, the aesthetic response involved an engagement with and response to, the various components of design, including tone, rhythm of line, colour, plasticity and form (Gould 2003: 127). Cézanne, on whom Fry published a *monograph* in 1927, was one of the artists he most rated (see for example **Figure 11**).

Cézanne believed in the importance of strong design in his compositions, a principle which Fry believed had been lost by the Impressionists in their pursuit of purely optical sensations. For similar reasons, Fry advocated other avant-garde work by Georges Seurat (1859–91), Vincent van Gogh (1853–90) and Paul Gauguin (1848–1903) and by cubist artists such as Picasso and Braque – all of whom he regarded as inheritors of the classical tradition of Raphael and Poussin (Fernie 1995: 157).

Fry believed that the best art evoked an emotional response which was communicated to the attuned spectator receptive to artistic intention. Like Bell, he generally disparaged the importance of narrative art or the belief it should have a moral or educative purpose. Appointed Slade Professor of Art at Cambridge shortly before his death, Fry's brand of formalism remained influential within British art and art history. His belief in the progressive autonomy of art and the emphasis given to formal design over representation proved a durable influence on modern abstraction. The prominent British art critic and writer Herbert Read (1893–1968) continued to support a formalist line in his advocacy of British and European artists and sculptors throughout the 1930s and 1940s (Harrison 1985: 218).

AVANT-GARDE ART AND THE CRISIS OF TASTE

Across the Atlantic, formalist ideas found an unlikely sponsor in the initially Marxist-inclined thinking of the American art critic Clement Greenberg (1909–94). In his essay, 'Avant-Garde and Kitsch' (1939) published in a little-known left-wing magazine, the *Partisan Review*, Greenberg made what was to become a symbolic and important intervention in an ongoing debate about the political role of art and literature prompted by the slide towards war in Europe and the increasing power of totalitarian regimes in Germany, Italy and the Soviet Union (Harrison and Wood 2003: 539).

Greenberg used the pejorative German word *kitsch* to characterise what he claimed was the low-grade, mass *culture* produced under both Western capitalism and state-sponsored socialism. Originally a product of the Industrial Revolution which had 'urbanised the masses', kitsch included the debased aesthetic supposedly evident in Hollywood cinema, magazine covers, advertisements, jazz and nineteenth-century academic painting. Greenberg claimed that

faced with the relentless logic of commercialisation and the coercive demands of totalitarian politics, the distinctive role and contribution of the avant-garde was, as he put it, 'to keep culture moving in the midst of *ideological* confusion and violence' (Greenberg 1986). Greenberg traced the origins of this crisis in taste, and the distinct approach to avant-garde art making which it provoked, back to tendencies apparent in mid-nineteenth-century avant-garde French painting. Looking to recent and contemporary avant-garde artists, Greenberg cited Constantin Brancusi (1876–1957), Cézanne, Matisse, Piet Mondrian (1872–1944), Joan Miró (1893–1983), Braque and Picasso as having created a new art typified by a concern with issues inherent to the medium rather than with illusionism or narrative.

A second essay, 'Towards a Newer Laocoon' (1940), mapped out what Greenberg believed were some of the distinctive and authentic features of avant-garde art which differentiated it from academic painting and kitsch. Greenberg's essay referred to a much earlier work by the dramatist Gotthold Lessing (1729–81), and a more recent essay by Irving Babbitt, *The New Laokoön: An Essay on the Confusion of the Arts* (1910), both of which had considered the distinctions between the visual and the verbal arts. Greenberg's essay was an attempt to establish whether the very distinctness of abstract art from other art forms could provide the basis for making judgements of aesthetic value (Harrison and Wood 2003: 562).

According to Greenberg's article, the abstract art produced by the avant-garde was characterised by its 'progressive surrender to the resistance of its medium' which was most clearly apparent in the flattening out of the picture surface. He continues:

> the picture plane itself grows shallower and shallower, flattening out and pressing together the fictive planes of depth until they meet . . . upon the real and material plane which is the actual surface of the canvas.
>
> (Greenberg 1986 [1940])

According to this argument, faced with the pressures of kitsch and debased popular taste, the logic behind the development of abstract art was its refusal of illusionism and an increasing paring down of painting to the essentials of medium and composition. Among the artists Greenberg mentions as emblematic of this new tendency was

the French painter Manet. Describing Manet's style, Greenberg notes 'his insolent indifference to his subject' and continues:

> Like the Impressionists he saw the problems of painting as first and foremost problems of the medium, and he called the spectator's attention to this.
>
> (Greenberg 1986 [1940])

In the light of Greenberg's comments about flatness and the refusal of particular painters to conceal the actuality of the painted surface, we might choose to see the sketchy and simplified elements of Manet's painting, *A Bar at the Folies-Bergère*, 1882 (**Figure 22**, p. 151), as an articulation of the very avant-garde qualities which Greenberg held had eventually culminated in the entirely abstract work of Jackson Pollock (1912–56). The impossible and dissonant mirror image (far right) underlines the extent to which modern art had ceased to define itself as part of a *mimetic* tradition of picture-making (Prettejohn 2005: 157). Greenberg also claimed the work of Cézanne and, more centrally, the legacy of Cubism and those inspired by it – Miró and André Masson (1896–1987) – as symbolic of the avant-garde's shift from the pictorial assumptions which had underpinned Western art since the *Renaissance*. Greenberg's inter-pretation of formalism became widely known as *Modernism*.

GREENBERG AND THE DOMINANCE OF MODERNISM

An acerbic and combative personality, Greenberg played a key role in the subsequent institutionalisation and ascendancy of American abstraction (Marquis 2006). His initial art criticism appeared at a time when what American abstraction there was had yet to achieve any kind of serious or informed evaluation. Greenberg combined a lucid and at times elegant prose style with the utter conviction that his particular characterisation of modern art was the only one valid. For example, in one review, following the logic of modern art's supposed development, Greenberg eloquently describes 'Matisse's cold hedonism and ruthless exclusion of everything but the concrete, immediate sensation' (Greenberg 1986 [7 June 1947]). Greenberg's long-running and bitter feud with another contempo-

rary critic, Harold Rosenberg (1906–78), arose in part from the latter's critical characterisation of Abstract Expressionism in terms of its social and political origins, rather than the purely visual and technical (i.e. Modernist) terms on which Greenberg esteemed it (Marquis 2006: 133–37; Orton 1996: 177–203).

In his essay 'The Decline of Cubism' (1948) Greenberg claimed a symbolic shift had occurred. Noting the lessening quality of work by Picasso and that of other Europe-based artists, Greenberg saw in the rise of new stateside talent, such as that of Pollock, Arshile Gorky (1904–48) and the American abstract sculptor David Smith (1906–65), confirmation of America's *hegemonic* position as the home of modern abstraction. In the years which followed, and after the first wave of Abstract Expressionist artists, Greenberg was instrumental in promoting subsequent work by Anthony Caro (b. 1924), Helen Frankenthaler (b. 1928), Morris Louis (1912–62) and Kenneth Noland (b. 1924). In keeping with the idea of Modernism's inexorable internal logic and historic development, Greenberg had labelled the work of the latter artists, evidence of 'post-painterly abstraction' (Harrison and Wood 2003: 774).

The classic statement of what became known as his 'Modernist' art criticism was Greenberg's essay of 1961, 'Modernist Painting', which claimed its philosophical antecedents from Kant, and the *Enlightenment* philosopher's idea of 'immanent' criticism or self-criticism (Barlow 2003: 152). Here Greenberg asserted that Modernist abstraction was typified by, as he put it, 'the use of the characteristic methods of a discipline to criticise the discipline itself, not in order to subvert it, but to entrench it more firmly in its area of competence' (Greenberg 1965 in Frascina and Harrison 1992: 5).

The invocation of Kant supported Greenberg's cardinal belief that judgements of taste were intuitive and that issues of subject matter had no relevance to perceptions of aesthetic quality – understood as the 'disinterested discriminations of value' (Frascina 1985: 15). The idea of Modernist art as a systematic paring down to the essentials of its medium was used by Greenberg as the retrospective basis for identifying what he regarded as the internal dynamic behind the most successful paintings of the previous century. Some critics have seen this as little more than a convenient rationalisation of Greenberg's own aesthetic preferences, whilst others have seen it as a prescient identification and 'well-founded critique' of innovative

technical changes already afoot in the paintings of mid-nineteenth-century avant-garde painters (Harrison 1985: 218).

MODERNISM AND THE WHITE CUBE HANG

Modernist ideas were not just influential in asserting a highly selective *canon* of abstract works, but they determined how those works were shown and displayed in museums and galleries. In 1976, the critic Brian O'Doherty (b. 1934) referred to a 'white cube' by which he meant an exhibition space in which there are minimal distractions. In the case of canvases, this typically resulted in carefully lit single-line hangs in which the art had plenty of space to 'breathe' or, in the case of installations, plenty of floor space to enable uninterrupted consideration of the art's formal properties. Characterising this context for Modernist art, O'Doherty writes of:

> the suave extensions of the space, the pristine clarity, the pictures laid out in a row like expensive bungalows. . . . The pictures recur as reassuringly as the columns in a classic temple. Each demands enough space so that its effect is over before its neighbour's picks up.
> (http://www.societyofcontrol.com/whitecube/insidewc2.htm)

The precedent for this approach to exhibiting work was set by New York's Museum of Modern Art (MOMA) which has been described as the 'paradigmatic Modernist museum' in its exhibition of a 'selective tradition' which endorsed abstract painting as central to its policy of acquisition and display (Frascina 1993a: 81). Regardless of the critical objections to Greenberg's Modernism and with the exception of the Royal Academy's summer shows, white cube hangs have since become central to the curatorial and commercial gallery world.

OBJECTIONS TO GREENBERG'S FORMALISM

As some commentators have noted, in retrospect it may seem strange that such a subjective and exclusive narrative of modern art achieved the durability that it did within American culture. However, between the 1940s and mid-1960s, the critical account of Modernism provided the dominant explanation and history of modern art (Frascina 1985: preface). Greenberg's mentoring of

highly successful artists throughout the 1940s and 1950s was combined with an acute eye and a seductive thesis which asserted the historical logic behind the apparent dominance of American-led Abstract Expressionism.

In what was for the history of Modernism useful timing, Greenberg's allegedly de-politicised advocacy of American artists over an exhausted European avant-garde, furnished the cultural parallel to America's recently established superpower status. Greenberg's Modernism appeared to accommodate the increasing conservatism of post-war American culture, the collecting ambitions of its major museums, and the politics of the McCarthy era.

The criteria upon which Greenberg's Modernist canon was based were exclusive and excluding. The contribution of the Surrealist avant-garde was written off as little more than aesthetic stunts and the innovative use of photomontage as a political intervention within the historical avant-gardes such as Constructivism was not recognised. Greenberg perceived Pop as a novelty art and was antagonistic to the increasingly diverse range of conceptual practice which at first challenged, and then superseded, his account of Modernist painting and sculpture from the mid- and later 1960s onwards (see Chapter 7).

Greenberg gave no consideration to issues of *gender* or social causation and scant recognition to the achievements of contemporary women artists like Lee Krasner (1908–84), Hedda Sterne (b. 1916) or Anne Truitt (1921–2004) (Pollock 1996: 245). His account of abstract art similarly denied the role of social history and agency in the formation of debates about value and taste.

Instead, Greenberg situated Abstract Expressionism and post-painterly abstraction as the culmination of an internal dynamic or logic of self-criticism whereby artists progressively purified their medium in the pursuit of aesthetic quality. These exclusions were examined by the Marxist art critic and contemporary of Greenberg, Meyer Schapiro, in 'The Social Bases of Art' (1936) and 'The Nature of Abstract Art' (1937). Schapiro and others like him questioned Greenberg's justification for isolating art (and aesthetic judgements) from wider debates about social causation and political significance. However, by the time of the Cold War, the ideas of those like Schapiro were marginalised in favour of Greenberg's Modernist paradigm.

ART AFTER GREENBERG

> It was the zeitgeist. Basically, he was out. He was a formalist, even
> though he said he wasn't. He was just a shadow, a negative. By the
> 1980s, it was as if he didn't exist anymore.
>
> (Collings, 1998)

Greenberg's concept of Modernism was marginalised by the shift
from abstraction and two-dimensional art which characterised the
later 1960s (see Chapter 7). His ideas were taken up by Michael Fried,
who for a time fought an increasingly defensive action against the new
postmodern avant-gardes, although more recently his ideas have
found some resonance in the qualified formalism of Nick Zangwill
(1999). However Collings' valediction has proved more or less apt,
with the contemporary concepts and dynamic of culture entirely
alien from anything Greenberg would probably have recognised.

In the light of Schapiro's corrective to Modernism, later social art
historians reconsidered those artists like Manet and Gustave Courbet
(1819–77) whose work was invoked to justify a Modernist genealogy.
The subject and technique of their painting was seen as constitutive
of very different concerns – social modernity and dislocation, urban
alienation, *spectacle* and the disorientating effects of Baron
Haussmann's reconstruction of Paris (c.1850–1870s). As Blake and
Frascina suggest of this period, 'artists and critics saw modern social
experiences as inseparable from a self-conscious attitude to the means
by which those experiences could be represented' (1993: 53). It was
these very different social conjunctions rather than a sanitised concern
with flatness for its own sake and issues intrinsic to the medium
which were seen to be distinctive of modern avant-garde art.

For example, Manet's dissonant image, *A Bar at the Folies-Bergère*,
1882 (**Figure 22**, p. 151), has been placed in one of the 'glorified beer
halls which came to be known as cafe-concerts' which proliferated
in the newly designed boulevards of Haussmann's Paris (Clark
1984: 206). The composition registers the flattening glare of electric
light, which was replacing gas across the French capital. Its 'halluci-
natory' quality captures the unreality of an urban spectacle in which
widely differing social classes rubbed shoulders contrary to the offi-
cial protocols of the day.

Although Greenberg's Modernist ideas are no longer widely discussed, at its best, his prose brought clarity and eloquence to writing about art and the specificity of the aesthetic experience.

SUMMARY

This chapter has explored how formalist analysis and vocabulary can be used to consider compositional and technical concerns within narrative and abstract art. It has noted that formalist ideas developed into an influential theory and account of art, rationalising the move of many avant-garde artists away from naturalistic paradigms which had characterised Western art making since the Renaissance.

The most influential version of formalist ideas, Greenberg's theory of Modernism, asserted a selective canon of the best art on the basis of its systematic paring down and exploration of the medium. This so-called 'orientation to flatness' became the central principle by which post-war American abstraction was judged to be the culmination of a distinct and qualitatively superior tradition. Critics of Modernism pointed to its refusal to elaborate the exact basis on which such judgements of taste were made, in addition to the way in which the more politicised and narrative-based avant-gardes of the twentieth century had been overlooked. Additionally, Greenberg's wilful disregard for art's social or political context was challenged. Other commentators have noted the extent to which Greenberg's allegedly de-politicised advocacy of abstract art seemed to mirror post-war American economic and political hegemony.

Modernist theory was largely superseded by the advent and eventual dominance of non-painting-based, conceptual art practice which increasingly characterised the late 1960s and 1970s. Subsequent art historical interpretations of some of the artists valorised by Greenberg have revised and questioned Modernist claims. For example, the technical innovations associated with Manet have been interpreted as a mediated response to the external and disparate influence of modernity – the fractured and fragmented experience of urban and metropolitan life, rather than simply a self-referential exploration of form divorced from context. However, whatever the limitations of Modernism, Greenberg did initiate a serious critical discourse which underlined the durability and attraction of formalist ideas in responding to art and the aesthetic.

FURTHER READING

Mary Acton's *Learning to Look at Paintings* (London and New York, 1997) is an informative text which provides a useful introduction to formalist terminology and approaches to looking at art. Acton also provides relevant and well-presented case-studies, spanning painting, drawing, sculpture and installations which illustrate how formalist and descriptive terminology can be used in practice.

Charles Harrison's *Modernism* (Movements in Modern Art Series, London, 1997) is an accessible introduction to the subject of modernism, evaluating its historical and more recent connotations.

A WORLD STILL TO WIN: MARXISM, ART AND ART HISTORY

INTRODUCTION

> The Formalists are followers of St John. They believe that 'in the begin-
> ning was the word'. But we believe that in the beginning was the deed.
> The word followed as its phonetic shadow.
>
> (Trotsky 1925)

Picasso chose to stay on in Paris and at the seaside resort of Royan
after France fell to the Nazis in 1940. Among the paintings which
he had with him was **Guernica**, 1937, the mural-sized work provoked
by the German carpet-bombing of the ancient Basque capital during
the Spanish Civil War. In an exchange which allegedly took place
when German soldiers entered his studio, one pointed to the canvas,
asking 'Did you do that?' 'No,' Picasso is said to have replied 'you
did.' On another occasion, Picasso gave postcards of **Guernica** to
German soldiers on leave in Paris (Hilton 1996: 256).

Apocryphal or otherwise, these stories emphasise the resonance
and power of the visual. The style and content of Picasso's **Guernica**,

fiercely debated by the socialist and communist left, symbolised many of the broader *aesthetic* and political questions which urgently faced art and its academic study throughout the 1930s and the decades which followed.

This chapter considers how Marxist ideas and assumptions have been used to explore the contexts of artistic production and the meaning of art. To what extent has Marxism influenced debates on the visual arts? Following the collapse of Soviet Russia, the Eastern Bloc, and the apparent demise of communism as a viable social and political project, can the philosophy of Marx and his successors provide relevant insights on art and the realm of the aesthetic?

WHO WAS KARL MARX?

Karl Marx (1818–83) was a socialist revolutionary, social philosopher, and a political economist. Formally trained in the disciplines of philosophy and law, Marx was an internationalist, steeped in the thought and aspirations of the European *Enlightenment*. A witness to the vicious and exploitative character of nineteenth-century capitalism, he advocated the complete transformation of all existing social, cultural and political relations. Marx is probably most well known for the *Communist Manifesto* (1848), published in collaboration with Friedrich Engels (1820–95), and for his critique of capitalism, *Das Kapital*, the first volume of which was published in 1867. Expelled and exiled from several European countries for his political activities and for the advocacy of workers' rights, Marx spent his last years in London.

Throughout this chapter, Marxism is referenced in the singular. However, the 'Marxist tradition' signifies a rich plurality of ideas, aspirations and interventions which have been argued for and applied across the world – not just in relation to theory, but more importantly, to aspects of social and political practice.

ART AS IDEOLOGY

With more pressing matters at hand, Marx never developed a theory of art, although aesthetic concerns and interests are intrinsic to his work (Eagleton 1977: 1–2). Marx was also disarmingly ambivalent about the possibility that his name and ideas might actually be

invoked by subsequent generations of 'zealous disciples' in formu-lating an intellectual and critical tradition (Craven 2002: 267). But despite his apparent reticence, Marxist-inspired ideas have formed one of the most influential yet contested social theories in human history.

Marxist theory and its accumulated intellectual tradition has radi-calised art history as an academic discipline. Typically, these ideas consider art's context – its relationship with broader social, political and economic realities. However, Marxist-inspired social art histories are not just concerned with the material production of art as such. Critical attention has equally been given to those institutions and interests involved in the promotion, display and consumption of art, as well as the social and political assumptions which have underpinned claims to aesthetic value and meaning (Boime 1971; Wallach 1998).

Marxism understands art, and the wider realm of the aesthetic (in essence how we respond to what we see), as a carrier of tacit and explicit meanings. Art is situated as both a highly specialised prac-tice and also as a form of social consciousness (Baxandall and Morawski 1977: 12). Art is not perceived as value-free, but like all cultural representation, is understood as inherently *ideological*. Marxists have argued that throughout history, the dominant or *hegemonic* representations of reality within society have been those typically serving the interests of the ruling elites, rather than those social classes divorced from power and influence.

Marxism approaches art not as a disinterested or transcendent activity, but rather as a specialised material practice which mediates in complex and indirect ways the cultural, social and political perspectives of its time. It follows that a socially driven Marxist art history directly counters the *formalist* claims explored in Chapter 2, whilst at the same time conceding to art and *culture* relative inde-pendence (Hemingway 2006a: 3–4). You may wish to keep some of these distinctions in mind as you read this chapter.

Crucially, as various commentators have pointed out, Marxist and post-Marxist ideas are not just concerned with analysing societies, but are engaged with concrete issues of economic and political liber-ation. Marxism is self-critical and holistic – it is concerned with the totality and 'connectedness' of social and economic life. Art, and the wider realm of the aesthetic, are part of this broader knitting together of society and the aspiration towards a radically more authentic human identity.

CONTEXT AND INTENTION

Before we consider some of the beliefs and assumptions associated with Marxism, it is worth thinking about how the idea of artistic context might be explored in practice. This is not to suggest that an interest in context as such is automatically Marxist – it is not. Likewise, general questions about the 'background' of a work of art do not constitute a specifically Marxist or social art history. However, they do provide a start for more detailed analysis and investigation of the multiple and interlinking social influences behind art and its meanings.

Consider the oil painting **Oath of the Horatii**, 1784 (**Figure 12**, p. 63). What kinds of questions do you think might be relevant to exploring this painting's context?

First, we might ask who made the painting and why? Assuming the work to have been a commission, the patron, either an individual or an institution, may have had a particular motivation in mind. Alternatively, perhaps it was created for an academic competition of some kind or speculatively undertaken by the artist. If commissioned or bespoke, what motivations might have been at play? Did the patron or artist leave any records which could support a particular reading, or are there biographical or *secondary sources* which might suggest other interpretative accounts?

From reading this, you will be aware that some of these issues relate to intentionality – that is, the extent to which the thinking or purpose behind the painting was stated or was otherwise evident in its form and content. However, as we see from the chapters on *psychoanalysis* and *semiotics*, art frequently sustains unintended meanings or may have unintentional consequences. For example, according to semiotic theory, meaning can also be unstable and deferred. Even when, as is the case here, we have surviving information about the painting's production, art can accrue readings which revise or displace earlier interpretations or which reflect subsequent cultural conventions (Gombrich 1978; Baxandall 1985). Likewise, responses to images will vary according to differing audiences, social classes and interests.

DAVID AND THE FRENCH SALON

Oath of the Horatii (henceforth the **Horatii**) was painted by Jacques-Louis David (1748–1825). David, already a noted and

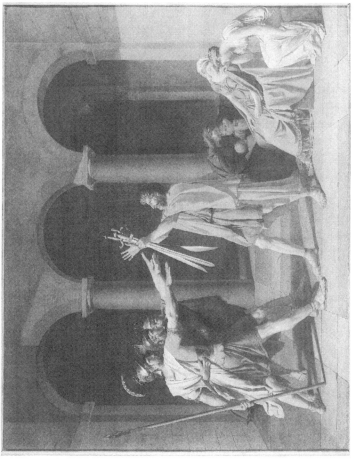

Figure 12 *Oath of the Horatii*, Jacques-Louis David (1748–1825), 1784, oil on canvas, 330 × 425cm, Louvre, Paris, © photo RMN/© Gérard Blot/Christian Jean.

successful artist, had recently visited Rome where he had under-
taken the then customary study of *classical* Greek and Roman
sculpture. He subsequently returned in order to complete the
Horatii. Originally begun as a sketch intended for exhibition at the
salon (annual competition) of 1783, the completed painting, a royal
commission, was finally unveiled in Rome and subsequently at the
Paris salon of 1785.

The commission, placed by the Ministry of Fine Arts on behalf
of Louis XVI, was for history paintings with a moral or educative
purpose. Such competitions were also a pragmatic means of
supporting and subsidising emerging artistic talent – like that of
David. The Marxist art historian Frederick Antal claimed that the
gesture was an attempt by an absolutist monarchy to demonstrate
an enlightened and contemporary taste by choosing a subject and
style which was fashionable with some of its wealthier subjects
(1966: 4).

It is generally thought that David was influenced in his choice of
subject by the play *Horace* by the French dramatist Pierre Corneille
(1606–84), a performance of which had been revived to commemorate
the centenary of the playwright's death. The subject of Corneille's
play was a seventh-century BCE feud between two neighbouring
tribes, the Horatii of Rome and the Curiatii of neighbouring Alba.
Following various territorial skirmishes, and to avoid wider fatali-
ties, it was agreed that each side would elect champions to defend its
cause. In the ensuing combat, only the eldest of the Horatii brothers
survives, but the final tragedy arises from the marital ties between
the two tribes. Camilla, the sister of the surviving brother, curses
him for the loss of her (Alban) husband in the combat. Camilla is
then murdered by her surviving brother, angry at her rebuke and
apparent betrayal. The scene which David's painting depicts is that
of the three Horatii taking the oath to defend their people and their
tribe before combat. They are witnessed by their father and being
mourned by their family.

REACTIONS AND RESPONSES TO THE *HORATII*

A second question might be to ask: what were the reactions to the
painting? What was it about the painting which generated the
response that it did?

Initially displayed in Rome, David's painting was a sensation, attracting crowds and even prompting interest from the Vatican (Lee 1999: 87). After being included in the salon of 1785, it was re-hung in a better position after the closing date was extended. David's *Horatii* was fêted for its directness, economy of expression and sheer drama. Among the suggested reasons for such acclaim was the 'modern' treatment of the 'new aesthetic of the body' and David's ability to capture its power of gesture. His approach to *composition* was dynamic and stylistically innovative, challenging previous formulaic treatments of the antique (Johnson 1993: 14). But with this information we should be wary of attempting overall charac-terisations since the views of a salon-going public may not have been the same as those of a social elite whose testimony is more likely to have survived. Besides, within France's autocratic *ancien régime*, it was unlikely that all views would have been expressed – or permissible.

ACADEMIES AND THE 'HIERARCHY OF GENRES'

We might also consider whether the type or genre of David's painting was significant in relation to contemporary ideas about the status of different subject matter within art? What might the *Horatii* suggest about the wider context of ancien régime France?

The *Horatii* is a history painting. To understand its relevance, we need to remember that a 'hierarchy of genres' had accompanied both the professionalisation and institutionalisation of art practice following the establishment of the *academies*. The aim was to shift the making of art and sculpture away from their *craft*-based origins, to the status of a fine art with training academies dedicated to elevating the social and economic status of artists (Pooke and Whitham 2003: 14–15).

By the close of the seventeenth century, the academies had codi-fied and ranked painting according to its subject matter and what was perceived as the level of technical and intellectual ability which its execution required. First came paintings depicting historical, religious and mythological scenes as well as those that illustrated sacred figures such as saints and the Virgin Mary. This was followed by portraiture; then 'genre', subjects taken from daily life; land-scape; and finally still-lifes, depicting the arrangement of everyday objects, flowers and fruit (Walsh 1999: 93). The status of the various

genres followed the formulations of France's Academy of Painting and Sculpture (est. 1648) although similar distinctions were upheld by academies in England (est. 1768) and Italy (est. 1563).

David was therefore working within well-defined conventions relating to choice of *genre* and the social and intellectual status which was understood to derive from it. The overall prestige and status of the various genres, however, was culturally relative. For example, the still-life in the strongly Protestant, commodity-conscious Dutch Republic of the seventeenth and eighteenth centuries had symbolic connotations which partly arose from selective inhibitions about the display of personal wealth (Hall 2000: 291). If ostentatious clothing was frequently seen as inappropriate, the depiction of highly expensive, imported flowers, spices and fruit, meticulously captured in oils, could at least be justified as a cautionary homily about the transience of life. Part of the popularity and relative status of the Dutch still-life genre was probably due to the fact that it enabled displays of personal wealth and taste in a socially acceptable way.

Whilst David's **Horatii** was acclaimed as a history painting in France and Italy partly because of its dramatic subject matter, by contrast, the emphasis in much Dutch art was on description – the convincing depiction of objects (Alpers 1984). With these examples in mind, we might consider the choice and status of genre as one way of understanding the role of art and the social values of a particular cultural elite. In the nineteenth and twentieth centuries, the advent of Impressionism and subsequent *avant-garde* movements initially questioned, and then superseded, the value-driven distinctions between the various art genres.

THE *HORATII* AS POLITICAL METAPHOR

Returning to our question, how might we explain David's choice of genre, and its relevance for a fuller understanding of this painting and its context?

As you will probably have guessed from its title and subject, David's **Horatii** is couched in the history of the ancient world, placing it within the top genre. David is recorded as actually having increased the painting's size to 3m × 4m, the largest dimensions which a state commission could have (Lee 1999: 92). The adaptation has been interpreted as David asserting his independence from

Academy regulations and from the contemporary protocols of picture making, although in doing so he was trading off the artistic status of a genre which the Academy had sanctioned. However, this distinction was also underlined in other ways. The **Horatii** was compositionally innovative in the way the figures are off-centre with the converging swords at mid-axis and with further asymmetry provided by the *female* figures to the right of the oath-takers.

What does this very brief survey of context suggest about the painting's social meaning? The art historian Walter Friedländer wrote of the **Horatii**:

> This is a Spartan and Roman heroism, united with the highest civic virtue. Here is created a highly political symbol – four years before the outbreak of the Revolution.
>
> (Friedländer 1975: 17)

For Friedländer this painting is primarily a political metaphor for the coming revolution. Certainly, after the events of 1789, David, as 'Pageant Master of the Republic', actively supported the revolutionary cause and was prominently involved in the reorganisation of the French Academy. But at the time the **Horatii** was painted, it has been claimed that David was a 'political innocent' (Brookner 1980: 68), republicanism was not a political force and the prospect of revolution and regicide seemed remote (Lee 1999: 94). The painting's explicit associations as a 'pre-Revolutionary republican manifesto' only seem to have started retrospectively in the 1790s with the austere and stoical themes of sacrifice, duty and brotherhood counterposed to the frivolous *rococo* aesthetics of the ancien régime and work by painters such as Jean-Antoine Watteau (1684–1721) and François Boucher (1703–77) (Brookner 1980: 69).

In concluding this section, we should make some general points about context:

- Questions of context typically address the conditions and circumstances in which art was materially produced, displayed and discussed.
- Context underlines art's embedded status within society – art is not transcendent of social and political cultures or histories.

- Exploration of context can lead us back to address the specifics of the art work – its meaning and purpose.
- Questions of context index the histories, values and priorities of the period under consideration, whilst also indirectly inviting reflection upon the preconceptions and assumptions of those who raise such questions.

Addressing issues of context provides a useful start in exploring the specificity and nuances of an image. However, Marxist or social histories of art are not simply reducible to 'euphemisms' of context, but are concerned to understand the complex determinations and interconnections in which representations are produced and within which they assume cultural meanings (Orton and Pollock 1996: iv). It follows from this that an exploration of context is a necessary preliminary to more detailed investigation of cultural meaning and mutually determining histories and influences.

ICONOGRAPHY AND ICONOLOGY

Some of the issues explored here have given us clues as to the wider cultural context and meaning of David's painting. We have considered aspects of its style and the critical responses which were both contemporary with and subsequent to the painting's completion.

Much of the work of the art historian Erwin Panofsky was concerned with understanding the multiple layers of meaning in Italian and Flemish art. In attempting to structure his response to frequently allegorical and highly symbolic art, and having explored in detail some of the questions which we have started to consider here, Panofsky devised a three-layered structure.

A *pre-iconographic* stage, literally meaning 'before the image', is undertaken when we describe the configurations of form and colour within a particular representation – its 'factual' components (Panofsky 1972 [1939]: 5). So, for example, in looking at David's **Horatii**, we literally see four men, three women and two children, shown in front of a three-arched entrance. In the original painting, we would note the use of colour and tone (discussed in Chapter 2) and how these might contribute towards the painting's mood (the 'expressional' aspects of an image).

With the next *iconographical* stage, we would attempt to relate the *symbolism* of the motifs (the taking of an oath, the crying women) with a narrative – what is actually being depicted in this scene. So we would note that an agreement of some kind is being undertaken and, from the response of the seated figures, it is an action which will have grave consequences. We might also speculate on the familial relationships between the figures depicted. In doing this, we are inevitably making judgements based on our own experience of human behaviour.

ICONOLOGY AND 'INTRINSIC MEANING'

The third and final *iconological* stage attempts to formulate the image's actual or intrinsic meaning. As Panofsky puts it, the job of the art historian is to ascertain the 'underlying principles which reveal the basic attitude of a nation, a period, a class, a religious or philosophical persuasion – unconsciously qualified by one personality and condensed into one work' (1972 [1939]: 7).

Panofsky's attempt to situate images within larger frameworks of social and historical meaning ran counter to prevailing formalist ideas (see Chapter 2). In devising his schema, Panofsky frequently stressed that in looking at images we need to be alert to the culturally specific use of pictorial traditions and symbols which influence how we understand what we see. It might also be noted here that making art, whether figurative or *abstract*, is not always the rational and consistent activity that Panofsky implies (Istrabadi 2004: 226). However, whatever the limitations of this particular method, the intention was to broaden awareness of how art mediates social and historical values and ideas.

If we return to the **Horatii**, an iconological reading should remind us of Friedländer's comment about the painting's political symbolism. As we move on to consider some of the principles and applications of Marxism to a social art history, Panofsky's trichotomy illustrates one way of structuring and ordering some of the initial questions about context and meaning that social art histories typically address. Panofsky's concern to acknowledge the specificity of the image as object and to understand its relationship to a broader context was symptomatic of a major and distinguished tradition within art history associated with scholars such as Aby Warburg

and Max Dvořák (1874–1921), both of whom accepted the principle
of art's connection with society (Stirton 2006: 48).

ART, ALIENATION AND OUR 'SPECIES BEING'

According to Marx, humankind has a 'species being' – specific
evolutionary, communal and behavioural characteristics which are
uniquely ours (Marx 2001 [1844]: 270–82). Marx believed that
human potentiality is created through involvement in the produc-
tive process, but under an exploitative capitalism we become
estranged and *alienated* from our 'species being'. Throughout the
Marxist tradition there is an interest in the connection between
human sociability and creative labour which is exemplified through
the making of art. This reflects a broader conviction that throughout
history, humankind has come together to create communities, not
just because of external necessity or threat, but also because of a
predisposition towards mutuality and the need to express it
through forms of social organisation.

Marx believed that art represented an authentic expression of
the human condition, as it might be, freed from social alienation.
This is not an absolute distinction since art, like other forms of
social and economic activity, has always served various purposes,
including the recording of human conflict. However, it does explain
why the aesthetic as an aspirational expression of our 'species
being' is such a recurrent dimension within Marxist thought. Put
simply, art and culture are perceived as intrinsic to human self-
creation.

Strictly speaking, the making of art, the writing of books or the
scoring of music are supplementary activities. They are not vital for
the physical or economic survival of societies. But culture, under-
stood here in the widest, anthropological sense as the values we
hold and the things we do – clubbing, watching football or visiting
art galleries – provides a sense of who we are, and what we might
be. For this reason Marx famously praised *Classical* Greek culture,
suggesting that it reflected the freshness of humankind in its
infancy. Marx believed that ancient Greek culture had yet to experi-
ence the fragmentation of social relationships and commodified
production which arose with capitalism. The art that was created
within Greek society reflected a harmony between nature and man

which, by its agrarian nature, was 'limited' (Eagleton 1977: 12). For Marxism, art and the realm of the aesthetic stands for a more authentic and less alienated life because it registers the realities of those who make it, and their aspiration to a better world.

Marxist interpretations of art are *materialist*. They situate the production of art and culture more generally as particular, if highly mediated, forms of social and economic activity. From this, it has been argued that through history, art has been employed to communicate the power or *hegemony* of particular individuals, groups, social classes and institutions at particular times. Human history is understood as one of ongoing class conflict between those with access to capital and those subject to it; the mercantile class against the peasants during feudal times and the capitalist and bourgeoisie against the industrial proletariat during and after the Industrial Revolution.

> the history of all hitherto existing society is the history of class struggles.
> (Karl Marx and Friedrich Engels, *The Communist Manifesto*, 1848)

Marx believed that world revolution would be the eventual consequence of the ever increasing imbalance between those with economic goods and ownership of the factors of production (land, labour, capital), and the dispossessed, compelled to sell labour and skill for their own subsistence and survival (Marx and Engels 1998 [1848]).

Artists, as skilled artisans (in feudal times) and members of the intelligentsia in the *modern* period, were also subject to the alienating conditions of capitalism, since they too, according to Marx, were dispossessed of the true value of their work and of that part of themselves which had gone into its creation. It should be stressed here that when Marx was alive, revolution and insurrection had occurred across the industrialised capitals of Europe. These ideas were not abstract formulations, but attempts to think through a system which Marx and others like him believed to be in terminal and accelerating crisis.

ART AS COMMODITY AND A 'DEPOSIT OF A SOCIAL RELATIONSHIP'

At the level of exchange, art was, and remains, a commodity, but its commodity status, largely secularised in the West since the

Industrial Revolution, is hardly new. For example, much art produced during the *Renaissance* was in fact bespoke, produced to order, according to particular social conventions and pictorial formats, prompting its description as a 'deposit of a social relationship' (Baxandall 1988: 1). The making of pictures as a trade skill also required a level of social interaction and knowledge outside the studio, even before the purchase of the finished goods by the client. This included the sourcing, preparation and mixing of pigments, the correct gauging of costs, weights and measures and – with larger commissions or in busy workshops – the employment and supervision of assistants and apprentices.

Michael Baxandall's (b. 1933) account of the Renaissance art trade is not particularly Marxist in its emphases, but as his subtitle indicates, it does outline 'a social history of pictorial style' which situates art as a specific material practice subject to considerable levels of contractual predetermination. This is not to imply that artisans and artists did not have creative and individual agency and that they were not valued for their particular talents. However, it is to suggest that Western concepts of art as a highly individualised, expressive and relatively autonomous activity have more to do with comparatively recent concepts of artistic enterprise (from the eighteenth and early nineteenth centuries onwards) than they do with what was, for the generality of artisans and artists, a far more precarious and client-orientated subsistence in the previous centuries (Kempers 1992: 5–6).

Historically, much painting and sculpture has been commissioned for various personal and civic reasons which in turn reflected the emerging aspirations of a largely self-appointed religious, political and mercantile elite. By way of rationalising such motivations Baxandall quotes one merchant, who, when asked for the reasons behind his patronage, replied that it was because such things gave him:

> the greatest contentment and the greatest pleasure because they serve the glory of God, the honour of the city, and the commemoration of myself.
>
> (Baxandall 1988: 2)

In this case, Baxandall reports a mixture of personal pleasure, religious and civic recognition and personal aggrandisement. For

Marxist art historians, the making of art is *teleological* – a purposive activity serving particular political and economic interests. The disclosure of such interests, the extent to which they are manifest or concealed through the various interactions of art making, has been among the central concerns of Marxist-inspired social art histories.

SUPERSTRUCTURE AND INFRASTRUCTURE

Marxist approaches to art situate it as a variously mediated activity, ultimately influenced not just by the creative agency of the artist, but by socio-economic conditions and ideological interests.

The exact nature of this relationship is disputed, with overly deterministic readings (art as a 'reflex' of the economic base) attributed to misinterpretations of the fragmentary formulations of Marx and Engels and the subsequent exigencies of war and revolution. However, the various interpretations of this relationship reflect what Perry Anderson describes as a broader and unresolved 'disjuncture' in Marx's own writing – between the forces of production on one side and the collective agency of people and the dynamic of class struggle on the other (Anderson 1984: 34).

Whatever emphasis is made, art and the aesthetic *are* social forms which *do* exist in the context of various factors of production – land, labour and capital (the *infrastructure*) – and those cultural and social forms – systems of governance, civil organisation, values and culture more generally (the *superstructure*).

More recent Marxist and post-Marxist theories have tended to emphasise the inter-dependent and reciprocal relationship between these two areas, but all Marxist art histories recognise this connection which explains the material origins of the aesthetic. On the one hand, the physical components of art arise from pre-existing relations of capital (money, physical resources, skilled labour) – the infrastructure – and, on the other, its use, ownership and social significance places it within the superstructure. In this sense, art and culture are the *hybridised* outcomes of infrastructure and superstructure.

Additionally, both these areas of social life develop at different speeds, with the superstructure (including art) frequently changing

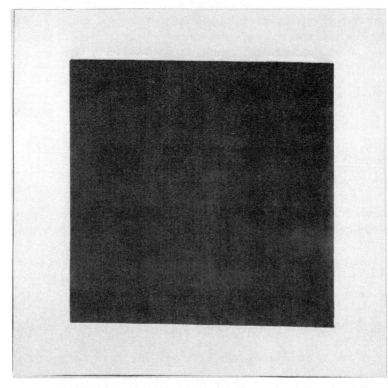

Figure 13 *Black Square*, Kasimir Malevich, *c.*1929, 106.2 × 106.5cm (Tretyakov Gallery),
© Courtauld Institute of Art, London.

more rapidly than society's economic base. For example, the initial
version of Malevich's **Black Square**, *c.*1915, was conceived in an
autocratic society in which effective serfdom remained wide-
spread. (For one of the later versions completed in 1929 see **Figure
13**, p. 74.) Within two years of the first version being completed,
Russia had witnessed a communist revolution which had collectivised
ownership of the means of production, irrevocably changing the
country's future. The sheer and stark modernity of Malevich's
image can be interpreted as a utopian metaphor for the social and
economic changes of revolution and the futuristic ambitions of the
new state.

ART AND AGENCY – 'LIFE CREATES CONSCIOUSNESS, NOT CONSCIOUSNESS LIFE'

Taking Malevich's example, whilst art might be historically and ideologically locatable because of style, subject matter or format, it is also the outcome of individual imagination and creative agency. Much like everyone else, artists do not live beyond or outside history. As the Marxist idiom goes, 'life creates consciousness, not consciousness life' – how we see life depends upon our particular exposures to or experiences of it. Whilst we may have the ability and opportunity to change our circumstances, that ability is delineated and circumscribed in various ways – we have relative autonomy. However, art is also contingent and transformative; images accrue histories, or develop meanings independent of intention. The production of art, in whatever form, is as much the outcome of an artist's aesthetic, conceptual and imaginative ability as it is anything else. This is not to mystify or to make confusing what artists do, but it is simply to suggest that, like Marx, we respond to art as a particular – and in some cases exceptional – form of creative social labour.

DAVID'S *HORATII* AS A REVOLUTIONARY MANIFESTO

Having noted some of the ideas and assumptions associated with Marxist theory, let us return to David's **Horatii**. Antal (1966) understood *neo-classical* and romantic art as an index to the values of the eighteenth and early nineteenth centuries. This is what he had to say about David's aesthetic:

> The whole tendency of David's painting . . . the exaltation of patriotism and civic virtue in all its austerity . . . was radically directed against his own patrons. Its overwhelming success, indeed its very existence, were determined by the strong feeling of opposition then prevailing against the demoralised Court and its corrupt government.
>
> (Antal 1966: 4)

For Antal, David's painting was primarily created as a consciously revolutionary manifesto; its 'objective rationalism' a call to arms which anticipates the French revolution. David's marriage of

naturalism and classicism, the austere and linear composition, the patriotic subject matter and the use of Roman sources, was interpreted as a direct reference to French radicalism which looked to classical example to justify its nascent politics and culture.

THE *HORATII* AS A CANONICAL PAINTING OF THE FRENCH REVOLUTION

David's **Horatii** and other paintings which he executed at the time, were later embraced in the 1790s for these and similar reasons. Some readings have suggested that David's motivation appears to have been far from politically programmatic – at least in France's pre-revolutionary period. More recent commentators like Lee and Johnson have claimed that David was not consciously articulating a political position in this state commission, but was rather exploring new aesthetic directions and seeking to re-vivify a classical representation of subject matter in a tradition which stretched back to Poussin and Claude (Claude Lorrain, 1600–82).

The issue is the extent to which David's choice of subject and his neo-classical painting style can be read as the 'visual analogue of republicanism' (Vaughan and Weston 2000: 21). Or put another way, within an autocratic system in which artistic patronage was centred on the court, in what way might an aspiring artist assert a deliberate political or social message through their work – if that was indeed their intention? In any event, what did it mean to assert political or social meaning through French painting in 1784? What were the codes and symbols that an artist could use and to whom would they be intelligible?

Although Antal also recognised David's stylistic innovations, as a Marxist art historian, his iconological interpretation privileged a declarative, political intention behind the **Horatii**. In claiming a particular political meaning for this painting, assumptions are being made about the contemporary significance of classical or antique iconography and subject matter. How were David's style and content perceived in relation to a nascent republicanism, and by whom? That the **Horatii** came to be celebrated, and indeed recognised, as emblematic of the revolution, and that David became a prominent propagandist for the republican cause, provides some evidential support for Antal's interpretation (Schnapper 1980).

This fairly well-known painting underlines the extent to which interpretations are historically constructed viewpoints which are subject to revision, challenge and re-interpretation. Art can have multiple meanings, both for contemporary constituencies and for successive generations. In the case of the **Horatii**, different contexts of reception – who saw it, when and where – determined its meaning within particular histories and critical accounts. This is not to deny the importance of the painting's symbolic resonance, its socio-economic context or the cogent insights made by Antal and others on the ideological uses of art. However, it is to suggest that we should be receptive to the multi-dimensionality of objects and those who make them. Likewise, any and all interpretative accounts mediate the assumptions and preconceptions of those who make them.

TENDENCY AND SOCIAL COMMITMENT – WHAT SHOULD ART AND ARTISTS DO?

So far in this chapter we have explored some examples of how Marxist ideas and terminology can be used to inform a social art history. In addition to Antal, Marxist art historians like Hauser, Klingender, Max Raphael (1889–1952) and Schapiro were among the generation which followed Marx, but attempted to apply and develop his insights to the art of the past and also to fashion its relevance to the art and aesthetics of their own time.

Whilst Marx's observations on art and culture had not been methodologically prescriptive, his intellectual legacy was inevitably reframed by the wars, revolutions and urgent social demands of the early twentieth century. The publication of Marx's early writings, the *Economic and Philosophical Manuscripts* (1844), in the 1930s made possible a re-evaluation of the early Marx, supporting a renewed emphasis on the centrality of the aesthetic, in all its dimensions, within his thought.

Even before the publication of this early work by Marx, there had been attempts to formulate and develop a comprehensive sociology of art from Marx's fragmentary legacy. *Art and Social Life* (1912–13) by the prominent communist theorist and aesthetician Georgi Plekhanov (1856–1918) drew on various traditions within nineteenth-century Russian aesthetics which had emphasised art's

social utility rather than an 'art for art's sake' formalism. Plekhanov's apparent endorsement of naturalistic art over avant-garde experimentation was important, since it anticipated an issue which became central to Soviet aesthetics and Marxist theory in the decades which followed (Laing 1978: 16–17).

Before and after the Russian Revolution of 1917 and the ending of the First World War, among the crucial cultural issues was the response and 'tendency' of the artists to the events around them. Should art make direct comment in support of the progressive social and political causes of the day? And, if so, what form might this take? Throughout the 1920s and 1930s these debates became more pressing as economic depression, large-scale unemployment and social instability increased throughout Europe and America. For example, the art historical response just quoted by Antal in relation to David's **Horatii** (1935) belongs to this historical moment. After the October Revolution in Russia and with the rise of fascism in Germany, Italy and Spain, Marxist and communist ideas enjoyed considerable popularity as people attempted to find answers to their social and economic conditions and what appeared to some as the terminal crisis of industrial capitalism.

MALEVICH'S *BLACK SQUARE* AND THE 'ZERO OF FORMS'

Before we consider some of the debates which developed, consider one of the versions of Malevich's abstract painting, **Black Square** (**Figure 13**, p. 74). Keeping in mind the general context just noted, you may wish to hazard some guesses as to its possible iconology.

Kasimir Malevich came to prominence in the years just before and after the Russian Revolution of 1917. Russia's artistic and cultural background was very different to that of northern Europe and America. Central to such a context was the *icon* or devotional image (Cormack 2000: 2). Often painted on simple limewood bases, these stylised depictions of religious figures were placed not only in churches, but in public buildings and on roadsides in small makeshift shelters. In houses, which observed the Russian Orthodox religion, it had also been a frequent custom to hang icons across the corner of the room, in part to symbolise the protective presence of divinity.

After the October Revolution of 1917, icons were formally banned as churches were closed by the new authorities. Many avant-garde Soviet artists responded to the radically new social and political order by developing and extending the possibilities of abstraction. The first of four versions of Malevich's **Black Square** was exhibited in December 1915 (Néret 2003: 49). Like a religious icon, it was hung in a corner of the Nadezhda Dobychina Bureau, Petrograd. During the exhibition of futurist art Malevich claimed, 'I have transfigured myself in the zero of forms' – by which he meant a new type of art for a new society (Néret 2003: 50). He was not alone, and many other avant-garde artists responded to the new social order by making innovative textile designs, abstract sculptures, photomontages, films, stage sets, paintings and even new schools of architecture (Figes 2003: 447–54). Like David's **Horatii**, avant-garde Soviet art became a metaphor for the new (Bolshevik) order, which many artists had supported.

In a largely non-literate country with no common language, the new communist leaders like Vladimir Ilyich Lenin (1870–1924) and Leon Trotsky (1879–1940) realised the power of the image as educative propaganda, and attention increasingly focused on the most effective way this could be achieved. Some believed that artists should be given freedom or independence to create the work they wished and, if that was abstract, so be it. In *Literature and Revolution* (1925), Trotsky outlined this belief, asserting the 'relative autonomy' of artistic practice. Others took a more conservative line, advocating, like Alexander Bogdanov (1873–1928), the development of specifically working-class culture. In practice, this generally meant that art and other aesthetic forms – literature, films, theatre, should be *realist*. That is, they should attempt to depict things figuratively and so be more easily understandable by the industrialised and agriculturally based masses.

ART AND THE 'SOCIAL COMMAND': SOVIET SOCIALIST REALISM

Throughout the 1920s, the Communist Party of the Soviet Union refrained from giving explicit support for any of the various artistic factions which had developed and which variously competed for hegemony and patronage in the new order (Laing 1978: 34). However,

communist interests began to steer the direction of art and other cultural forms as the economic and political re-shaping of the Soviet Union intensified through the various centralising five-year plans (Taylor 1992).

In 1934, at the Congress of Soviet Writers, Soviet artists were mandated to depict 'socialist re-construction' through a blend of romanticised naturalistic painting using nineteenth-century academic technique – *Soviet Socialist Realism*. In the Stalinist period 'progressive' came to mean that which was stylistically conservative and thematically traditional. As Sim notes, art became something which was 'heavily committed to figurative representation and idealized forms. Art became relentlessly propagandistic' (1992: 448).

The Communist Party's control of all patronage and access to materials ensured that Soviet Socialist Realism became the official house style of the Soviet Union and its territories. Abstract art by Malevich and those like him was discouraged; much avant-garde art was lost, smuggled abroad or simply hidden.

Consider for example Gabo's *Square Relief* (**Figure 10**, p. 45), the formal aspects of which were discussed in Chapter 2. Originally made in 1920–21, during the period of civil war and widespread privation which directly affected Gabo and his siblings, *Square Relief* was completed at a time when Soviet cultural policy had yet to be crystallised. Initially galvanised by the revolutionary fervour and involved in avant-garde debate and organisation, Gabo finally fled the Soviet Union for Germany in 1923 (Nash 1985: 17). *Square Relief* became emblematic of the kind of abstract art which was eventually proscribed by the Soviet authorities. Ironically, and with all the benefits of hindsight, such art – abstract, innovative, futuristic and utopian – was a very powerful metaphor for the modernising aspirations of the Bolsheviks.

Debate continues as to whether what actually happened in Russia (both politically and artistically) did in fact have anything to do with the theory of Marxism. However, there is little doubt that the Soviet example and what followed during the Cold War had major repercussions not just for the status and reputation of Marxist theory throughout the world, but by implication for the status and currency of Marxist approaches to art and aesthetics.

CRITICAL THEORY AND THE 'FRANKFURT SCHOOL'

As mentioned earlier, part of the allure of Marxist theory was its promise of political and economic transformation. However, throughout the 1920s and 1930s, Western capitalism proved far more durable than its critics had expected. Although these decades witnessed international conflict and social instability, the global communist revolution remained elusive. From the 1950s and 1960s, in America and northern Europe particularly, consumer-led capitalism appeared to have successfully accommodated aspirations for a materially better lifestyle. These achievements were compared to the systemic failures of the Soviet Union's command economy and the freedoms enjoyed by artists in the West, which were contrasted to the diktats and privations faced by those within the Eastern Bloc.

A new generation of Marxist-orientated intellectuals began to re-formulate their responses to this new global order. The Frankfurt School of critical theorists emphasised the philosophical dimension to Marxist thought, incorporating insights on human rationality gained from social psychology and the legacy of Sigmund Freud (1856–1939). Theodor Adorno (1903–69), Herbert Marcuse (1898–1979) and Max Horkheimer (1895–1973) were its most prominent members, although the work and legacy of Walter Benjamin (1892–1940) anticipated key aspects of their research, including the nature of cultural reproduction and the problematic relationship between art and modernity (see Chapter 7).

In his essay 'Author as Producer' (1982 [1934]), Benjamin had attempted to reconcile the aesthetic quality of a work with its social or political meaning, calling for a critical avant-garde art which used new technological means such as film, photography and *photomontage*. Benjamin's engagement with modernity, the contradictions of high culture and the ideological conflicts of his time, was cogently conveyed by Peter Kennard (b. 1949) in 1990. Kennard's photomontage (**Figure 14**, p. 82), originally printed in the *Guardian* newspaper, commemorated the fiftieth anniversary of Benjamin's suicide on the French/Spanish border, following the fall of Paris and the onset of German occupation. The repetition of Leonardo da Vinci's (1452–1519) **Mona Lisa**, c.1503–7, references Benjamin's belief in the potentially liberating effects of cultural reproduction on human consciousness.

Figure 14 *Walter Benjamin*, Peter Kennard, 1990, photomontage. © the artist.

Benjamin's contemporary, Adorno, remained opposed to overtly politicised forms of art, asserting that only the autonomy of a truly 'oppositional art' could offer fragile and utopian resistance to instrumental thought and coercive ideologies (Adorno 2001 [1962]). Adorno believed that art and culture had become commodities within an entirely 'administered' political system dominated by technology and corporate interests. In such a situation, human freedom and the aspirations of art were at best compromised and at worst illusory. These ideas were explored in influential texts such as the *Dialectic of Enlightenment*, co-authored with Horkheimer in 1947 (Adorno and Horkheimer 1986), *Negative Dialectics* (1973) and *Aesthetic Theory* (1970). The emancipatory potential of the European Enlightenment was seen as having been reversed through human domination of nature and an emerging rationality which has instrumentalised and alienated human relationships at every level of a technologically administered society (Adorno and Horkheimer 1986: 54).

Despite the social coerciveness of contemporary capitalism, members of the Frankfurt School believed that art retained a utopian potentiality as resonant as it was mute and powerless. Commentators have seen similarities here in the approach to abstract painting taken by the contemporary German artist Gerhard Richter (b. 1932), whose reflexive work has oscillated between figuration and abstraction but with a self-consciousness about the historical and cultural meanings attributed to both (Wood 1993: 251). Richter is on record as describing painting as a 'moral act' through which he has broached the subjects of terrorism, the uses of photography, the conditions of cultural reproduction and its legacy for contemporary practice. His startling juxtapositions of the painterly and the photographic might be seen as explorations which consider the aesthetic limitations, potentialities and renewal of both (see for example http://www.gerhard-richter.com/home/index.php).

Unlike earlier generations, Adorno and his contemporaries were faced with having to re-formulate a Marxist tradition 'dispossessed' – without the conviction that revolution and class agency would provide the long-awaited human emancipation. Rose writes:

> The [Frankfurt] School sought to define Marxism *sui generis* on the assumption that there is no longer any privileged carrier of that cognition, any universal class.
>
> (Rose 1978: 3)

The tenor which underpins much of the analysis of Adorno and Marcuse can be seen as a legacy of the social crisis which characterised the institution's early years in Germany. With its members menaced and then exiled by the threat of fascism, the Frankfurt School was compelled to witness the increasingly authoritarian diktats of Stalinist Russia, and the post-war consolidation of Western capitalism. Although influential on some of the debates of the *New Left*, the Frankfurt School was part of the intellectual tradition of Western Marxism which had been shaped by its defeat as a mass political movement outside the Soviet Union in the years after 1917 (Anderson 1984: 15–16). For various commentators, this historical legacy has been most apparent in the work of Adorno and his pessimistic reading of the prospects for art and culture under an administered 'culture industry' – essentially the conditions of *postmodernity* (Adorno 2001).

Some of the theoretical concerns of the Frankfurt School theorists have been continued in the work of Jürgen Habermas (b. 1928). In 'Modernity – An Incomplete Project' (Habermas 2003 [1980]), he interprets the phenomenon of postmodernity as a means by which the reactionary ideas opposed to modernism have been 'legitimated'. Rather than conceding a positive assessment of postmodernity, Habermas has called for an 'aesthetic of resistance' to counter the totalising and coercive claims of an administered society (Habermas 2003 [1980]: 1124–30). This idea has some resonance in the claims of a critical postmodern visual culture discussed in Chapter 7. Its stress on the importance of human agency and the specificity of artistic practice within modernity also underpins the orientation of more recent Marxist art theory.

T. J. CLARK AND A BRITISH MARXIST TRADITION

The early 1970s have been characterised as marking a decisive point of renewal within a Marxist art historical tradition (Orton and Pollock 1996: viii–xviii). Although marginalised by the Cold War, the work of earlier émigré Marxists such as Antal, Hauser, Klingender and Raphael provided a point of reference (and departure) for a new generation of art historians. A resurgent *New Left* and the social and political protests of the late 1960s and early 1970s were the context and impetus for views which dissented from a prevalent formalist tradition.

John Berger's (b. 1928) collaboratively authored primer, *Ways of Seeing* (1972), was written as a materialist rejoinder to Kenneth Clark's (1903–83) *Civilisation* television series and book of 1969, which had asserted an 'aristocratic Tory view of "civilisation"' (Orton and Pollock 1996: ix). In a series of short, discursive word-and-image-based essays, Berger explores the social construction of culture and aesthetic value, taking insights from Benjamin, Antonio Gramsci (1891–1937) and other critical theorists.

Timothy J. Clark (b. 1943) has been claimed as the 'most significant Marxist art historian of the post-1945 period' (Harris 2003: 68). Clark is particularly known for what has since become a *canonical* series of books within a Marxist social art history: *Image of the People: Gustave Courbet and the 1848 Revolution* (1973a), *The Absolute Bourgeois: Artists and Politics in France 1848–1851* (1973b) and *The Painting of Modern Life: Paris in the Art of Manet and His Followers* (1984). Clark's detailed exploration of specific images situated them in relation to a 'particular conjuncture of conditions and relations of production' which typically included political, social and economic, as well as material and aesthetic, considerations (Harris 2003: 68).

Although Clark acknowledged an antecedent Marxist tradition (Clark 1974: 561–62), he was concerned to develop a social art history which explored individual agency and which accorded art objects 'a more active and even occasionally dramatic role in the historical process' (Hemingway 2006b: 191). At the start of his book on Courbet, Clark writes:

> What I want to explain are the connecting links between artistic form, the available systems of visual representation, the current theories of art, other ideologies, social classes, and more general historical structures and processes.
>
> (1973a: 12)

For Clark, works of art are not abstracted from history and placed against something called 'context' but are constitutive of and implicated within social processes and formations. Contemporary with Clark, other interventions by Laura Mulvey (b. 1941), Linda Nochlin (b. 1931) and Griselda Pollock (b. 1949) (see Chapter 6) interrogated the patriarchal assumptions of older Marxist theory, whilst adapting

Marxist insights to issues of cultural representation and the specificity of gendered experience.

POST-MARXISM?

Post-Marxism can be understood as a melding of Marxist ideas with more recent theories such as postmodernism, *deconstruction* and *discourse* theory. It has been argued that the collapse of communism and the rise of neo-liberal philosophies have rendered the cultural and political project of a critical Marxism obsolete. As one of Jean-François Lyotard's (1924–98) *metanarratives*, communism has been superseded by postmodernity and a liberal pluralism – the argument advanced by Francis Fukuyama (b. 1952) (see Chapter 7). But as Hemingway notes, such valedictions are not new, and ignore the resurgent oppositional consciousness of anti-globalisation and anti-war campaigns (2006a: 2).

For many on the political and cultural left, the receding prospect of the much promised post-Cold War 'peace dividend' has made explicit the social and moral deficits of contemporary capitalism, as have the recent domestic and foreign policy disasters of Anglo-American neo-conservatism. From the vantage point of 2007, Fukuyama's thesis of the 'end of history' looks pretty remote. For its defenders, a critical Marxist project remains alive and well. Politically, within the developing and Third World context, the social and economic consequences of *globalisation* and free markets are yet to be reconciled. From this perspective, it is by no means clear if the managed political options of the West will ultimately define the choices made by the rest of the globe.

Within art history, literary criticism and cultural studies more generally, Marxist and post-Marxist ideas are so pervasive that they have entered the mainstream and are frequently not even identified as such. The deconstruction of texts and meaning sponsored by Jacques Derrida (1930–2004) can be seen as a reaction to forms of Marxism which were extant in the 1970s, since it is concerned with claims to knowledge (epistemology) and claims about the nature of reality (ontology) – issues central to Marxism as a social and political philosophy (Joseph 2006: 128). Derrida's project is political insofar as it encourages exploration of 'radical otherness or *différance*' rather than an imposed and dominant meaning (Joseph 2006: 129).

In this sense, Derrida has upheld the critical and subversive ethos of Marxism even if he does not subscribe to the entirety of Marxist ideology (Derrida 1994).

The durability of a critical Marxism can in part be attributed to the reflexive plurality of its ideas and perspectives, although with the common aspiration of linking belief with practice. More recent emphasis arising from a critical realist tradition has extended and renewed engagement with Marx's original commitment to human agency or praxis and its role in the formation of social forms and institutions. Among the most characteristic aspects of much art historical research over the past thirty years has been this close and consistent attention to the specificities of the art object, practice or movement, combined with a reflexive awareness of art's sociologically complex role within material culture.

Within art history, Marxism's most abiding legacy has been to embed art in the realm of social relations and human agency, rather than in the esoteric concerns of a formalist tradition abstracted from history. In an age of increasing specialisation and atomisation, a critical contemporary Marxism speaks to the aspiration of our common 'connectedness' and of the vital role of art and the aesthetic in salvaging what it means to be more truly human.

SUMMARY

This chapter has introduced and explored Marxist ideas and terminology. It has considered how both might be used in relation to specific examples of art, as well as in contributing to broader discussions about Marxism's relevance or otherwise for contemporary visual culture. On one hand, the fragmentary nature of Karl Marx's views on art has been historically problematic yet enabling and galvanising a richly discursive Marxist aesthetics. At their best, Marxist ideas have attempted to reconcile concerns over aesthetic quality and innovation with a belief in the social relevance and agency of art and artists. At their worst (and some would deny that there is any justification in linking the two), overly prescriptive ideas claiming Marxist inspiration have created debased and unimaginative art, originally characterised by an initially left-leaning Greenberg as kitsch (see Chapter 2). Such a mixed legacy recognises the extent to which Marxist aesthetics were part of a broader intellectual

trajectory which was, from its inception, embattled and compromised by brute reaction and pragmatic, political necessity.

Perhaps the most eloquent and powerful case made for the resonance of Marxist aesthetics has been by approaches which have been either resistant to, or sceptical of, some of the traditional closures and determinations of more 'orthodox' and pragmatic forms of Marxist theory. The various interventions associated with the critical theory of Adorno and the historically specific analysis of 'conjunctures' demonstrated by T. J. Clark's social art history are two such examples.

In both cases, highly nuanced treatments attempt to register the specificity of the object under discussion in relation to wider social and political formations. With Adorno, it can be art's opaqueness and refusal to signify – its 'mute resistance' in the face of the culture industry – which eloquently registers its redemptive power. But the most formative legacy of a holistic Marxist tradition has been an oppositional consciousness and a belief in the agency of men and women to change their lives. In this sense perhaps, we have yet to see a truly authentic Marxist art and aesthetic.

FURTHER READING

The bibliography on Marxism and post-Marxism is extensive, and any choice inevitably reflects personal perceptions of what the Marxist tradition is understood to be. However, *Marxism and Social Theory*, by Jonathan Joseph (Joseph 2006), and *Post-Marxism: A Reader*, edited by Stuart Sim (Sim 1998), are both very useful and readable introductions to issues and debates in and around the Marxist tradition as a social and political philosophy.

In view of the pervasiveness of Marxist ideas within culture and art history, the reader is as likely to encounter examples of such approaches within general anthologies of articles and essays as they are in course texts or monographs on particular artists. The most recent publication about Marxist historiography specifically in relation to the visual arts is *Marxism and the History of Art: From William Morris to the New Left*, edited by Andrew Hemingway (London, 2006). In addition to exploring various neglected figures within a 'classical' Marxist art history, Hemingway's anthology explores the impact of the New Left and the re-definition and re-focusing of concerns and thematics which arose from the 1970s onwards.

Also of interest is *The New Art History: A Critical Introduction* by Jonathan Harris (London and New York, 2001). This book offers a comprehensive and readable introduction to the fundamental theoretical shifts and related texts which have characterised recent art history. Although not principally 'about' Marxism, this text offers a very useful contextualisation of Marxist ideas and their contribution to the art history which has arisen over the last thirty years.

OTHER RESOURCES

There is the Marxist internet archive at: http://www.marxists.org which holds an extensive range of material.

The Marx Memorial Library at 37a Clerkenwell Green, London, is a Labour movement lending library and research centre with over 100,000 books, pamphlets and periodicals available to members, including wide-ranging material relevant to art and aesthetics. For further details, email: marx.library@britishlibrary.net or web address: http://www.marxlibrary.net.

The Society for Co-operation in Russian and Soviet Studies (SCRSS), 320 Brixton Road, London, is an educational charity which promotes knowledge of the culture, language and history of Russia and the former Soviet Union. It has a considerable archive and loan library open to members. For more details, email: ruslibrary@scrss.org.uk or web address: http://www.scrss.org.uk.

SEMIOTICS AND POSTSTRUCTURALISM

INTRODUCTION

Semiotics is concerned with everything that can be taken as a sign.

(Eco 1976: 7)

Umberto Eco's observation provides a start point for exploring the relevance of *semiotics* to art history and visual interpretation. Consider Bronzino's ***An Allegory with Venus and Cupid***, *c.*1540–50 **(Figure 15**, p. 91) (henceforth ***Allegory***), and the motifs which contribute to its meaning. There are prominent elements in the painting which allude to time (Old Father Time), jealousy or despair (the howling face on the left) and pleasure or deceit (the *hybrid* creature with a human face on the right). However, a deeper understanding of the way signs work should provide further insight into ways of interpreting this image. How and why do these elements work? How can we situate signs in their original and contemporary cultural contexts? What does their use tell us about the broader meanings of the image?

Semiotics is the study of signs and signification. It developed from studies of language and logic undertaken independently by Ferdinand de Saussure (1857–1913) in Switzerland and Charles

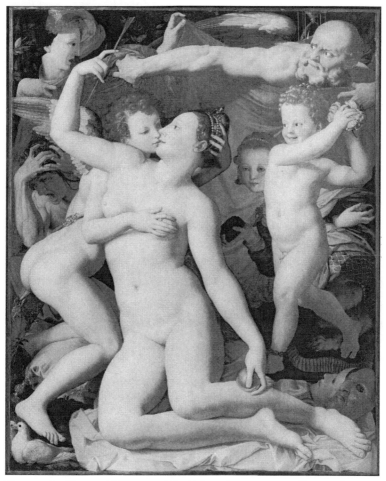

Figure 15 *An Allegory with Venus and Cupid*, Bronzino, c.1540–50, oil on wood, 146.5 × 116.8cm, © National Gallery, London.

Sanders Peirce (1839–1914) in America in the late nineteenth and early twentieth centuries. The theories proposed by these scholars have been elaborated and extended through the twentieth century, mostly as two separate stands of research. These later studies have influenced the definition and interpretation of art within contemporary art history. They have also informed the interpretations underlying much contemporary *gender* and postmodern theory (discussed in more detail in Chapters 6 and 7).

This chapter explores the principles of semiotic theory and considers its relevance to contemporary theories of art. It concludes with a consideration of the limitations and repercussions of poststructuralist theories.

SOME BASICS ABOUT LANGUAGE AND LINGUISTICS

Saussure and Peirce (pronounced 'purse') developed different theories for explaining the workings of linguistic signs. Saussure explored signs in relation to language.

Fundamentally, language is a means of communication between human beings (and possibly animals (Sebeok 1972)) and the study of languages is called linguistics. The components of language are verbal – relating to speech, sounds or phonetics – and written – relating to the written representation of sounds and words. The academic discipline of linguistics studies the structures and relationships of these different components in order to understand the construction and origins of languages. For example, linguists might look at the structures within a written language, the structural connections between two different languages or relationships between verbal and written forms of a language. A subset of the discipline is phonetics, which studies the sound systems of languages and how individual verbal sounds (phonemes) form words.

FERDINAND DE SAUSSURE

Saussure explored language from a perspective diferent to these approaches. He sought to explain how words in a language – linguistic signs – mean what they mean. He wanted to understand

the construction of signs and their meaning rather than the structures of specific languages.

Saussure indentified two components in the linguistic sign:

- the physical element, the actual spoken or written word – the signifier;
- the mental concept, the idea of the sign – the signified.

These two components are interdependent but separate. For example, if I say the word 'shoe' there is the phonetic sound and the idea in my mind of what a shoe is. It is not a specific shoe (such as the left green suede shoe), but a general concept of a shoe. I cannot say the word shoe, and you cannot hear it, without invoking the idea of a shoe.

In separating the two components, Saussure acknowledged their arbitrary relationship. Not only could other signifiers conjure the same mental concept (for example, different languages have different words for shoe), but also the word shoe is just the word which has been assigned by time, convention and practice. That is not to say that signifiers can be changed randomly but that there is no intrinsic reason for a particular signifier/signified relationship. The arbitrary nature of the signifier/signified relationship means that language is in some ways constructed independent of the reality which it describes.

Saussure also claimed that the meaning of the word shoe is relational and depends on its *difference* from other words. Put another way, because the word shoe only arbitrarily means the concept of a shoe it requires the context of and difference from other words and concepts to give it meaning. Therefore shoe is different phonetically from 'two' or 'hoe', and conceptually from boot or sock. Saussure therefore theorised that the signifier/signified relationship could not be understood independently from the language system to which it belonged (Saussure 1983: 112–20).

Saussure called the study of signs *semiology,* as opposed to semiotics. He called the system of signifier/signified, or linguistic signs, 'langue' and the practical application of the system within a specific language, or act of speech, 'parole' (Chandler 2002: 231).

Although Saussure's original studies and theories relate to language, the principles he developed became fundamental to

exploring sign systems across other media and communications, including images and art (for example Bal and Bryson 1991 and Frascina 1993b). His theories provided the foundations for the European school of studying signs exampled in work by Michel Foucault (1926–84), Derrida, Roland Barthes (1915–80) and Julia Kristeva (b. 1941) (Cobley and Jansz 1997: 37); but more of them later.

CHARLES SANDERS PEIRCE

Peirce approached the concepts and structures of signs from a different direction. As a philosopher and logician he explored the sign within the broader context of ontology – the study of pure being and the essence of things; and phenomenology – the study of experiencing phenomena in the world.

Rather than the two-part theory of signs proposed by Saussure, Peirce proposed three elements to the sign:

- the sign itself, for example a word – the representamen;
- the object to which the representamen refers – the object;
- the sense of the thing which links the other two – the interpretant.

The interaction of the three components of the sign is called *semiosis* and is of a triangular form. Compared to the Saussurean model there is the addition of the object into the sign structure but there is also a dynamic element to the system. The interpretant can be a representamen to another sign leading to a potentially infinite cycle of representamen-object-interpretant/representamen-object-interpretant/representamen, etc. In this way the Peircean model can be seen as a process compared to the structure of the Saussurean model (Peirce 1931–58).

Peirce's triangular model provided the basis for later theorists to develop variant or simplified semiotic systems based around the triad (a thing of three parts):

- A – sign vehicle/signifier/representamen
- B – sense/signified/interpretant
- C – referent/object, sometimes also linked to signifier.

However the nature of each component of the triadic model is often debated and, as can be seen, the equivalence between the models is not precise (Chandler 2002: 34–36).

DEVELOPMENTS OF SEMIOSIS

The process of semiosis provided Peirce with a model which could be elaborated. First, he identified different states or stages of the object and interpretant, which further clarified their meaning and involvement in the sign system. Second, he developed a typology of signs based on the different modes of relationship between the components of the triad. The three modes – symbolic, iconic and indexical – can be understood on a scale of arbitrariness or conventionality (Chandler 2002: 36–43).

At one extreme is the symbolic mode. These are arbitrary signs, i.e. there is no intrinsic relationship between the elements of the sign. The relationship between the representamen/signifier and interpretant/signified would be entirely based on convention. An example of this mode could be the image of the dove in the bottom left corner of *Allegory* (**Figure 15**, p. 91) which conventionally represents good tidings or peace.

At the other end of the scale is the indexical mode. These are signs in which there is a direct connection or genuine relationship between the representamen/signifier and interpretant/signified. An example of this mode is the portrait of *Mrs Fiske Warren (Gretchen Osgood) and Her Daughter Rachel*, 1903, by John Singer Sargent (**Figure 21**, p. 145), where the image has a direct relationship to the sitters.

In between these two extremes is the iconic mode. These are signs which owe their connection to the object through some resemblance between representamen/signifier and interpretant/signified. An example of this mode is the raised swords in *Horatii* by David (**Figure 12**, p. 63), which signal the coming fight between the two families (see Chapters 2 and 3).

It is important to note that a sign may have more than one mode. For example, the swords in the *Horatii* have other potential symbolic meanings (justice, constancy or fortitude) as well as the specific iconic meaning within the painting (Hall 2000: 294–95).

SO WHAT ABOUT ART AND SEMIOTICS?

This introduction to the theories of Saussure and Peirce provides a brief overview of the origins of semiotic studies and gives an idea of the complexities of the concepts involved. Although some art historians have engaged directly with these theories, their importance has primarily been to lay the foundations for subsequent theories of structuralism and poststructuralism (Leja 2002: 303–16; Hatt and Klonk 2006: 201–12).

At a basic level, theories of sign systems relate to the use of symbols, signs and meanings in art. For example, in Chapter 6 the concept of difference is used to develop the characterisation of gender within visual representation. However, the study of signs and the separating out of the components of sign systems have resulted in a more fundamental reconsideration of the construction of knowledge and value systems. This has led to radically new interpretations of social, political and cultural phenomena, including art. Therefore the principles of semiotics underlie contemporary theories of gender, power, ethnicity, the postmodern and postcolonialism.

SIGNS AND THE REPRESENTATION OF REALITY

In Chapter 1, we introduced the concept that art is sometimes about representation of a perceived reality and that the principle of art as *mimesis* has been challenged throughout the twentieth century. The way semiotic theories separate the signifier, signified and referent (object) introduces the possibility that signs are in some way independent of the reality they represent. Perhaps the outcome of this is self-evident – a brief consideration of words and their meanings (for example boot, box or tight) reveals how they can be used to mean different things in obvious or not so obvious ways. This concept, however, leads to more radical questioning of how accurately sign systems (e.g. language) represent reality.

A 'realist' view might be that signs do have a one-to-one relationship to objects or concepts. The complexities of language, however, suggest that this cannot be the case. As noted in Chapter 1, works such as a painting or even a photograph represent only one viewpoint or perspective of the reality their originators sought to present.

The 'idealist' alternative to the 'realist' view is that things do not exist at all independently of the sign systems which describe them. In other words, because we cannot conceive of reality without the use of a sign system, the reality does not exist for us as a separate entity from the sign system.

Some argue that the way words and languages describe and differentiate the world does correlate with the objects and divisions of the real world, although different languages do not do it in the same way. It must be acknowledged that words do not 'name' things in the real world; rather they create a separate world which is abstracted from the real one (Chandler 2002: 55–58).

MODALITIES OF THE SIGN

The semiotic models of both Saussure and Peirce, in different ways, separate the sign from reality and propose that the real world can only be known through signs. This stance led Peirce to propose degrees of accuracy, the 'modality' of signs – in other words, how close is a sign to reality?

Again there are different views on this point. 'Idealists' argue that reality is totally constructed by signs, whilst 'realists' state that signs only offer a viewpoint on a tangible reality which exists independently from the signs that describe it. An intermediate viewpoint is that signs construct a 'social reality' but acknowledge the existence and importance of the physical world (Chandler 2002: 58–59).

The 'modality' of a sign offers the possibility of exploring how close a sign or text is to reality. Although degrees of 'modality' can be theorised – that one text or medium is more reliable or authentic than another – no firm rules can be drawn. For example, we might think that **Mrs Fiske Warren (Gretchen Osgood) and Her Daughter Rachel** by Sargent (**Figure 21**, p. 145) is close to reality but could we suggest this of all portraits? Similarly, **Adam and Eve** by Cranach (**Figure 20**, p. 142) might be seen by some as entirely allegorical and by others as representing a critical moment in Biblical history. Also, the circumstances of an encounter with the text or sign might mean that its proximity to reality is emphasised. Have you ever read a book or looked at a painting and been so absorbed by it that you are surprised when you returned to

reality? Surprised, for example that the sun was shining when the 'reality' of the text or image assured you that it was raining? Eco has argued that familiarity with an iconic sign in a particular context can mean that it becomes more 'real' than reality (Eco 1976: 204–5).

Typically, photographic representations, particularly film and television, are judged most 'realistic'. In Chapter 1, we noted that photographic and artistic representations, however closely they represent reality, offer only a mediated perspective of it. In Chapter 6 we discuss how film forms in the mid-twentieth century rein-forced the 'reality' of the *masculine* and *feminine* roles in society. Within any media – painting, text or film – genres can be constructed with sets of 'modality markers' (indices to reality) which create value systems or 'realities' for the viewer or reader (Chandler 2002: 60–64). It is easy to see how the prominence of particular art *genres* and styles at certain times might be explained within this theory of 'modality markers'.

An example of a reality created by art is the case of *single point perspective*. Developed in the early fifteenth century by Filippo Brunelleschi (1377–1446), it was adopted as the standard way of representing space for over 500 years. Based on the idea that the image was being viewed through a 'window', it created a perspective from a single viewpoint (Turner 1997: 91–115). Artists became exceptionally skilled at manipulating the image to construct this viewpoint, and it was not significantly challenged until Cubism questioned its assumptions. In the real world, we have panoramic sight; even if we hold our head and eyes still we do not have a single viewpoint, and our two eyes ensure we see objects in three dimensions.

So why did this method of representation become the dominant form for hundreds of years? Some see its origins as a desire to introduce the human perspective into art in response to humanist concerns, but this has been challenged (Burke 1986: 20). It was certainly a response to the renewed interest in *classical* art and architectural values. It was not until the 1920s when the art histo-rian Erwin Panofsky wrote 'Perspective as Symbolic Form' (1927) that the idea emerged that it had a signification of its own. Panofsky's work opened the debate on what we can now see is a signifying system which for a time eclipsed all other forms of

representation, and which is still today viewed by some as the right way to paint a three-dimensional image.

CHALLENGING 'REALITY'

The Surrealist painter René Magritte (1898–1967) explored the contradictions of representation in his painting *La Trahison des Images* (The Treachery of Images), 1929 (Los Angeles County Museum of Art). The work contains a relatively realistic representation of a smoker's pipe with the following words written underneath – 'Ceci n'est pas une pipe' (This is not a pipe). The solution to this visual puzzle can be sought in the word 'This'. Does 'This' mean a pipe, the painting or the sentence? There is no correct answer (Schneider Adams 1996: 137–38, 157, 166).

Magritte's intention was to highlight the impossibility of reconciling words, images and objects and to engage with representations of reality, particularly in advertising. A semiotic interpretation reinforces the idea that the representation – the sign – is not the same as the real thing – the object (Foucault 1983; Boyne 2002: 341–42; Chandler 2002: 64–65).

Magritte's questioning of representations of reality was taken up by a generation of Pop artists including Robert Rauschenberg (b. 1925), James Rosenquist (b. 1933), Roy Lichtenstein (1923–97), Richard Hamilton (b. 1922) and Andy Warhol (1928–87), who explored and challenged images of 1960s reality. In the context of semiotics, these artists ask us to re-consider our assumptions about the reliability of the relationship between images (signs) and the world they represent (objects) (Hughes 1991: 341–56).

In certain circumstances the viewer or reader is encouraged to overlook the medium of the signifier – painting, text or film. In other words, the viewer or reader is deceived into thinking the signifier is the reality. The medium effectively becomes 'transparent', reinforcing the confusion between signifier, signified and object. The challenge for painters from the *Renaissance* onwards was to see how closely they could imitate reality on a two-dimensional surface. But however successful they might appear to the eye signs are still only signs. Twentieth-century *avant-garde* artists rejected the 'deceit', or conceit, that you could represent a three-dimensional reality in two dimensions, instead focusing

their artistic interests on the nature of the two-dimensional surface (see Chapter 2).

WHOSE 'REALITY' IS IT ANYWAY?

The separation of signifier, signified and object has raised questions over the stability of the relationship between them. Postmodern and poststructuralist theorists argue that there is no firm link between signifier and signified. The signifier can mean whatever the 'user' wants it to mean. In this context the 'user' might be the author or the listener/viewer of the signifier. This means that the signifier might mean anything – an 'empty signifier'. This fluidity between signifier and signified has been developed by postmodern theorists to propose a number of theories concerning the interpretation of visual signs and images.

Roland Barthes, the first theorist to make explicit use of the term 'empty signifier', hypothesised that signifiers were open to interpretation by anyone. He proposed that any listener or viewer could make their own interpretation of the sign or image, regardless of authorial intention. Based on this theory, he proposed the 'death of the author', where the author (or the artist) has no control over how his text (or painting) is interpreted after it is completed (see Chapter 7). In other words, the original signifier/signified relationship of a sign can be replaced by any number of alternative signifier/signified relationships.

Jacques Derrida went further in deconstructing semiotic structures, proposing that the relationship between the signifier and the signified was irresolvable. His term *différance* encompassed both the idea of difference, defined by Saussure, and the deferral of the resolution of the signifier/signified relationship. He argued that the meaning of a particular sign is constantly deferred because its ultimate meaning is dependent on the meanings of other signs in a text. The process of exploring this phenomenon in texts is called *deconstruction*. This continuous cycle of deferred meaning has parallels to Peirce's theory of an infinite cycle of representamen-object-interpretant/representamen-object-interpretant/representamen (Chandler 2002: 74–75).

Underlying Derrida's theories is a criticism of Saussure's belief that speech was more important than writing. Derrida claimed that Saussure's sign system implied that the spoken word/signifier

is closer to the signified (the thought) than the written word/signifier. This purity of speech over writing has been a central theme within philosophical thought since Plato, but Derrida believed that speech and writing were equally limited in their ability to objectively represent reality (Derrida 1976).

Derrida saw this as an indication that Saussure's system was logocentric – i.e. self-referential. Derrida argued that the setting down of any knowledge system, from politics and philosophy to social and cultural values including Saussure's semiology, was self-referential. In other words, the process of formulating any theory requires the construction of a self-referencing sign system related through *différance*, which in turn cannot produce objective 'truths'. Any theory is built up from interdependent signs which rely on themselves to create a 'truth'.

Another theorist, Jean Baudrillard (1929–2007), explored how representations distort reality or conceal the absence of reality in a sign (Baudrillard 1994). His theory of *simulacra* is discussed in Chapter 7. His 'categories' of representing reality resemble the three key 'representational paradigms' (the 'modalities' of signs introduced earlier in this chapter) of the relationship within sign systems:

- symbolic – the signifier has no connection to a referent but refers to other signs;
- iconic – the signifier is not directly connected to the referent but represents it transparently;
- indexical – there is seen to be a direct connection between the signifier and referent.

Within the contemporary world of advertising, spin and media-hype, it is possible to see how the signifier has become a tool in the hands of whoever wishes to create a reality for their own ends. Critics have argued that Baudrillard's perception that the signifiers only refer to other signifiers is ignoring the reality upon which the signifier is based.

The artistic response to this detachment of signifier and signified has been the rejection of art with a higher meaning, i.e. the rejection of art as a tool within a wider value system such as existed, for example with Renaissance or *Modernist* art. As a result much contemporary art does not claim a set of accepted values but rather

is open to valid interpretation on many, any or no levels. For example, Jeff Koons' (b. 1955) *Three Ball Total Equilibrium Tank (Two Dr J Silver Series, Spalding NBA Tip-Off)*, 1985 (**Figure 23**, p. 168), is discussed in relation to these ideas in Chapter 7.

STRUCTURAL ANALYSIS

Semiotic theories have been used to develop a way of investigating the sign systems within a text or social practice called structural analysis. This method of analysis seeks to reveal the underlying signifying relationships within a text or social practice and the values or assumptions within the world they represent.

The process of structural analysis is based on exploring the differences between signifiers within a text. There are two kinds of differences:

- syntagmatic – concerns the position of the sign, for example the position of a word in a phrase or sentence. The syntagm was described by Saussure as a 'chain' of signifiers that are linked together in an ordered fashion. Syntagmatic analysis considers the horizontal relationships in a text, for example the grammatical relationships such as subject, verb, object.
- paradigmatic – concerns the ability to substitute one signifier for another and hence alter the meaning of the text. Paradigms link signifiers and signifieds into categories on a vertical axis. For example, a word in a sentence might be substituted for another word to explore how the meaning changes.

The premise is that signifiers are chosen from within syntagm and paradigm constructs and reflect the rules of the text or social practice. On a basic level this might be the rules for grammar, for example, but on a more complex level it can reflect the underlying value system within which the text was written.

SYNTAGMATIC ANALYSIS OF IMAGES

In the same way, an image such as *Allegory* (**Figure 15**, p. 91) has been constructed with a set of signs that accord with signifying

rules of the period in which it was painted. The composition or sequence of signs in **Allegory** is a syntagm, whereas the signs themselves were chosen from a comparable range of signs to achieve the specific message of the image.

The types of syntagm relations in texts can be related to the construction of images. Spatial relationships within an image are not neutral. As Western European language is read from left to right, so Western art has traditionally arranged elements to be read from left to right. Sequential relations introduce the idea of the narrative which has also traditionally been a component of image construction. For example, David's **Horatii** is most appropriately read from left (the brothers swearing the oath) to right (the women's response to the men's actions). Similarly up/down, centre/periphery and close/distant are used to support hierarchical constructs in images. For example, Christian religious imagery often makes use of the up/down syntagm – up is closer to God and heaven; down is earthly, human and hell (Chandler 2002: 79–89).

DISCOURSE AND POWER

The term *discourse* is often used loosely to refer to a cohesive group of ideas or rules which govern a particular subject or theory. A discourse might include various interconnected textual, visual or spoken components which present a set of ideas. Here, discourse refers to an aggregation of signs used within any cohesive set of texts, speeches or images.

Saussure was only interested in studying the underlying structures of sign systems rather than their use. More recent studies have looked at the interconnectedness of signs within a discourse. For example, structural analysis is concerned with the relationship between signs in a text or discourse and also between the signs that are used compared to those that are not.

Michel Foucault developed a theory of discourse as a theoretical construction within which humans operate. It can perhaps best be understood as an organisation of signs which defines and constrains the language and interactions of a particular area of existence. Foucault explored discourses within medical and psychiatric treatises of the late nineteenth and early twentieth centuries with particular reference to madness and *civilisation* (1971). He was

interested in understanding changes in the nature of medical knowledge from myth and superstition to an increasingly 'scientific' and apparently objective basis. His studies convinced him that the goal of an ultimate 'truth' did not exist – there were only discourses which shifted over time.

Foucault went on to develop his theory of discourse in relation to punishment and prisons (1977). Ultimately he concluded that knowledge systems were developed as systems of power and domination. He argued that knowledge systems – medical, legal, political or philosophical – rather than being based on rational and objectively deduced 'truths', were constructed to support social hierarchies (Foucault 1980b).

DISCOURSE AND 'METANARRATIVES'

It is worth drawing attention here to the theoretical connections between discourse, the search for hidden meaning through structural analysis and Jean-François Lyotard's construct of the *metanarrative*, discussed in Chapter 7. Lyotard's initial task was to explore the state of knowledge in capitalist society, and he created the concept of the metanarrative to explain the structure of knowledge-generating systems, such as science, at the highest level (1979). It is possible to see parallels between Lyotard's idea of a grand system of rules which controls the processes of knowledge systems (a higher level of understanding or meaning), and the interconnected structures of a discourse exposed by structural analysis.

Lyotard went on to explore the nature of metanarratives, where the elements of meaning in a discourse – sentences, phrases and texts – can be separated or re-connected to reveal multiple overlapping metanarratives (1983). Lyotard's studies of the structures of knowledge systems explored meaning on a higher level than the sign but they presented parallel challenges to our ability to represent meaning in a single or consistent way.

PARADIGMATIC OPPOSITIONS

Central to both the structural analysis of a text and the sign systems underlying the discourse, or metanarrative, is the concept of paradigmatic oppositions. Just to recap – the syntagmatic differences

refer to the relationships between signifiers within the text and the paradigmatic differences refer to the choice of signifier included in the text compared to those not included.

If we take the following sentence as an example (it is usually used as a mnemonic for the alphabet):

The quick brown fox jumps over the lazy dog.

Syntagmatic analysis explores the relationships between the actual words in the sentence, for example the grammatical relationship between the subject (the fox), verb (jumps) and object (the dog). Paradigmatic analysis looks at the choice of words used in the sentence, such as quick, fox, lazy and dog, and considers what alternatives might have been used. If we explore these alternatives – oppositions – we can see a framework of signifiers emerging – quick opposed to slow, fox/dog, lazy/active and dog/fox. The choices made between the oppositions frame the meaning of the sentence.

The theory of binary oppositions was a key analytical tool used by Roman Jakobson (1896–1982) and has become highly influential in the development of gender and *postcolonial* theories. Believed to be rooted in early childhood psychological development and a fundamental characteristic of language, binary oppositions impose order on the experience of the world (Jakobson and Halle 1956: 60; Lyons 1977: 271). Jakobson believed that the meaning of opposites is bound together so that one could not have meaning without the *other*. For example, the meanings of wet and dry are dependent on each other – wet is not dry and vice-versa – it is difficult to conceive wet without reference to dry.

Although some oppositions are opposite or mutually exclusive, for example birth/death, others are simply 'contrasts', for example young/old, where the difference may be graduated. Although these oppositions are not intrinsic to the natural world they can become embedded within our consciousness. For example, we may see these oppositions as fundamental to the world rather than something created by society. In Chapter 6 we see how the opposition of masculine/feminine and *male/female* has been questioned by feminists and queer theory. The latter has argued, for example, that the culturally constructed oppositions of gender are no longer valid, proposing more flexible and diverse alternatives.

Binary oppositions or 'paired signifiers' are thought to create the fundamental underlying structures to texts, or images, so that further relationships are embedded. If we return to the sentence analysed earlier we can see that the signifiers (words) create a paradigm in which the fox is quick, fast and active and the dog is slow and lazy. They engender positive and negative connotations for the characteristics of the dog and fox, precluding the possibility of alternatives – that the dog might be fast and active or the fox slow and lazy. As a whole, the sentence is more than a simple observation and might be interpreted as a discourse about the nature of dog and fox! Whether this is true in reality or metaphorically is irrelevant; the discourse is self-referential and relies on the underlying oppositions to create meaning.

If we use this method on texts or images which deal with, for example, representations of masculine and feminine roles or characteristics we can see that the underlying oppositions are critical to gender discourse. We might see, for example, that in representing men as powerful and strong we are also representing woman as emasculated and weak. In the ***Horatii*** (**Figure 12**, p. 63), the characteristics of the men and women are clearly presented and are in opposition. The men are strong, muscular, active, powerful, in control and decisive, whereas the women are weak, languid, disempowered and have no influence over the unfolding events. This image presents a discourse in which the roles and characteristics of men and woman are clearly defined and opposed. In contrast, Barbara Kruger's (b. 1945) ***We Don't Need Another Hero***, 1987 (**Figure 16**, p. 107) directly questions these assumptions and the *stereotypical* role of the male hero. In her work the image and words challenge the accepted oppositions in the discourse of traditional gender roles.

The anthropologist Claude Lévi-Strauss (b. 1908) analysed systems of meaning developed in cultures by studying social rules, practices and myths. He proposed that binary oppositions form the basis for dealing with the complexities of cultural dilemmas or contradictions. In other words societies construct binary oppositions to handle and resolve conflicting situations. As a result binary oppositions attract additional connotations of good and bad, permitted and forbidden. Based on perceived oppositions in the natural world, these oppositions become embedded within the structures of society and assume the guise of 'natural' oppositions, even though they are culturally formulated. Although Lévi-Strauss'

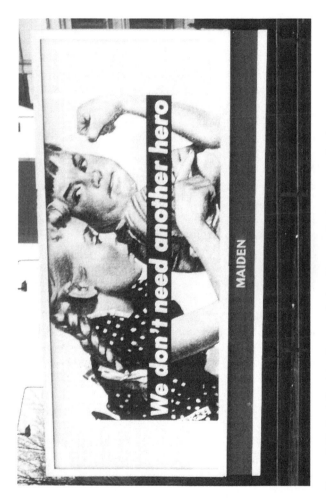

Figure 16 *We Don't Need Another Hero*, Barbara Kruger, 1987. Commissioned and produced by Artangel, © DACS, London, 2006.

studies did not take a historical perspective, he did acknowledge that oppositions were fluid and could change over time (Lévi-Strauss 1974 [1962]).

BINARY OPPOSITIONS AND ART

Art movements can be fitted into this structure of oppositions, with particular *aesthetic* interests allied to certain oppositional characteristics. For example, surveys of eighteenth-century art typically identify three 'movements':

- *Rococo* – associated with the frivolous and decadent society of the French court;
- *Neo-classicism* – associated with renewed values of the classical world and the rationalism of the *Enlightenment*, which was popular with Napoleon Bonaparte;
- *Romanticism* – associated with a rejection of the rational in favour of the imaginary.

Each development has been characterised in opposition to the previous style, despite evident contradictions. For example, artists classified as Romantic never saw themselves as a movement, and the styles of Francisco de Goya y Lucientes (1746–1828) and Caspar David Friedrich have little in common. Matthew Craske's recent re-evaluation of the period shows how the traditional oppositions break down when the art is viewed from new perspectives (Craske 1997: 7–21).

MARKEDNESS

Jakobson proposed the theory that all components of linguistic systems are classified by their markedness – i.e. the presence or absence of a characteristic (cited in Lechte 1994: 62; Chandler 2002: 110–15). With paradigmatic oppositions, the two poles of binary opposites or paired signifiers are either marked or unmarked. The marked signifier is in some way distinguished from the unmarked by some feature. Signifiers can be marked in various ways, for example 'dress' and 'home' are unmarked whereas 'undress' and 'homeless' are marked. With paired oppositions, the two signifiers

have different values – the unmarked is primary and the marked is secondary. In this way markedness differentiates oppositions as 'positive' or 'negative', 'term A' or 'term B'. Although the primary signifier is dominant, we have seen how Derrida showed that it cannot have meaning without the secondary signifier (Derrida 1976).

Typically, in paired oppositions, the dominant or the unmarked signifier comes 'naturally' first in the pairing, for example man/ woman, good/bad, high/low and fact/fiction (an extensive list of opposites and their markedness is given in Chandler 2002: 114). This 'natural' hierarchy can sometimes be traced to a historical event when the markedness was first defined. Foucault's studies of social power dynamics explored how markedness is created and maintained (1970 and 1974).

Derrida, among others, sought to challenge or overturn the dominance of the unmarked, or 'term A'. He questioned, for example, the dominance of speech over writing and used deconstruction to undermine conventional pairing hierarchies (Derrida 1976). In tune with these concerns, contemporary artists have sought to challenge and reverse the dominant signifiers in gender, postcolonial and postmodernist spheres, as we shall see in the following chapters.

FIGURATIVE LANGUAGE

The model developed by Saussure for the signifier/signified relationship suggests a one-to-one system, but the Peirce model identifies the potential for a continuous cycle of referential meanings. The structural analysis of texts, or images, has shown how signifiers are interconnected. It is possible to see that language systems offer the potential for hidden meanings and structures of thought. We can also see that language is rhetorical – it is used to persuade others of the cultural 'norms' of society.

Another aspect to this is the use of figurative language. Figurative language employs tropes – a word or expression used to mean something other than its literal sense – such as metaphors and metonyms. Chandler provides a detailed analysis of the four 'master tropes' (2002: 127–40):

- Metaphor – is describing or referring to one thing but using another. This means one signifier is used to refer to

another signifier, which in turn refers to a signified. Lakoff and Johnson have classified metaphor into three kinds of relationships between the linked signifiers – orientational (e.g. spatial), ontological (e.g. conceptual) and structural (broader metaphors built on the other two kinds) (Lakoff and Johnson 1980). Examples are 'the weather is Arctic'; 'the grass is greener'; the dress and surroundings of the sitters in Sargent's **Mrs Fiske Warren (Gretchen Osgood) and Her Daughter Rachel**, 1903 (**Figure 21**, p. 145) are a metaphor for the wealth of the husband.

- Metonym – using one signified to mean another signified, where they are closely related. The signified is substituted for a related signified – effect for cause, object for user, substance for form, place for event, person or institution, institution for people/person and vice-versa. Examples are 'crown' for king; 'throw the book at him' meaning 'charge him under the rules'; the apple in Cranach's **Adam and Eve**, 1526 (**Figure 20**, p. 142) is a metonym for the sins of the world in Christian thought.

- Synecdoche – there are various definitions for this but the most widely used is the 'substitution of the part for the whole, genus for a species and vice-versa' (Lanham 1969: 97). It is sometimes seen as a type of metonym because it is also the substitution of one signified for another. Examples are 'wheels' for 'car'; 'England' for the English cricket team. It might be argued that many twentieth-century art works could be described in this way. For example Picasso's **Guernica**, 1937, represents the carnage of one attack to signify the horrors of war in general. Similarly, Warhol's **Campbell's Soup Cans Series**, 1962, either individually or collectively could represent commercialisation.

- Irony – similar to a metaphor, where one signifier is used to mean another, but we only know of this through the presence of other signifiers. Often the signifier used means the opposite of what the other signifier means. Examples are 'can you go any slower?' when faster is what is wanted; Barbara Kruger's **We Don't Need Another Hero**, 1987 (**Figure 16**, p. 107), conveys irony in the conflicting message of the aggressively gesturing boy and the text of the poster.

Figurative language is more common in everyday speech than might be thought, and the use of analogy is central to language. The use of representation to explain something else underlies the maintenance of reality. Within this form of language, a signifier does not mean its obvious signified but another altogether.

The pursuit of an objective view of the world began in the seventeenth and eighteenth centuries. Scientists believed it was possible to record and describe the world in literal terms and philosophers debated the separate spheres of the mind and the body. However, language cannot be neutral or objective, and metaphor is fundamental to the way we describe the world. The term 'Enlightenment' is itself a metaphor.

Metaphor is widespread in art of all periods. This is perhaps easiest to see in *Allegory*, *c*.1540–50 (**Figure 15**, p. 91), or Cranach's *Adam and Eve*, 1526 (**Figure 20**, p. 142), but is equally present in Jeff Koons' *Three Ball Total Equilibrium Tank (Two Dr J Silver Series, Spalding NBA Tip-Off)*, 1985 (**Figure 23**, p. 168) (see Chapter 7).

Metaphor and its associated tropes operate on the level of the signifier, but alternative meanings can also operate at the level of the signified. The relationship between the signifier and signified is usually differentiated as denotation or connotation. At its simplest level, the denotation is the most obvious meaning – i.e. the most commonly used signifier/signified relationship. For example, the denotation of 'black' might be the colour. Connotations are subsidiary meanings for a signifier, i.e. other meanings of 'black' might relate to race, mood or darkness. However, studies by Roland Barthes and Valentin Voloshinov (1884/5–1936) demonstrate that such differentiation is not valid. They argue that the denotation is simply another connotation which has achieved dominance through experience, evaluation and consensus. Barthes developed this further by proposing levels of signification with denotation at the first level and connotation at the second level (Barthes 1972 [1957]; Hjelmslev 1961). A third order of signification has been related to myths or ideologies which underpin significant cultural concepts such as gender, ethnicity and freedom (Chandler 2002: 140–46).

SOCIAL SEMIOTICS

One criticism of Saussurean semiotics is that it does not provide tools for understanding the historical or social dimension of communication.

Saussure's approach is entirely synchronic in that it only considers the sign at the moment of its engagement and does not take account of changes or developments in sign usage over time – diachronic. He focused on the langue – the sign structures of language – rather than the parole – the specific implementations within an actual language.

Russian linguists Valentin Voloshinov and Mikhail Bakhtin (1895–1975) challenged this approach. Voloshinov argued that the meaning of signs could only be understood within the social context of their use, therefore placing emphasis on the parole – the implementation of langue. Russians Roman Jakobson and Yuri Tynyanov (1894–1943) also argued that the purely synchronic approach was flawed.

These theorists proposed that a particular speech, text or image was involved with previous events and was geared to a particular response. This breaks from the arbitrary relationship between signifier and signified and argues for a social grounding for meanings. Voloshinov went on to say that the sign was 'an arena of class struggle' (Voloshinov 1973: 166).

Within the social setting of semiotics, signs acquire conventional meanings and codes which are developed and adapted over time. As Frascina has shown in analysing the signs, codes and conventions of nudes at different times, the social context of signs is a critical element of artistic change. He demonstrates how the conventions of the nude have been successively challenged by Manet's **Olympia**, 1863, and Picasso's **Les Demoiselles d'Avignon**, 1907. He further argues that the challenges of avant-garde art are rooted in its ability to break the normal sign conventions and present multiaccentuality – engagement with multiple social classes (Frascina 1993: 122–33).

POSTSTRUCTURALISM AND ITS CRITICS

The development of semiotic theories since Saussure and Peirce first formulated their sign models can be understood as an exploration of the way meanings are created in language. The first phase of this – structuralism – was based on the structural nature of the theories of signs and meaning. A second phase – poststructuralism – had primacy in the 1970s and questioned the stability of signs and meaning. We have seen how this has created a wholly relational model – one in which there is a potential for a sign to mean anything.

At one extreme, the search for the source of meanings has found that signs can be manipulated; they depend on other signs for their meaning and are largely socially constructed. This 'disintegration' of meaning has been hailed by poststructuralists such as Foucault, Derrida and Kristeva as providing the potential for new perspectives for understanding signs, texts and discourses. However, other theorists have rejected this relativising free-for-all and have argued that things have gone too far. Marxist theorists such as Dews (1987) and Eagleton (1990) have attacked the apparent denial of grounded values which arose from the Enlightenment project of social emancipation. Discussing such relativism, Eagleton writes:

> Truth is a lie; morality stinks; beauty is shit. And of course they are absolutely right. Truth is a White House communiqué; morality is the Moral Majority; beauty is a naked woman advertising perfume. Equally of course they are wrong. Truth, morality and beauty are too important to be handed contemptuously over to the political enemy.
>
> (Eagleton 1990: 372)

Although critics point to the limitations of the methods of structuralist and poststructuralist theories, they have nevertheless proved highly influential in the analysis of art, culture and aesthetics. By exploring the self-referentiality of sign systems, structuralism and poststructuralism emphasise the nuances and complexities of representation.

SUMMARY

Ferdinand de Saussure and Charles Sanders Peirce founded the discipline of semiotics – the study of signs – with models for the relationship between signifier (the sign), signified (the idea or concept) and object. Although developing two different models, their studies established approaches to exploring the structure and meaning of signs which have influenced contemporary art historical approaches. The structure of signs was further explored through the mode of relationship between the signifier, signified and object. Modality is concerned with the arbitrariness or stability of the signifier/signified relationship, and therefore how close signs are to reality. Perceptions of this relationship vary from the idealist (far from

reality) and the realist (close to reality) viewpoints. Art exemplifies different modalities and has challenged the stability of sign systems. For example, poststructuralist theorists Jacques Derrida and Roland Barthes have argued for a complete instability between signs and meanings.

Derrida developed the approach of deconstruction, which explores the choices of signs used in a text, or discourse, in order to reveal elided meanings. The concept of difference, and *différance*, between paired signs, such as man/woman, good/evil, underlies language systems and demonstrates asymmetries of power in text, discourse and images.

Michel Foucault's studies of power dynamics in social and political structures have revealed the dependencies between the construction of knowledge systems, meaning and power. Figurative language, such as the metaphor, is also used to structure ideas. Some theorists have explored the social context and implementation of sign systems to argue that usage can also contribute to and change meanings. Some critics have challenged the lack of moral or ethical grounding resulting from a wholesale questioning of meaning within language. However, the importance of semiotic and poststructuralist approaches to the sign and its meanings is apparent in their use in feminist, postmodernist and postcolonial theories.

FURTHER READING

Daniel Chandler's *Semiotics: The Basics* (Abingdon, UK and New York, 2002) (also at http://www.aber.ac.uk/media/Documents/S4B/semiotic.html) is an excellent introduction to the subject. It provides clear and detailed explanations of the concepts, terms and developments in semiotics.

Also useful is Paul Cobley and Litza Jansz's *Introducing Semiotics* (Duxford, UK and New York, 1997).

Another lucidly written introduction is Bronwen Martine and Felizitas Ringham, *Key Terms in Semiotics* (London and New York, 2006).

Ferdinand de Saussure's original lectures, *Course in General Linguistics*, also provide a foundational text; the most recent edition is Open Court Classics (Chicago, 1988 [1916]).

PSYCHOANALYSIS, ART AND THE HIDDEN SELF

INTRODUCTION

> The rigidity of such [fetishistic] standards is reminiscent of the severe
> canons upheld by some critics or exponents of the fine arts. Indeed, if
> one did not know what was the actual subject matter of association, it
> would be difficult for the hearer to distinguish certain diagnostic
> discussions of the conditions for perverse sexual gratification from an
> aesthetic discussion of 'good' and 'bad' art.
>
> (Edward Glover, 'Sublimation, Substitution and Social Anxiety',
> in *On Early Development of Mind* (1956))

Glover's aside on the parallels between artistic *discourse* and human
character pathology underline their interconnection. The word
aesthetic stems from the Greek term 'aisthesis' – that which relates
to the realm of human perception and sensation (Eagleton 1990:
13). It is therefore unsurprising that psychoanalytic theories have
influenced recent approaches to art history and have been a signifi-
cant referent within twentieth-century art.

This chapter introduces psychoanalytic theories and discusses
how ideas and categories relating to the unconscious might be
used to characterise art and aesthetic creativity. How did Sigmund

Freud's theories of the unconscious develop and what was his legacy? How have subsequent revisions of his ideas by Melanie Klein (1882–1960) and Jacques Lacan (1901–81) influenced theories of cultural representation? How can we apply theories of *psychoanalysis* and the unconscious to themes in art and approaches to art history?

FREUD, PSYCHOANALYSIS AND PSYCHO-SEXUAL DEVELOPMENT

Freud coined the term 'psychoanalysis' in 1895, based on his observations of patients with severe mental disorders. Drawing upon patient behaviour and response to therapy, Freud theorised about the nature of the mind – the psyche – and the origins of mental disorders. In *Studies in Hysteria,* terms such as the unconscious, repression, trauma (Greek for wound) and pathogenic (disease-creating) were used for the first time in describing a patient's mental condition (Freud and Breuer 1895).

For Freud the unconscious was the part of the mind in which memories and thoughts were held but of which the patient was not conscious. He believed that problems associated with these memories were therefore hidden or repressed – unavailable to the conscious mind. His therapeutic technique was to uncover these hidden memories – thoughts, emotions and desires – in order to resolve the conflicts and disruptive symptoms they caused (Appignanesi and Zarate 1979: 26–41). Freud used hypnotism, word play and dream analysis to expose mental disorders within the unconscious, and to explore the nature and development of the psyche.

From his early studies Freud proposed that the psyche had two parts – the unconscious and the preconscious:

- The unconscious contained unorganised desires and impulses for basic needs such as food or *sex*. These were driven by the instinct for pleasure – which Freud termed the pleasure principle.
- The preconscious contained organised thoughts and memories that can become conscious. The drive here was for managing the real world – termed the reality principle.

Freud perceived a tension and conflict between the pleasure principle and the reality principle. In studying his patients' symptoms and responses to treatment, Freud identified four key mental phenomena which derived from the unconscious. These were dreams, jokes, slips (commonly termed Freudian slips) and psycho-neurotic behaviours (physical behaviours which could not be explained by physical causes, e.g. facial tics, psychosomatic paralysis). These provided a window, as it were, onto the unconscious mind, allowing Freud to understand the causes of mental disorders (Wollheim 1991 [1971]: 65–106).

Freud sought explanations for the mental pathologies he treated in relation to the development of sexual identity and sexual desire. His *Three Essays on Sexuality* (1905) suggested that the two concepts of sexual pleasure – the desire for sex – and genital pleasure – specific stimulation of the genital area – were defined by different drives. The sex drive with which we are born – the libido – has mental (psyche) and physical (soma) elements. Healthy development of the libido resulted in sexual desires that were satisfied by appropriate stimulation. If development was atypical, sexual desire could become directed at other stimulants and lead to sexual perversions such as voyeurism, exhibitionism and fetishism. These concepts are discussed in relation to art later in the chapter.

Freud located the origins of these characteristics in the earliest development of childhood sexuality. At birth the child's sex drive has no structure or direction, which Freud called 'the polymorphous perverse'. By this Freud meant that the infant takes pleasure from stimulation of any part of the body – an erotogenic zone. As the child develops and gains experience of the world, its psyche and libido go through various stages of psycho-sexual development. The first, oral stage, depends on the pleasure of the mouth through sucking the mother's breast for food. At this stage the infant sees itself in control of the world – its world. In the second, anal stage, the infant gains pleasure through controlling its bowels. The retaining or releasing of excrement provides a new means of control over its world. At the third, phallic stage, around three or four years old, the child explores pleasure through genital stimulation and begins to recognise differences in sexual anatomy (Wollheim 1991 [1971]: 107–19).

THE OEDIPUS COMPLEX

Freud proposed that when the child is five or six years old, it enters the Oedipal phase. The child's relationship with its mother and father now becomes the focus of sexual development. Freud theorised that as boys recognised that their sexual anatomy matched their father's, they became anxious that their desire for their mother would result in castration by their father. This desire also triggered the urge to kill their father, who is perceived as a rival and threat. Freud associated these processes with the Greek myth of Oedipus, who killed his father and married his mother – hence the Oedipus complex. Possibly more problematic is Freud's explanation of how girls negotiate the Oedipal phase. He believed that they recognised the genital differences and perceived themselves as already castrated. This allegedly resulted in penis envy which led to the rejection of the mother, who is blamed for the girl's castrated state, and the subsequent acceptance of a passive sexual role (Wollheim 1991 [1971]: 119–22).

Freud recognised that there were two natures within the individual – the *masculine* and the *feminine* – effectively proposing that all individuals are inherently bisexual. The process he proposed by which an individual develops and defines their sexual identity is complex. Between the age of six and puberty, the sex drive appears dormant and the early desires and experiences are repressed – submerged into the unconscious. Having laid the foundations of the libido, they remain as unconscious memories which will be involved in future sexual desire.

According to Freud, it is when these early stages of sexual development are not fulfilled correctly that neuroses – physical or psychological signs of mental disorder – emerge. Individuals can become fixated in one of the stages of development, resulting in inhibited behaviour patterns. Alternatively, others might regress to an earlier stage of development with aspects of the sexual identity incompletely developed. For example, fetishists need a particular object to achieve sexual excitement, whereas for narcissists the object of sexual desire is the individual's own body. Freud concluded that as the sex drive could be orientated in many different directions, it had no natural object (Appignanesi and Zarate 1979: 89–98).

Although Freud's ideas of sexual development have been challenged and criticised, for example by the Swiss psychiatrist Carl Jung

(1875–1961), they established the basic principles of subsequent psychiatric theory.

THE TRIPARTITE STRUCTURE OF THE PSYCHE

In 1923 Freud proposed a model of the mind which mapped the centres of desire (*The Ego and the Id*):

- The *id* is the psyche of the newborn infant and is the reservoir of unconscious desire. In the grown person the id resides in the unconscious. As the child becomes aware of the external world, the id is altered and the psyche moves to the next stage. The transition from the id coincides with the developing awareness of bodily activities.
- The *ego* is differentiated from the id. When the infant becomes aware of the real world, the ego enables the child to become self-aware through interactions of the mouth, anus and genitals. The ego resides in the conscious but its repression of the id is unconscious. In the grown person the ego provides a defence mechanism against the primitive urges of the id.

Freud extended this thesis to a third element, the *superego*, which develops from the Oedipus complex. The hostility the child feels for its parents during the Oedipal phase is repressed but translates into introjections of parental control. As a result the id's aggressive urges are renounced (Wollheim 1991 [1971]: 192–96).

INSTINCTUAL ENERGIES, CREATIVITY AND SUBLIMATION

Freud believed that instinctual conflict involved interaction between the twin dynamics – the pleasure principle and the reality principle. He realised that these two drives were not actually in conflict, but that each discharged tension in the pursuit of pleasure. In exploring these issues, Freud sought to understand why individuals repeated the trauma of unpleasant experiences. One example which he encountered was that of soldiers repeatedly dreaming of terrifying experiences from the First World War. He proposed the concept of

the death instinct – thanatos – in which the individual fights against perceived threats. This can lead to aggression against external threats, but can also lead to destructive urges when directed against the self. In parallel to this, the love instinct, eros, drives the individual to reproduce.

Sublimation is the redirection of instinctual urges – for example sexual drives or libidinal energy – towards non-instinctual behaviour. For example, the problems arising from atypical development of sexual drives result in those drives being directed towards atypical sexual activities. According to Freud, art, *culture* and social norms arise from the sublimation of these instinctual energies, beliefs outlined in *Beyond the Pleasure Principle* (1920). Applying these ideas, Freud (1963 [1910]) also analysed the life and work of Leonardo da Vinci. Although partially based on a flawed translation of da Vinci's writings, Freud situated aspects of da Vinci's iconography in the context of the artist's relationships with his mother and step-mother.

SURREALISM AND PSYCHOANALYSIS

Freudian theories have directly influenced aspects of art practice and art historical discourse throughout the twentieth century. One particular *avant-garde* in which Freudian ideas played a formative part was that of Surrealism. Although the movement contained diverse practices and personalities, Freudian concepts of dreams, fantasies, neuroses and *fetishes* became central to the *iconography* and debates of many Surrealists. For example, Fer has described the 'feminine' as 'Surrealism's central organising metaphor of difference' (Fer 1993: 171). Various artists associated with Surrealism situated the feminine other in relation to Freudian concepts of the unconscious and the *uncanny*.

Despite Freud's denials, many Surrealist artists believed it was possible to produce art that visualised the workings of the unconscious. This was most famously explored by Masson and his association with the technique of psychic automatism (Fer 1993: 172). Masson, stepbrother of the French psychiatrist Jacques Lacan, believed that automatic painting could be driven by the unconscious, allowing the display of previously hidden emotions and ideas. Artists contemporary with Masson such as Salvador Dalí (1904–89) and Magritte

also incorporated Freudian motifs in their work, for example *The Reckless Sleeper*, 1928 (Tate Modern, London). In this painting, a sleeping figure lies above a panel containing 'Freudian symbols', which have latent meaning within Freudian dream analysis, such as the mirror and the apple.

Surrealist ideas are a recurrent aspect within the work of modernist and contemporary artists. The following websites provide insights into the work of the earlier avant-garde and that of more recent artists:

http://www.gosurreal.com
http://www.surrealism-artlinks.com

Magritte's *The Reckless Sleeper*, 1928, can be found on the Tate Modern collection website http://www.tate.org.uk/modern.

GOMBRICH AND PSYCHOANALYSIS

The widely known Austrian-born art historian Ernst Gombrich was introduced to psychoanalytic ideas early in his career through collaborations with the Freudian analyst Ernst Kris (1900–57). Although subsequent work made extensive use of psychology in relation to theories of artistic perception and representation, Gombrich adapted Freud's idea of the verbal joke, rather than the dream, as a paradigm for artistic creativity. However, it has been suggested that Gombrich made comparatively limited use of Freud's ideas because he was concerned about the extent to which the clinical evidence could be corroborated (Woodfield 2002: 431).

KLEIN, STOKES, FULLER AND THE 'INFANT–MOTHER' PARADIGM

Melanie Klein was a student of Freud who took his ideas a stage further. She emphasised the early years of infant development and the central role of the child's ambivalent relationship and connection with its mother. During this stage the child only recognises those part objects of the mother upon which it is dependent for survival and nurture, for example the breast. Klein characterised this as the 'paranoid-schizoid' position. This is understood to give way to the 'depressive' stage within which the child acknowledges

its own identity, perceiving its mother as a separate person (Rycroft 1977: 80–81). Central to this stage is the child's developing awareness of the pain and aggression which it had previously displayed to its mother. For Klein, human identity is understood in terms of this alternation between positive and negative impulses, with eventual maturity arising through the resolution of conflicting drives.

Adrian Stokes (1902–72) was a painter, critic and art theorist who made extensive use of psychoanalysis in his own work. Between 1929 and 1937, Stokes underwent a formative course of psychoanalytic treatment with Melanie Klein, after which he began to paint and to author the books for which he is most remembered: *The Quattro Cento: A Different Conception of the Italian Renaissance* (1932), *Stones of Rimini* (1934) and *Colour and Form* (1937). Arising from his therapeutic experiences, Stokes' art criticism has been characterised by its author's intense self-absorption in the linking of the art objects to perception and biographical experience (Scruton 1981: 148).

Stokes applied Klein's 'organicist' ideas to art making as an externalisation of the process of 'reparation' to the mother. Through this process, the artist's psyche asserts and delineates its presence within the world. For example, Stokes maps the acts of 'carving-modelling' onto the two developmental stages identified by Klein. Carving is understood as indicative of the depressive position and the creation of an autonomous and separate object – both literally and psychologically. However, modelling is suggestive of the earlier 'paranoid-schizoid' stage which is expressed by the emphasis on 'flatness, decoration, and failure to establish a separate identity, or to recognise the distinction and space between the self and the mother' (Fuller 1988 [1980]: 149). Stokes perceived both these stages of the aesthetic process as compensatory and interlinked, applying not just to the physical and creative making of art, but also to its contemplation and critical evaluation (Kite 2003: 260).

Critics have characterised Stokes' work following the Second World War as a major project which explored the implications of Freudian and Kleinian paradigms for the creative process. He published extensively, tackling monographs on modernist artists like Cézanne (1947) and Monet (1958); and applying psychoanalytic insights to ancient *classical culture* (1963); the *genre* of the *nude* (1967); and the relationship of art and science in *Renaissance*

painting (1949). The legacy of Stokes' ideas has been cited in work by critics and cultural philosophers such as John Berger, Peter Fuller and Richard Wollheim (1923–2003), and art historians like Michael Baxandall and John Shearman (1931–2003) (Read 2002: xxi–xxii).

The art critic and broadcaster Peter Fuller (1947–93) acknowledged the ideas of Stokes, and in turn applied psychoanalytic ideas to the creation and critical response to art (Fuller 1988 [1980]). For example, Fuller believed that psychoanalysis had a valuable contribution to make to issues of aesthetic experience and aesthetic value which more orthodox or instrumental theories had ignored. In consequence he interpreted the spatial dynamic of *Modernist* art in relation to Klein's idea of the 'depressive position' and the attempt to establish an aesthetic independent of representation. Fuller writes:

> These early modernist painters certainly acknowledged the external otherness, the separateness and 'outthereness' [*sic*] of the outside world, but having acknowledged it, they sought to transfigure and transform it. . . . Their new forms emerge . . . as an extension into an occluded area of experience.
>
> (Fuller 1988 [1980]: 156)

In the concluding observations to the collection of essays, *Art and Psychoanalysis* (1980), Fuller asserts a broader point about the importance of the 'infant–mother relationship'. For him, the formative and developmental connection between child and adult was a metaphor for a more authentically human social polity which addressed 'the past of each of us, and the future of all of us' (Fuller 1988 [1980]: 237).

LACAN: THE MIRROR STAGE; THE SYMBOLIC, THE IMAGINARY AND THE REAL

Jacques Lacan trained in medicine and psychiatry in Paris. His doctoral thesis on paranoia was influential on many Surrealists (Leader and Groves 1995: 10). Lacan reworked Freud's developmental model, exploring the importance of the 'mirror phase/stage' throughout his life. At the mirror stage the infant identifies itself in an external image – seen either in a mirror or in the image of another infant. This process of identification, or mis-recognition,

with an outside image – termed the ego ideal – effectively solidifies the boundaries of the self. The mirror phase is followed by the transition from the real (comparable to Freud's id) to the imaginary order (comparable to Freud's ego) when the infant still believes itself to be part of the mother. It then moves into the symbolic order (comparable to Freud's superego) when it recognises *difference* and begins to repress the imaginary order. The symbolic order is linked to the acquisition of language. The mirror stage is the beginning of the process of identifying self in the context of the *other* (Leader and Groves 1995: 18–61).

Lacan's seminars were attended by many of the next generation of critical thinkers including Michel Foucault, Jacques Derrida, Louis Althusser (1918–90), Julia Kristeva, Luce Irigaray (b. 1932), and Claude Lévi-Strauss. Lacan linked Freudian theory and *semiotics*; dream theory and linguistics, asserting slips and symptoms as signifiers. Lacan proposed that the agency of the unconscious was language.

FEMINIST CHALLENGES TO THE FREUDIAN AND LACANIAN PSYCHE

As discussed in Chapter 4, poststructuralist theorists question foundational knowledge systems including Freudian and Lacanian ideas. In particular, poststructuralist feminist theorists challenge the perceived patriarchal structures of the psyche developed by Freud and Lacan. It is not just that they question the construction of the *female* psyche as rooted in absence of the phallus – the lack of a penis – but that such views fundamentally challenge the whole patriarchal bias of Freudian psychoanalytic discourse. Following Derrida's use of *deconstruction* to reveal the underlying bias in texts and social ideologies, they have exposed the exclusion of the female as an equal identity within cultural structures. This has re-aligned cultural assumptions towards an equal female identity independent of the *male* for its definition. This approach is antithetical to the *masculine* value systems which had previously dominated epistemological and cultural debates.

Hélène Cixous (b. 1937) and Luce Irigaray were two of the originators of French poststructuralist *feminism*. Cixous wrote about the relationship between sexuality and language. Derrida coined the term logocentrism (logic of the same) to describe how scholars and

philosophers, including Plato, used words to explain the world, thereby constructing a self-fulfilling definition of the natural order. Cixous and Irigaray perceived a further distinction in which the patriarchal drive dominated these knowledge constructions, coining the term phallogocentrism. The viewpoint contains only one gender – male – which provides the universal referent for all gender constructions. In other words, the domination of the phallus in Freudian and Lacanian theory demonstrates logocentrism, i.e. the self-fulfilling of male domination. Cixous' concept of 'écriture féminine' proposed that female readers break out of phallogocentrism to find a new feminine form of expression – termed *jouissance* – equating to the experience of the female orgasm.

Cixous and Irigaray challenged binary oppositions, enabling the conception of an independent female identity. They aimed to create two autonomous genders recognising two equal sexes. Their theories focus on the pre-Oedipal phase where experience and knowledge derive from bodily contact, promoting the mother–daughter relationship, which is considered to have been devalued by patriarchal society. Irigaray indicates three aims within her work:

- the exposure of male ideology underlying the system of meaning and therefore of language;
- the creation of a feminine counter-system as a positive sexual identity for women;
- the establishment of an inter-subjective relationship of 'being two' between men and women.

There has been broad-based criticism of the *canon* of French post-modernists, including Lacan, Kristeva and Irigaray, by Alan Sokal and Jean Bricmont who have argued that such discourse has abused scientific terms, by using them either out of context or without regard for relevance or meaning (Sokal and Bricmont 1998).

CREATIVITY, SADISM AND PERVERSION

As suggested by these ideas, psychoanalytic paradigms have explored the construction and motivation of human character pathologies. These encompass a spectrum of character behaviours, including ideas concerning atypical or aberrant behaviour. Janine

Chasseguet-Smirgel's (1928–2006) *Creativity and Perversion* (1992) explores and expands Freud's 'anal structure of perversion', and the 'regressive and sadistic' impulses which abolished sexual and generational difference (Kernberg 1992: ix). Although some of her insights applied to group psychology and political discourse, the book's main focus was the relationship between pregenitality (i.e. the stage in infant development before the recognition of sexual difference) and creativity.

Following Freud, sublimation is understood as a key aspect of the aesthetic process in which pregenital drives and energies are routed or displaced into less instinctual activities. According to psychoanalytic thinking, all forms of aesthetic and cultural activity are a consequence of sublimation within human ego development (Rycroft 1977: 159–60). As Eagleton puts it, 'men and women go from toying with their faeces to tinkering with trombones' (1990: 264).

The central characteristic of the 'perverse' personality is identification with the mother rather than the ego ideal of the father. As contemporaries of the atypical subject move towards genital maturity, the perverse personality is compelled to re-emphasise the pregenitality of its own drives. This is manifest through defensive mechanisms of self-idealisation, narcissism and fetishism. These various identifications are points within which the perverse personality becomes fixed in its libidinal orientation (Chasseguet-Smirgel 1992: 91).

Chasseguet-Smirgel describes various examples of pregenitality in which extreme narcissism and aberrant compulsions typify the artistic persona. Creating art therefore becomes a form of symbolic displacement through which the artist externalises and re-creates his/her own world. For example, the contorted and objectified mannequins and dolls associated with the Polish-born artist Hans Bellmer (1902–75) have been interpreted as aesthetic objectifications of pregenital drives (Chasseguet-Smirgel 1992: 22–23). These impulses directly reference the ideas associated with the Marquis de Sade (1740–1814):

> The Sadian hero identifies with her [Nature], a cruel and almighty mother, taking over the role of the originator of creation, that of God himself. For this destruction represents the creation of a new dimen-

sion where undifferentiation, confusion and chaos prevail. The Sadian hero actually becomes the grinding machine, the cauldron in which the universe will be dissolved.

(Chasseguet-Smirgel 1992: 5)

Chasseguet-Smirgel's psychoanalytic paradigm suggests how particular character pathologies and Sadian personality formations are externalised through art. For example, the unapologetically coprophiliac imagery of Gilbert & George might suggest 'pregenital dramas of retention, defilement, power and self-becoming' (Taylor 2006: 10; Pooke 2006: 139–59). Similarly, we might consider the transgressive iconography of work by Andres Serrano (b. 1950) and Joel-Peter Witkin (b. 1939), and the explorations of prosthesis and body parts by Cindy Sherman (b. 1954), as symptomatic of wider and more inclusive dimensions of desire and human subjectivity. The subject and iconography of these artists makes apparent some of the psychoanalytic drives just discussed. By contrast, psychoanalytic readings might interpret the highly naturalistic and minutely painted landscapes and glossy portraits of the canon (see Chapter 1) as symptomatic of repressed and denied neurosis.

Sade's ideas have assumed a central significance for psychoanalysis. As a libertarian and atheist, his thinking prefigures the *materialism* and anti-idealism of post-Enlightenment thinkers like Friedrich Nietzsche (1844–1900), Marx and Freud. His concerns with desire, corporeality and human self-creation anticipated the preoccupations of *modern* and postmodern culture. For example, the Surrealist poet Paul Eluard (1895–1952) acknowledged Sade's cultural importance, claiming that he:

wished to give back ... the force of ... primitive instincts and to liberate the amorous imagination from its fixations. He believed that in this way and in this way only would true equality be born.

(Hood and Crowley 1999: 163)

These theorists have closely associated psychoanalytical paradigms with the creative processes of art and the expression of unresolved developmental neuroses. They offer powerful insights into art practices and art historical approaches which are tangential

to the *formalist* and contextual perspectives discussed in earlier chapters.

A FREUDIAN POSTSCRIPT: FROM SYMPTOMS TO SYMBOLS

To coincide with the 150th anniversary of Freud's birth, the Freud Museum in London hosted a small exhibition of work by Tim Noble (b. 1966) and Sue Webster (b. 1967). Curated by James Putnam and titled 'Polymorphous Perverse' (8 November 2006–7 January 2007), its theme arose from Freud's characterisation of infant sexuality as perverse and amoral – tendencies suppressed by socialisation and education. The exhibition featured two works: **Scarlet**, 2006, is a multi-media *installation* based on the artists' actual studio workbench upon which clamp, vice, pliers, mallet and scalpels competed for space with mechanical fornicating dolls, eviscerating motor-operated saws and partial bird carcasses. Using a 'cornucopia of Freudian references', the exhibition text describes:

> a nightmarish wonderland of repressed sexual and sadomasochistic fantasies and transgressions . . . innocent children's playthings have been bastardized into objects of apparent perversion.
>
> (Putnam 2006)

The use of the artists' workbench offered a deliberate parallel to Freud's desk, which was covered with antique figurines and favourite objects (Wood 2006). Through such collected miscellany, Noble and Webster index the conceptual hinterland to their own installation.

Their second piece, **Black Narcissus**, 2006 (**Figure 17**, p. 129), is made from a mass of silicone rubber casts of Webster's fingers and Noble's penis in 'various states of arousal' (Putnam 2006). Placed on a tall plinth, the installation has been sited in Freud's preserved study at the museum. Strategically conceived and positioned, the installation casts a shadow which creates a silhouette of the artists' facial profiles adjacent to the carved bust of the psychoanalyst. This powerful aesthetic and literal inscription might be seen as a metaphor for the legacy of Freudian and post-Freudian paradigms upon contemporary art and art history.

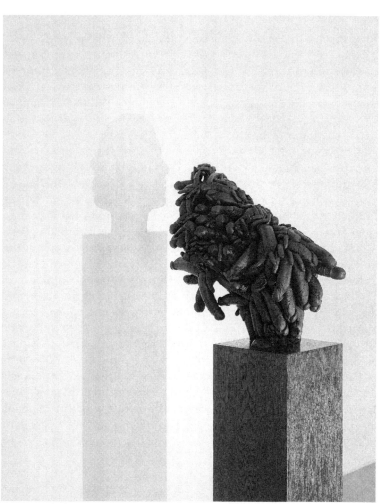

Figure 17 *Black Narcissus*, Tim Noble and Sue Webster, 2006, black silicone rubber, wood, light projector, sculpture 38 × 72 × 60cm, plinth 30.5 × 30.5 × 91.5cm, courtesy of the artists, © the artists.

ART AND ABJECTION

Julia Kristeva (b. 1941) is an influential theorist who has made wide-ranging interventions spanning linguistics, literature, feminism and in more recent decades, psychoanalysis. Kristeva initially came to prominence through the interpretation of work by the Russian social philosopher Mikhail Bakhtin and the emphasis given to his theory of the carnival (Lechte 1994: 141). Using a signature style which is highly poetic and literary, Kristeva has articulated a cogent critique of contemporary rationality, advancing the proposition that art and literature play a key role in the emancipation of human consciousness and subjectivity. She has explored Lacanian theories of the imaginary and the symbolic orders of childhood in order to propose an alternative reading of the psyche. Kristeva has identified a semiotic order which relates to the fundamental feminine maternal nature. Although pre-linguistic, the semiotic order is inscribed within the rhythm, tone and colour of art; it is present, but unrepresentational.

In 1980, Kristeva wrote *Powers of Horror: An Essay on Abjection* in which she explored the meaning and resonance of the abject and the ways in which social instrumentality has attempted to delineate human subjectivity. For Kristeva, the abject is 'a point of ambiguity beyond what can be consciously coped with by either the individual or society' (Lechte 1994: 142). Art may attempt to visualise such ambiguity by exploring and provoking extremities of human response. Although Kristeva frequently uses the immediate example of literature as a 'privileged signifier' to situate her ideas, the idea of the abject transcends genre or *medium* and amounts to a pervasive cultural and psychological condition which society attempts to mask. Kristeva writes:

> all literature is probably a version of the apocalypse that seems to me rooted ... on the fragile border ... where identities (subject/object, etc.) do not exist or only barely so – double, fuzzy, heterogeneous, animal, metamorphosed, altered, abject. ... / ... in these times of dreary crisis, what is the point of emphasizing the horror of being?
>
> (Kristeva 2003)

Characterised in this way, there are parallels with Bakhtin's idea of the carnival which embraces corporeal truths revealed through

sensation and experience, and which concedes the ambivalence and amorality of laughter.

ABJECTION, AMBIVALENCE AND CONTEMPORARY ART

In recent years, ambivalence, *spectacle* and objecthood have become recurrent thematics within postmodern art. For its defenders, a resurgent interest in the body was a long-awaited reaction to Modernism's apparent denial of corporeality and its fetish for a detached aesthetic response to art – the 'disembodied eye'. The changed conditions of art making that appeared in the 1960s and 1970s – performance, land art, minimalism – all implicitly challenged Modernist claims to aesthetic autonomy, variously soliciting an engaged and subjective response from the spectator (Vergine 2000).

If the abject is transformative – that which refuses identity and order – there is much within recent practice which resonates with Kristeva's thinking. The practice of artists as diverse as Vito Acconci (b. 1940), Franko B (b. 1960), the Chapman Brothers, Chris Burden (b. 1946), David Falconer (b. 1967), Eva Hesse (1936–70), Rebecca Horn (b. 1944), Robert Mapplethorpe (1946–89), Tim Noble and Sue Webster, Andres Serrano and Joel-Peter Witkin, variously reference themes and propositions which can be interpreted or made intelligible through psychoanalysis.

Turner Prize nominees Jake (b. 1962) and Dinos Chapman (b. 1966) came to prominence in the early 1990s, creating work which they described as a 'scatological aesthetics for the tired of seeing' (Buck 1997: 71). The Chapmans' reworkings of Goya's **Disasters of War** etchings and a life-sized re-presentation of his **Great Deeds Against the Dead 1 and 2**, 1994, combined the transgressive *iconography* of the original with aestheticised mannequins, suggestive of Disneyland or shopping malls. Their most iconic and technically ambitious piece to date was **Hell**, 1998–2000 – a tableau of nine different landscapes featuring thousands of painted miniature figures in Nazi regalia variously engaged in Sadian acts of torture, dismemberment, crucifixion and decapitation (Holborn 2003: 13–14).

Referring to some of these and similar images featured at the major retrospective of the Chapmans' work, 'Bad Art for Bad People', at the Tate Liverpool in 2006/7, the journalist Anna Blundy

described their subject-matter as 'sex, death and torture ... screaming Freud' (*Newsnight Review*, BBC2, 15 December 2006).

Consider the mixed media installation **Zygotic Acceleration, Biogenetic De-sublimated Libidinal Model (Enlarged × 1,000)**, 1995 (**Figure 18**, p. 133). This installation comprises fused child mannequins with misplaced genitals and orifices, which have been described as 'monstrous hybrids' (http://www.tate.org.uk/liverpool/exhibition/jake anddinoschapman/guide/room1.shtm). The use of child mannequins deliberately references shop merchandise – 'compromised objects' which prompt ambivalent response (Germaine Greer, *Newsnight Review*, BBC2, 15 December 2006). This and similar works have been situated in relation to debates about the sexualisation and commodification of children, experimental genetics, consumer culture and the complicity of the viewing subject. Also directly relevant are Freudian ideas of the uncanny and the displacement and repression of sexual desire. In interview, Jake and Dinos Chapman have described how the powerful oppositions and conjunctions established in their work establish a process of 'physiological oscillation' in which:

> the reading [of the work] never really clearly becomes one or the other; either a conscious rationalisation of an idea or merely an expressionistic discourse.
>
> (Chapman and Chapman 1996)

The Chapmans acknowledge that there are 'no transcendent propositions' within their work. Instead, their iconography frequently references psychoanalytic assumptions and ideas in which 'desire as a representation of power' situates the twin libidinal drives of sadism and masochism (Chapman and Chapman 1996). These themes are frequently mediated through a concern with replication, orders, permutations and a terrifying of the subject through spectacle – subject matter which evokes an amoral and aestheticised Sadian universe. However, the psychoanalytic register of the Chapmans' work also interrogates our presuppositions about moral frameworks, inviting 'self-suspicion' about human drives, motivation and desire.

Externalising traumatic childhood experience has been central to the powerful iconography of ceramic vases made by the 2003 Turner Prize winner Grayson Perry (b. 1960). Interviewed by Melvyn Bragg (*The South Bank Show*, ITV, 17 December 2006), Perry stated

Figure 18 *Zygotic Acceleration, Biogenetic De-sublimated Libidinal Model (Enlarged × 1,000)*, Jake and Dinos Chapman, 1995, mixed media, 58 13/16 × 70 9/16 × 54 14/16in. (150 × 180 × 140cm), courtesy Jay Jopling/White Cube (London), © the artists.

that his creativity derived from 'emotional resonance' and that the experience of psychotherapy had been central to his work.

In the light of these comments, consider Perry's glazed ceramic vase, **Barbaric Splendour**, 2003 (**Figure 28**, p. 209). Seated in the foreground is a dejected and sad-looking child; an entwined couple occupy the middle space and an adult and child walk in the distance. Towards the top of the urn, adjoining a terrace of houses there is an industrial-looking building with what appears to be a brick chimney. Incongruous hoardings advertise 'Holidays of a Life Time' and 'Dream Homes'. The narrative uncertainty is continued on the top of the lid, which features a teddy bear (possibly Perry's much loved childhood teddy Alan Measles?), which is tied to a tree. The disjointed imagery suggests a dream sequence (possibly recalled in therapy?) at a time when Perry was coming to terms with abusive childhood experiences at the hands of his stepfather, and his transvestite coming out as nine-year-old alter ego, Claire (http://www.saatchi-gallery.co.uk/artists/grayson-perry.htm). Perry's now trademark use of highly personal yet compelling iconography on elaborately executed vases and pots might be understood in psychoanalytic terms as a form of personal cartharsis in which repressed memories and experiences are objectified as part of a therapeutic process of memory and healing.

SUMMARY

Freud's study of mental disorders and their physical manifestations provided the foundational theories of psychoanalysis. In exploring the psyche – the mind – of his patients, he identified the unconscious as a repository of repressed, early childhood experiences. Freud defined the Oedipus complex as the time when the child resolved its relationship with its parents and discovered sexual identity. Freud's theory of sublimation recognised that otherwise instinctual energies and drives could be directed into making art and into the realisation of culture more generally.

Klein and Lacan developed Freud's theories further in relation to the differentiation of the individual in childhood. Stokes and Fuller explored the importance of the infant–mother relationship to the creative process. Feminist theorists, however, have criticised the implicit patriarchal bias to Freudian and Lacanian psychoanalytical systems. Irigaray and Cixous

have sought to develop an independent feminine identity, whilst Julia Kristeva has also drawn upon psychoanalytic theory to explore issues of abjection and the nature of the aesthetic. Chasseguet-Smirgel has been concerned with particular character pathologies viewed in relation to Freudian categories.

Many artists, critics and theorists have appropriated aspects of psychoanalytic theory and the implications arising from its use. For example, the work and iconography of the Surrealists, the Chapmans, Grayson Perry, Gilbert & George, Tim Noble and Sue Webster, can variously be evaluated and understood in relation to Freudian and post-Freudian psychoanalytic paradigms. However, one of the central legacies of such ideas has been the extent to which they have interrogated post-Enlightenment assumptions concerning human subjectivity, progress and identity.

FURTHER READING

Introducing Freud by Richard Appignanesi and Oscar Zarate (Duxford, UK, 1979) and *Introducing Lacan* by Darian Leader and Judy Groves (Duxford, UK, 1995) survey the development of psychoanalytic theories, incorporating text with images. Although largely accessible, the complex subject matter takes time and effort to understand.

David MacLagan's *Psychological Aesthetics: Painting, Feeling and Making Sense* (London, 2001) is a useful and generally accessible introduction to psychological aesthetics and how aspects of artistic form can be situated in relation to phenomenology and psychology.

One recent anthology which has explored the legacy of Freudian, Kleinian and Lacanian paradigms for postmodern art is *Sculpture and Psychoanalysis*, edited by Brandon Taylor (Aldershot, UK, 2006). This anthology of essays explores the work of artists such as Barbara Hepworth, Eva Hesse, Rebecca Horn and Gilbert & George, in the context of psychoanalytic insights. The anthology is arranged thematically, with sections on 'modern objects', 'abstraction' and 'installation and performance'.

A useful summary of some key contributors to the psychoanalytic tradition is Jaye Emerling's *Theory for Art History* (New York and London, 2005). *Freud's Art: Psychoanalysis Retold* by Janet Sayers (London, 2007) explores the mutual influence of art and psycho-analysis.

6

SEX AND SEXUALITIES: REPRESENTATIONS OF GENDER

INTRODUCTION

> I think sexuality is a supple as well as a subtle thing . . . I think that in some people some drives can be discouraged and others encouraged; I think some people can choose. I wish I were conscious of being able to. I would choose to be gay.
>
> (Matthew Parris, *The Times*, 5 August 2006)

Have you recently been asked to give your *sex* or *gender* on a form or internet application? Were the choices *male* and *female*? Could you have entered a gender other than the choices given? Have you ever wondered what these questions really mean?

Defining an individual's gender is an important contemporary issue. Ideas of gender – *femininity* and *masculinity* – have been central to art and the exploration of the human form for millennia. However, the binary polarities of man/woman, male/female and *masculine/feminine* are problematic in contemporary society. The experience of transsexuals, gays, bisexuals and cross-dressers suggests that gender and sexual identity can be complex issues. In art the visual features used to characterise sex or gender differ between social and cultural contexts. Since the 1970s, research into

gender representation and meaning has radically changed its visual interpretation. Similarly, contemporary art explores many facets and perspectives of sex, gender and sexuality.

This chapter discusses different representations of the human form in art in order to demonstrate underlying gender differences and relationships. It considers the patriarchal bias of past art and the challenges posed by feminist and postfeminist theorists. It explores the nuances of contemporary interpretations including queer theory and the human body as sensorium and *spectacle*. Last, changing perspectives on gender, sex and sexuality are explored within contemporary art and art history.

WHAT DO WE MEAN BY SEX AND GENDER?

The subtleties of sex, gender and sexuality highlighted in the above quote demonstrate the complexities of the subject. Within art, however, where the human form can be visually manipulated, the issues are further complicated. Initial definitions for these terms are therefore needed to help our discussion.

An individual's sex is traditionally determined by biological and physical attributes (notwithstanding transsexuals' physical transformations) and the categories of sex are male and female.

Gender, on the other hand, provides a looser classification which is socially and culturally determined (Perry 1999: 8–9). The categories of masculine and feminine therefore relate to a range of characteristics which are used to typify gender. These vary across cultures, periods and societies. Since the nineteenth century, in Western society men have largely worn trousers and the portrayal of a trousered figure came to signify masculinity. When women sought the vote in the late nineteenth and early twentieth centuries some adopted clothing which emulated male attire, challenging established social norms and reinforcing their claim to equal suffrage (Tickner 1987). Notably, many public toilets continue to use the *stereotypes* of a trousered or skirted figure to differentiate the intended users.

Sexuality is related to sexual desire and can be most easily understood as how an individual chooses to express and enact their sex or gender. Many contemporary artists explore the expression of sexuality through the realms of performance and spectacle.

FEMINISM AND ART HISTORY

Since the 1970s, feminist art historians have challenged the histor-ical formulations of art history and explored radical approaches to gender in art (Harris 2001: 95–127).

Linda Nochlin's essay, 'Why Have There Been no Great Women Artists?' (1971), and the 1976 exhibition 'Women Artists 1550–1950' at the Los Angeles County Museum of Art, sought to re-evaluate the position of women artists in Western art history and to raise their profile (Sutherland Harris and Nochlin 1977). This was further explored by Germaine Greer's (b. 1939) *The Obstacle Race* (1979). Nochlin's thesis initially went further than simply inserting women artists into the existing Western *canon*, and explored the underlying reasons why women artists had been marginalised. She revealed that art institutions and education excluded women on various grounds, preventing them from devel-oping the required skills and reinforcing the perception that woman artists were inferior to men.

In the 1980s, Rozsika Parker and Griselda Pollock challenged Nochlin's premise that women should simply strive for equal opportunities in art (1981; Pollock 1988). They argued for a more radical challenge and revision of the patriarchal structures which led to the subordination of women. They implicated art as a means of stereotyping gender roles through gendered representations. These characterise *difference* between genders, following the principles of binary oppositions discussed in Chapter 4, in which the unmarked and marked pairings are male/female, masculine/feminine. The female is always constructed as the male's opposite; in other words defined by the terms of the dominant patriarchal system.

Rooted in Parker and Pollock's propositions, subsequent feminist theorists have explored broader issues of feminine identity as well as the specific involvement of art within patriarchal and femi-nine economies. Building on the idea of difference, Whitney Davis proposed the idea that gendered characteristics, such as body shape, costume or stance, might be used to imply gender identity. Davis used the term 'agreement' to describe this phenomenon (1996: 220–33).

Gender studies have also looked beyond the details of the art work to consider the relationship between image, creator and

viewer. Laura Mulvey explored the involvement of the *gaze* in visual gender relationships (Mulvey 1989 [1975]). The interactions of the separate gaze of the viewer, subject and artist have also been analysed. A work is no longer independent of the viewer, but is understood in the context of the viewer's visual experience (Olin 1996: 208–19).

CLASSICAL REPRESENTATION OF THE HUMAN FORM

Representation of the human form within the Western canon has roots in *Classical* Greece (*c.* fifth century BCE). Male nakedness was inherent to the values of the *classical* world and was closely linked with the heroic or divine ideal (Spivey 1996: 111–16). For example, the naked male appeared in representations of sparring gods, athletes, heroes who died in battle, the 'symposion' (a largely male social gathering) and the sexual antics of highly stimulated centaurs. The naked female goddess came to notorious prominence in the fourth century BCE with Praxiteles' *nude **Aphrodite of Knidos***. Commentators have linked naked female representations with voyeurism, claiming they are nudes (Spivey 1996: 173–86). However, representations of the goddess of love bathing present an alluring image and point to a developing fascination with female beauty.

Roman society *appropriated* many Greek artistic traditions, with works illustrating the diversity of gender roles and sexuality within the classical world (Clarke 1998: 7–12). Couplings between older men and male youths, for example, were represented in paintings, pots and metalwork, typified by scenes on the **Warren Cup** (mid-first century CE, British Museum, London).

The sculpture **Sleeping Hermaphrodite** (Roman copy of *c.*150 BCE original, mattress by G. L. Bernini, 1620, Louvre, Paris), depicted with breasts and male genitalia, highlights the ambiguities of gender in classical society (Beard and Henderson 2001: 132–39). Study of the classical period shows that gender and sexuality have been a preoccupation of artists and patrons for millennia.

Art from the *Renaissance* onwards responded to these classical forms. With the rise of humanism in the fifteenth and sixteenth centuries, rediscovered classical works were highly prized and

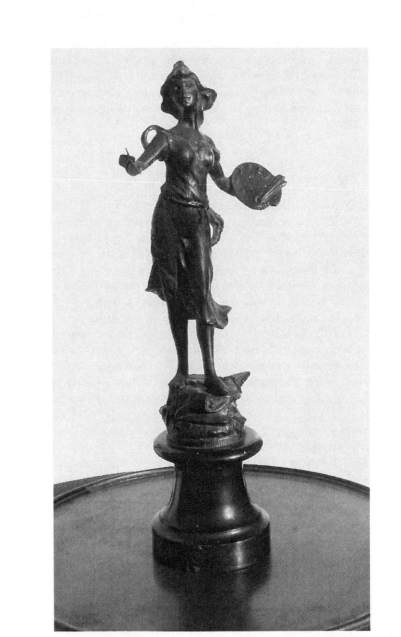

Figure 19 *Muse of Painting*, artist unknown, c.1930, 32.5cm including plinth (private collection), © photograph Diana Newall.

imitated. The pursuit of anatomical accuracy in representing the human body inspired artists like Michelangelo and Gian Lorenzo Bernini (1598–1680) (Beard and Henderson 2001: 85–87, 113).

In looking at these works it is useful to keep in mind the classical heritage of the Western canon. As noted in Chapter 1, the academic discipline of art history was also closely associated with the classical cultural ideal from its early stages. Even in the early twentieth century, despite moves towards *abstraction*, idealised representations of the human form were still widespread. For example, consider **Muse of Painting**, early twentieth century (**Figure 19**, p. 140). Contemporary artists who also actively respond to classical forms include Lucien Freud (b. 1922), Anthony Gormley (b. 1950) and Marc Quinn (b. 1964). The contemporary painting *An Enduring Offering*, 2005 (**Figure 25**, p. 187), by Jago Max Williams (b. 1972) illustrates the continuing importance of the classical heritage of representing the human form.

VISUALISING GENDER DIFFERENCE

The relationship between representations of females and males in art from the Western canon reveals the mechanisms of gender difference. These mechanisms are multi-layered. At the basic level are visual signifiers, such as genitalia and breasts, and more complex features such as dress differentiate gender. Beyond these, more subtle features such as stance, tone, compositional relationship, opposed dress (clothed vs. naked, armoured vs. un-armoured), and many other attributes, have traditionally characterised gender. At a psychological level these characteristics invoke value judgements which separate and oppose genders. The binary oppositions of male/female are therefore matched by binary values – for example, aggressive/submissive, rational/intuitive, hard/soft, high art/crafts, powerful/weak – which can be identified in works of art. The semiotic concept and implications of binary oppositions are discussed in Chapter 4.

Consider **Adam and Eve**, 1526 (**Figure 20**, p. 142), by Cranach. This panel painting shows Eve offering the apple to Adam surrounded by the animals in the Garden of Eden. The figures have different physical attributes – Eve's breasts and flowing hair and Adam's broad shoulders and beard – but foliage conceals their genitalia. The

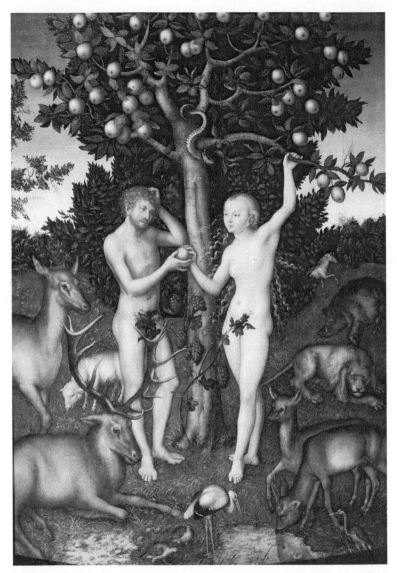

Figure 20 *Adam and Eve*, Lucas Cranach I, 1526, oil on panel, 117 × 80cm, © Courtauld
Institute of Art, London.

stag's antlers surrounding Adam's crotch, however, signify his genitalia and affirm his masculinity.

According to customary Biblical readings, Eve seduced Adam into eating the forbidden fruit, and was therefore complicit in the 'fall of humankind' (Genesis 3: 1–7). Eve's stance alludes to her seduction of Adam, whilst his uncertainty is suggested by the inclination of his head and raised arm. Beyond the basic gender characteristics the image alludes to Eve – the female – as the sinner-seducer and Adam as the innocent seduced. This follows historical Christian metaphors associating feminine with temptation, weakness and evil, and masculine with the moral high ground of innocence and goodness.

Representations of Eve offer one viewpoint on the feminine persona which is contrasted to the Virgin Mary in medieval and Renaissance imagery. Whereas Eve brought sin into the world, Mary brought redemption (Hall 2000: 5). Images of the Virgin Mary, the Mother of Christ, traditionally present the feminine attributes as humility, gentleness, chastity, mercy and maternal love (Warner 1976).

GENDER, STATUS AND POWER

Religious imagery was one context in which gender differences were visually expressed in the Western canon. The *genre* of historical or mythological painting demonstrates further aspects of gender difference. Chapter 3 explored some of the contextual references of the painting **Oath of the Horatii**, 1784 (**Figure 12**, p. 63), by David. Its representation of gender difference reveals inherent power relationships.

David's *composition* divides along the boundary between men and women. The active, masculine oath-takers on the left are separated from the passive women on the right. In the Roman legend, the Horatii and the Curiatii brothers were chosen as civic champions of Rome and Alba, but the women in the painting represent both families. The two women in the foreground are each sister to one family and wife or betrothed to the other. The older woman comforting the grandchildren is mother to the Horatii.

The figures in the painting conform to the legend but contrasting stance, physique, dress, colour and tone reinforce gender pairings and oppositions:

Masculine	Feminine
Rigorous	Languid
Striving	Defeated
Muscular	Limp
Tanned	Pale
Strong	Weak
Powerful	Powerless
Hard	Soft
Polychrome	Monochrome
Vivid	Muted
Bright	Dull

The illumination of the sisters indicates their importance in the overall narrative and strengthens the gender difference dynamic. Their attributes, however, stress a subordinate, supporting role – their subordinate, supporting gender (Nochlin 1989: 3–4).

In David's work the gender difference places the power with the masculine figures, characterising the power dynamic of the male/female roles within patriarchal society.

CHALLENGES TO GENDER BOUNDARIES

For a different example, consider **Mrs Fiske Warren (Gretchen Osgood) and Her Daughter Rachel**, 1903 (**Figure 21**, p. 145) by John Singer Sargent. The genre of portraiture has specific characteristics which centre on the patron's needs – in this case Fiske Warren, husband and father to the sitters. Sargent painted portraits for the highest echelons of society in Britain and America. The subjects (or objects) of this work – the wife and daughter of a wealthy American businessman – are dressed in rich gowns and surrounded by luxurious furnishings. Although this work does not contain the husband, he is present through his patronage and as one of the intended viewers of the work. His elided presence provides the contrast to evaluate

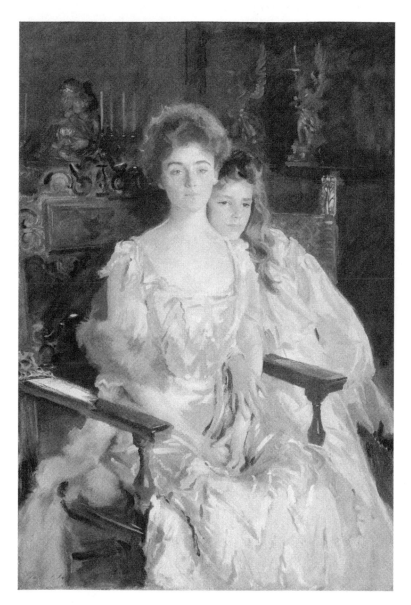

Figure 21 *Mrs Fiske Warren (Gretchen Osgood) and Her Daughter Rachel,* John Singer Sargent, 1903, oil on canvas, 152.4 × 102.55cm, Museum of Fine Arts, Boston, gift of Mrs Rachel Warren Barton and Emily L. Ainsley Fund, photograph © 2006, Museum of Fine Arts, Boston.

gender difference – viewer/viewed, owner/owned, free/constrained, subject/object – in addition to the manifestations of his wealth throughout the work. His wife's pensive expression implies acceptance of her role, whilst the daughter's faraway look suggests thoughts of a similar future. A further group of viewers might be implied – the husband's male peer group. As with the husband, these elided viewers strengthen the objectification of his wife as possession and trophy.

This reading of the image develops the idea of the gender roles within patriarchal society. It introduces the gaze of the male viewer, illustrating how it is involved in defining gender difference. There is, however, a different reading of this work. The direct gaze of the wife engages the viewer and challenges her traditional role of dutiful wife and mother. It might be engaging with the gaze of a different, possibly female viewer. Although it does not break the patriarchal structure, it suggests awareness that gender roles were changing at the beginning of the twentieth century (Prettejohn 1998: 9, 55–58).

Today, this work is titled **Mrs Fiske Warren (Gretchen Osgood) and Her Daughter Rachel**, acknowledging the wife's separate identity, independent of her husband (Ratcliff 1982: 157–79). It is also notable that Gretchen Warren, née Osgood, was an intellectual who wrote poetry, and studied philosophy and metaphysics at Oxford University, England, in 1904 (Ormond and Kilmurray 2003: no. 445).

VIEWING THE NUDE

Central to critical consideration of gender in the Western canon is the nude. The term implies a special status for the art form and signifies a difference between nakedness and nudity. Naked refers to the absence of clothing, literally the physical state of undress, whereas nude is a cultural category in which the body is an object of the gaze (Berger 1972: 47–64).

Why does the nude have special status in the Western canon (see for example Kenneth Clark's *The Nude: A Study of Ideal Art*, 1956)? In fact why do we say *the nude*, not just *a* nude or nude? A search on the British Library catalogue shows that at least 230 books have been written on the subject since the 1940s. The nude is obviously something special, but why? Why should painting the naked human body be so significant? We do not have a category of art called 'clothed' (a search on 'clothed' produces two entries!).

Consider the painting *An Allegory with Venus and Cupid*, c.1540–50 (**Figure 15**, p. 91), by Bronzino. This work contains several naked figures performing different roles in the composition. The central figure of Venus is presented as an object of love and desire positioned between allegorical figures representing pleasure and suffering. Cupid titillates and kisses Venus whilst she exposes her body to the viewer's gaze. She is the central object of the viewer's attention but her lack of pubic hair and pudenda distances her from the viewer – this is about erotic fantasy, not physical reality.

The gender difference in the work is ambiguous. Venus has breasts to signify her femininity but the smooth, rounded, paleness of her body, though typically characteristic of the feminine, is not very different from the other nude figures in the image. Cupid is depicted as youthful but his genitalia are hidden. Conversely, the boy with the roses has male genitalia but otherwise is plump and androgynous. The only obviously male figure in the composition is a balding Father Time with his muscular arm and bearded face. The obviously female figure is the girl to the right deceptively offering pleasure but hiding a monster beneath her skirts.

The work was probably a diplomatic gift from Duke Cosimo I de' Medici of Florence to Francis I of France and therefore intended for the male gaze (Berger 1972: 54–55). The figure of Venus might reflect contemporary ideals of feminine beauty and the embrace of Cupid is clearly sexually stimulating. The ambiguity of gender may also be designed to arouse the viewer. The different elements, however, contrast the pleasures *and* the dangers of sexual desire. Like the Cranach, it stigmatises the feminine as dangerous but irresistible; objectified yet stimulating. This further develops the gender oppositions and differences:

Male	*Female*
Seduced	Seducer
Viewer	Object
Detached	Engaged
Audience	Performer

The very ambiguity of the image reflects male anxieties concerning women. This is not simply a fantasy of feminine beauty and sexual arousal; it recognises the inherent tensions within the male–female relationship. Although ultimately this is a masculine viewpoint, it acknowledges and situates the active role of the feminine in the context of masculine judgement. Some of the psychological dimensions of gender and sexuality have been discussed in Chapter 5. In Camille Paglia's (b. 1947) analysis of Sandro Botticelli's (1445–1510) paintings of Venus she perceives the 'Apollonian identity' of the androgynous Venus in **The Birth of Venus**, 1485, and 'an unsettling *fusion* of Renaissance personae' in **Primavera**, 1478 (1990: 149–53). These characterisations are echoed in **Allegory**, where nothing is quite what it seems and the sexual tension is achieved between the displayed and the hidden; the controlled and the abandoned; the Apollonian and the Dionysian.

THE GAZE AND 'THE PLEASURE OF LOOKING'

The concept of how the gaze is instrumental in constructing gender values in general and supporting patriarchy in particular was first proposed by Laura Mulvey (1989 [1975]). She discussed how representations of men and women in film could be analysed in relation to Freudian theory and *psychoanalysis*. She identified relationships between roles played in narrative fiction films (primarily produced by Hollywood in the 1930s–1950s) and the pleasures experienced by the male viewer. She argued that these pleasures related directly to the construction of the male psyche, as understood by Freud. Not only did they reinforce patriarchal society, but they also underlined the patriarchal bias of Freudian psychoanalytical structures.

Mulvey linked the pleasure gained from the male gaze to three inter-related elements. First, the woman's objectification in the gaze of the male characters and audience stimulates the pleasure of erotic fantasy. Second, the male viewer's identification with the leading male protagonist links to a stage in the development of the *ego*, identified by Lacan as the point when the child first sees himself in the mirror – the mirror phase. This stage creates misrecognition in the child's mind between his actual self and how he sees himself – the ego ideal – which will be relevant in his future identification with

others. Through this mechanism the male viewer experiences the power of the male protagonist.

The third pleasure builds on the first two elements by allowing the male viewer, through the sadistic power of the protagonist, to subdue and punish the threat symbolised by the female's lack of a penis – symbolic of castration. To avoid this anxiety the female figure is turned into a *fetish* or *fetish object*. Each of these strategies places the female in a position in which she has no control or agency.

CAUGHT IN THE ACT: SUBVERTING THE PLEASURE OF THE GAZE

Margaret Olin explored the theory of the male gaze further in relation to art (1996). She proposed that such pleasure can be subverted if the viewer becomes aware of the manipulation inherent in the visual structures, or if the sadistic power of the viewer's gaze is exposed. She explored the power of the gaze in other contexts, such as the power of Hitler's gaze and the involvement of the gaze in power relations such as class. She also noted how the development of *single point perspective* strengthened the power of the viewer's gaze and how perspectival fragmentation undermined it.

We can revisit the art works discussed so far in relation to this more complex interpretation of the gaze and its involvement in the power dynamics of gender. Considering the Cranach, the highlighting of the male genitals reinforces the female's lack of a penis and strengthens the negative connotations of the gender difference. David's work also draws heavily on the association of the active brothers with the viewer's gaze, reinforcing the symbolic meaning of the subject. With the works by Bronzino and Sargent, the female figures are clearly being objectified and fetishised, although the direct gaze of the wife in the latter painting does partially subvert the pleasure of the male viewer's gaze.

MANET'S CHALLENGE TO THE MALE GAZE

In the mid-nineteenth century the French artist Manet challenged the assumptions of conventional illusionistic picture making (see Chapter 2). For example, **Olympia**, 1863, drew on earlier paintings

by Titian and Ingres but introduced a contemporary *realism* in its approach to subject matter. In *Olympia*, instead of the ideal fantasy of the nude Venus, Manet depicts a contemporary courtesan's 'consumable body' (Fer 1993: 21–30; Brettell 1999: 133–36).

Consider also *A Bar at the Folies-Bergère*, 1882 (**Figure 22**, p. 151). The painting depicts a young woman behind the bar of a popular Parisian music hall with the crowd and entertainment reflected in the mirror behind her. She sells drinks and oranges to the crowd and her male customer is reflected in the mirror to her left. The distortions to the reflection, especially the omission of the customer in front of the bar, were criticised at the time but serve to place the focus and the gaze onto the woman. Some contemporary critics interpreted the reflected couple's close conversation as alluding to prostitution, a known sideline of bar women at the Folies-Bergère. The woman's fashionable presenta- tion and detached expression are interpreted by Clark as placing her among the consumables on offer at the bar – an object for sale (Clark 1984: 239–55).

FEMINIST ART

Since the emergence of feminist perspectives on art and art history, women artists have responded with new approaches. Rejecting patriarchal artistic values, artists have sought a new feminine artistic language and value system centred on uniquely female characteristics such as the vagina, maternity or mother- hood. One example of this is Georgia O'Keeffe (1887–1986), who uses flower forms to represent and imitate female pudenda (Lynes 1999).

Another work, *The Dinner Party*, 1979, by Judy Chicago (b. 1939), presented a triangular dinner table with place settings for thirty-nine women from history, with finely embroidered runners and ornate plates symbolising the female genitalia. The names of a further 999 women were inscribed on the ceramic floor (Chicago 1999: 8–15). Chicago's work offered an alternative visual language, for example using the triangle (symbolic of the clitoris) instead of the traditional square. It included art forms traditionally the province of woman, such as embroidery, and celebrated women's achievements.

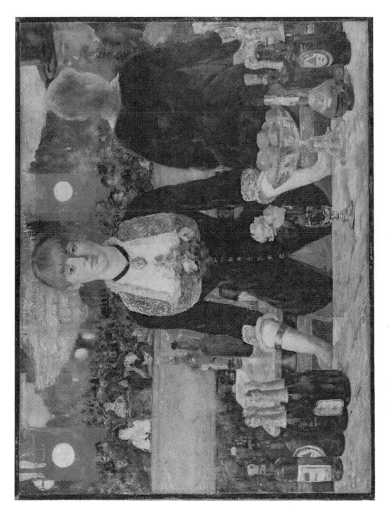

Figure 22 A Bar at the Folies-Bergère. Édouard Manet, 1882, oil on canvas, 96 × 130cm, © The Samuel Courtauld Trust, Courtauld Institute of Art, London.

Also of note is *Post Partum Document*, 1973–79, by Mary Kelly
(b. 1941) in which she chronicled the first six years after the birth
of her son with words and objects, such as soiled nappies and a cata-
logue of the baby's feeds (Crimp and Kelly 1997: 15–18). Kelly
sought to explore the feminine arena in relation to motherhood by
revealing the intimate details of her son's development and her
involvement in it. Again, traditional patriarchal art forms and
conventions were rejected.

Barbara Kruger's *We Don't Need Another Hero*, 1987 (**Figure
16**, p. 107), provides another challenge to the patriarchal construct
of the male as hero. Using imagery from the 1950s, it goes
further, questioning the value system which advocates heroism
and propagates the systems of masculine aggression inherent in
society.

EXPANDING FEMINISM: MARXISM, SEMIOTICS AND PSYCHOANALYSIS

In recent decades feminist scholars have explored a range of ideas
from the extremes of a politicised, utopian feminine programme to
the pursuit of basic legal and economic equalities. In these develop-
ments feminist theorists have drawn on Marxism, psychoanalysis,
semiotics, structuralism and poststructuralism to explore issues and
to further alternative understandings of gender identity and its
social dynamic.

In March 1968, a group of French feminists called 'Politique et
psychanalyse' (later known as 'Po et psych') marched with placards
which read 'Down with feminism'. This has been taken to signal the
beginning of postfeminism; these protesters were rejecting the
prevailing direction of feminism towards equality, which they saw
as assimilation into the patriarchal order. They supported difference
and wanted to endorse and promote the value of the feminine
(Phoca and Wright 1999: 3–14).

POSTFEMINISM

Postfeminism encompasses a wide range of theories, sometimes
contradictory, which arose from and went beyond feminism. It is
perhaps unrealistic to define a boundary between feminism and

postfeminism; rather the latter should be viewed as a radically questioning and polemical development of feminist theory. If feminism sought equality and feminist art historians developed feminine perspectives on art, postfeminist theorists developed new theories for situating the feminine.

Since the 1968 protest, and arising from the Po et psych group, French feminists have sought to define an alternative female and feminine identity independent of patriarchal constructs. They built on psychoanalytical theories, developed first by Freud and adapted by Lacan (see Chapter 5), and the poststructuralist approach proposed by Derrida (see Chapter 4). Successive feminist theorists have adapted and challenged ideas of how the feminine is constructed. Four scholars in particular have developed theories which are relevant to art – Irigaray and Cixous, Kristeva and Paglia.

As outlined in Chapter 5, Irigaray and Cixous challenged the patriarchal constructs inherent in Freudian and Lacanian psychoanalytical theory in order to reveal and promote the positive sexual identity of the feminine and maternal. Cixous also developed the revolutionary potential of the feminine with 'écriture féminine' (feminine writing) to break the dependency of the feminine on the masculine underlying Freudian psychoanalytical theory (see for example Cixous 2001 [1975]; Sellers 1996).

Julia Kristeva criticised feminism for seeking equality within existing patriarchal constructs. She reworked Lacan's psychoanalytical construction of identity. Lacan's imaginary and symbolic orders were stages in the development of the psyche separated by the mirror stage. The imaginary existed before the child recognised difference and the symbolic order. The symbolic repressed the imaginary and was linked to Freud's Oedipus complex and the recognition of the phallus. Kristeva proposed that the symbolic order was maternal; she termed it the semiotic order. This order was destabilising and therefore repressed by the symbolic paternal order after the mirror stage established separate identity. Kristeva characterised the semiotic as able to acknowledge the existence of both the one and the other, whereas the symbolic had to choose between them. She argued that cultural taboos concerning bodily functions developed to support the repression of the semiotic. The semiotic was associated with chaos, the

unclean or abject, whereas the symbolic was controlled and clean (McAfee 2003).

Following a different direction, Paglia believed in the *essentialist* view which situated a natural and biological difference between male and female. She argued that second-wave feminism, that of Pollock and Parker, was 'victim feminism' and that sex and nature were 'pagan forces' which manifest themselves in art through Western culture. In her groundbreaking book, *Sexual Personae*, she explored the fundamentally sexual, erotic, amoral and pornographic drives within Western culture (1990).

CONTEMPORARY ART HISTORY AND FEMINISM

Feminist art historians have continued to explore and reassess the work of women artists, representations of women in art and feminist interpretations of art in the context of these developing feminist theories. Recent feminist interpretations of art history include Jo Anna Isaak on contemporary art (1996), Mira Schor offering a controversial voice on essentialism, feminism and painting (1997) and Norma Broude and Mary Garrard exploring feminist art history in America in the 1970s (1994).

Studies of specific women artists from the Western canon include Mieke Bal (2005) on Artemisia Gentileschi (1593–1653). Deborah Cherry explores feminist perspectives on the art in Britain 1850–1900 across a wide range of art practices during the early period of women's struggle for equality (2000). Other studies consider women artists from specific countries including, for example, Arab women's art (Lloyd 1999), post-Soviet Russia, Estonia and Latvia by Renee Baigell and Matthew Baigell (2001), Latin America and the Caribbean by Eli Bartra (2003), and Ireland by Katy Deepwell (2004). Representation of women in art also continues to be explored, for example by Lynda Nead (1992), Marianne Thesander (1997) and Linda Nochlin (2006).

To illustrate the breadth of the subject, the last decade has seen a number of extensive text anthologies and surveys of feminist thinking on art and art theory. These include works edited by Katy Deepwell (1998), Hilary Robinson (2001), Helena Reckitt and Peggy Phelan (2001), Amelia Jones (2003), Norma Broude and Mary Garrard (2005) and Carol Armstrong and Catherine De Zegher (2006).

'FEMINISMS AND ART THEORY': MARSHA MESKIMMON (2002)

Meskimmon's analysis of art theory and feminisms summarises the subject's contemporary diversity. She highlights the centrality of the body to debates and the challenges of the subject/object relationship, as well as stressing the *postcolonial* context of feminist art practices. A concluding paragraph offers a positive future:

> ... reconceptions of subjectivity, agency and history ... do not efface or marginalize difference in favour of orthodox truths, exclusive canonical value-judgements or single narratives of historical agency. Feminist theory is instead about pleasure, collectivity and convergence, about meanings produced through processes between subject and dialogues which sustain diversity.

GENDER PERSPECTIVES ON CONTEMPORARY ART

Contemporary artists explore gender and the feminist agenda n diverse ways. The Guerrilla Girls advertise themselves as 'femini t masked avengers' exposing 'sexism, racism and corruption i politics, art, film and pop culture' (see their website, http://www guerrillagirls.com). Founded in 1995, these anonymous artists wear guerrilla masks in public and present art works, often in poster, photographic or *performance art* forms, which directly question and challenge traditional 'white male' values in art practice and display.

Dana Schutz (b. 1976) engages with the complex relationship between viewer, model and artist with a male model in her **Frank** series (2001–2) (http://www.saatchi-gallery.co.uk/artists/dana_schutz.htm). Repeatedly painting **Frank** in the desert in different poses and guises, Schutz manipulates her subject (or object) in a dynamic which contrasts with the traditional gender dynamics we have explored so far in this chapter. Marlene Dumas and Grayson Perry explore gender issues in images of children in contemporary society engaging with, for example, 'the corruption of innocence' and 'child abuse' (http://www.saatchi-gallery.co.uk/artists/marlene_dumas.htm and http://www.saatchi-gallery.co.uk/artists/grayson_ perry.htm).

Contemporary representations of the body challenge assumptions and conceptions of the historical nude, highlighting recent debates on gender. Jenny Saville's (b. 1970) painting *Passage*, 2004 (oil on canvas, 336 × 290cm, Saatchi Gallery, London, http://www.saatchi-gallery.co.uk/artists/jenny_saville.htm), shows a transvestite with male genitalia and prominent (enhanced) breasts. Saville specifically sought to explore 'the idea of floating gender' in this work (Schama and Saville 2005).

Can we call *Passage* a nude? Saville's model overtly displays her physical attributes to the viewer, so the work could be characterised as a nude. However, the nature of the subject provides a completely different perspective on gender difference and gender structures. There is little to suggest it has been painted for a specific gendered gaze – this means not only the male or female gaze but also that of any particular variation between these polarities. The transsexual body denies traditional visual markers of gender difference and challenges the binary oppositions inscribed within them. The work is not expressing gender difference but exploring gender instability itself.

The pose and display in *Passage* are comparable to Saville's paintings of headless animal carcases, such as *Torso 2*, 2004 (oil on canvas, 360 × 294cm, Saatchi Gallery, London). With these works Saville is also questioning the elevation of the human body to a special status in art, problematising conventional readings of the nude.

FEMINISM AND POSTMODERNISM

Postmodernity introduced new challenges for feminism in the 1970s (see Chapter 7). Lyotard announced the end of the grand narrative – of which feminism was one – and feminists have had to find ways to continue pursuing feminist agendas within this new theoretical landscape. On the one hand, the pluralism of postmodernism allows for the pursuit of equality and diversity but, on the other, feminism's own grand narrative has been challenged (Phoca and Wright 1999: 85–89). The concept of postfeminism has also been criticised for the implication that feminism has ended: Amelia Jones has described it as 'remasculinisation' (Jones 2001 [1990]: 496–506).

Another strand of feminist thought has focused on lesbianism. Various scholars have sought to locate homosexuality within feminist

theory, exploring the significance of female same-sex sex in ideas of sexuality and pornography (Phoca and Wright 1999: 100–3).

Since the 1990s some contemporary women have lost interest in feminism, seeing it as restrictive and prescriptive. Although feminists would argue that there was still much inequality and sexism in both Western and *non-Western* societies, others have moved beyond these concerns. The role of women in affluent Western societies now challenges male dominance, leading to what has been termed a crisis for male identity (Perry 2006a).

NEW PARADIGMS OF GENDER, SEX AND SEXUALITY

Contemporary theory has begun to explore flexible and non-restrictive paradigms for gender, sexuality and sex. Anxieties about the direction of some feminist thought led Judith Butler (b. 1956) to write *Gender Trouble* (1990), in which she articulated the issue:

> It seemed to me . . . that feminism ought to be careful not to idealize certain expressions of gender that, in turn, produce new forms of hierarchy and exclusions.
>
> (Butler 1999 [1990]: viii)

Building on poststructuralist theory, contemporary debates in cultural studies and American and French traditions of feminist thought, Butler explored interdependencies in the construction of sex, gender, sexual identity and the body, problematising the idea that 'gender is the cultural interpretation of sex' (Butler 1999 [1990]: 11). The conception of gender and sex paradigms discussed so far in this chapter assumes the essential, biological nature of the sex of an individual. Additionally, feminists such as Irigaray have proposed an essential feminine nature in opposition to the dominance of traditional masculine gender constructs. Butler questioned these assumptions, first in Lévi-Strauss' theory of incest taboo and homophobia in the construction of gender identity, and second in Lacanian 'subject formation'. Referencing Joan Riviere's (1883–1962) 'Womanliness as Masquerade' (1986) and Freud's thesis on loss of a loved one, she identified ambiguities in the stability of gender and sex identity (Butler 1999 [1990]: 3–100; Kirby 2006: 19–36). Her aim was to explore the foundations of 'heterosexist fundamentalism' in order to:

acknowledge the complex forces that render *any* identity inherently unstable.

(Kirby 2006: 19–20)

The last section of *Gender Trouble*, 'Subversive bodily acts', explored the concept of performativity. The aim was to unravel the theories which explain the creations of a heterosexual power dynamic (masculine or feminine) which marginalise gay and divergent sexual identities. A constant referent was the actual experiences of those whose sexual identity has been marginalised. Kristeva's conception of the semiotic order (see Chapter 5) and Foucault's *History of Sexuality* (1980a) are used to discuss the roots of the culture/nature dynamic, which determine sex, gender, sexual desire and the body.

THE HERMAPHRODITE BODY

Central to the question of gender and sex construction is Foucault's consideration of the life of Herculine Barbin, born in France in 1838 with both small female and male genitalia. Notable was Barbin's experience of living first as a woman and then being re-designated as male by legal authority and how her/his sexual identity might be interpreted (Foucault 1980c; Butler 1999 [1990]: 101–41; Kirby 2006: 36–42). In order to explain the construction of sex identity in this situation, Butler suggests that 'words, acts, gestures and desires' construct, as it were, a virtual body matching the actual body. The term performativity describes how these 'enactments' fabricate and regulate the sex and gender identity within the context of the proscribing discourses of gender (Butler 1999 [1990]: 173; Spargo 1999: 74–75).

These studies fundamentally question the nature/culture distinction generally perceived between sex as physically defined and gender as culturally constructed and the characterisation of the body. Monique Wittig challenges the sex/gender distinction, arguing that both sex and gender are culturally determined (Wittig and Butler in Butler 1999 [1990]: 141–90). Performativity of sex and gender identity is dependent on language. Rather than a clear framework in which an 'essential' sexual identity is either repressed (homosexual, cross-dressing or transsexual) or sanctioned (heterosexual) by the normative power of social structures, a more complex dynamic

exists between cultural 'reference points', the body and sexual performativity. The creation of sexual identity results from repeated actions, which cement the signification of its components – sex, gender and the body (Kirby 2006: 42–47).

The conclusion of *Gender Trouble* states:

> The deconstruction of identity is not the deconstruction of politics; rather, it establishes as political the very terms through which identity is articulated.
>
> (Butler 1999 [1990]: 189)

In *Bodies that Matter: On the Discursive Limits of "Sex"* (1993) Butler further explores the construction of the gendered body. A cultural conception of the body is proposed whilst some natural 'facts' – for example 'birth, aging, illness and death' – and 'minor' physical differences are acknowledged (Butler in Kirby 2006: 66). Theories which frame the body and gender identity in Freudian and Lacanian psychoanalytical structures; Slavoj Žižek's (b. 1949) study of the way language works; and Derridean semiotics are referenced to continually challenge the binary constructs of nature/culture, body(matter)/identity(sign) (Kirby 2006: 48–85). Most recently in *Undoing Gender* (2004), Butler has looked again at gender identity and sexuality in the context of new developments related to transgender, transsexuality, intersex and the emergence of queer theory. In this study she considers gender norms and normative power (Kirby 2006: 123–28).

QUEER THEORY

Some feminist activists perceive Butler's work as undermining their struggle, but gender instability is central to *queer theory*. Queer theory emerged in the 1990s as a development of gay and lesbian studies. Annamarie Jagose describes queer as 'less an identity than a *critique* of identity'. She suggests queer is an identity with potential for the future in formulating flexible and non-normative constructs of identity (Jagose 1996). Phoca and Wright summarise queer as not only challenging the binary oppositions characteristic of feminist debates, but as rejecting claims that there are any deviant 'sexual configurations' at all (1999: 104–7). Explorations of ambiguities in

biological determinations of sex and considerations of *hermaphrodite* bodies have also blurred gender essentialism (Dreger 1998).

The development of gay and lesbian studies in relationship to art history initially followed the feminist path by searching for homosexual artists in the Western canon. Most notable perhaps is the argument that Michelangelo was gay (see for example Crompton 2003: 262–75).

In contemporary art, the issues of gender identity and its ambiguities have been explored by many artists. We have seen Jenny Saville's representation of a trans-gender figure in **Passage**, 2004, and similar ambiguous representations of the hermaphrodite body are explored in the photographs of Witkin. In the Chapman brothers' **Zygotic Acceleration, Biogenetic De-sublimated Libidinal Model (Enlarged × 1,000)**, 1995 (**Figure 18**, p. 133), the non-gendered body is replicated in the context of a consumer society.

BEYOND GENDER: THE BODY AS SENSORIUM AND SPECTACLE

Consideration of the formulation of the body and the framing of its senses is echoed by other contemporary artists. Quinn's series of DNA and urine portraits directly address ideas of the body and identity as being made of its biological constituents. The performance artist Orlan (b. 1947) subjects her own body to cosmetic surgery to present 'carnal art' in which she explores concepts of contemporary beauty through the latest technologies (Spindlow 2003).

As an alternative to the artist's expression of their own bodily experience, the Carsten Höller (b. 1961) slide installation (Unilever Series, Turbine Hall, Tate Modern, 2006–7) offers the participant an experience which challenges the senses. Described by the French writer Roger Caillois as a 'voluptuous panic upon an otherwise lucid mind', the installation is part-sculpture, part-funfare slide (http://www.tate.org.uk/modern/exhibitions/carstenholler/default.shtm).

The commodification of the body, associated with fashion, advertising and the cult of celebrity, provides another contemporary context for art. Set against the concept of the male gaze, however, these developments might be seen as extensions of the objectification and fetishisation of the body discussed earlier. The objectification of the male body and the realms of the female, homosexual or

deviant gaze offer new perspectives on this subject. Cindy Sherman creates photographic representations of herself, mannequins and prosthetic objects, to challenge normative perceptions of the body (Galassi and Sherman 2003). Mapplethorpe's photographs also objectify male bodies (http://www.mapplethorpe.org).

The work of Gunther von Hagens (b. 1945) in *Bodyworlds* might also be considered here. The televising of autopsies and the plasticising of the physical remains of human bodies for display is taking concepts of objectification, fetish and spectacle beyond gender and sexuality. His work can be considered as an alternative subversion of visual concepts of gender and sex (http://www.bodyworlds.com/index.html).

POSTFEMINISM AND POSTCOLONIALISM

Gender studies – incorporating all perspectives on gender identity, sexuality and sex – have most recently been allied to broader considerations of other markers of difference in society. Issues of race, class and economic subjugations overlap with gender considerations to the extent that they cannot be studied in isolation. This interconnection is considered in detail in Chapter 8 within the framework of postcolonial studies. More broadly, an advertised strand of the AAH (Association of Art Historians) Annual Conference 2006, continued the interrogation of gender as a central issue in contemporary art history.

SUMMARY

Developments in gender studies since the 1970s have changed the way past art is interpreted. Feminist art historians have reinterpreted woman artists and explored the differences in male and female representations revealing underlying power asymmetries. The portrait and the nude can be interpreted in the context of the male gaze which privileges a patriarchal society. Through the stereotyping of gender characteristics and differences, art has mediated and reinforced patriarchal structures. Artists have responded with work following a feminist agenda which challenges patriarchal values. Studies by postfeminist theorists reveal the many

complexities of the defining and characterising of the feminine identity. Fragmentation of feminist ideology has created opposition between essentialists looking for a fundamental femaleness, and pragmatists seeking equal rights. Contemporary art extensively explores the ambiguities and alternative perspectives on gender, sex and sexuality.

In the 1990s, studies have raised questions about the stability of traditional gender differentiations – male/female – and sought to understand the construction of gender identities, sexuality and the body. The gay perspective has introduced new theories which question the normative/deviant paradigm of past gender configurations. Some artists have moved beyond gender to explore the human body as sensorium and spectacle. Most recently, gender is seen as just one of many issues – including class, race and identity – involved in postcolonial studies. Contemporary artists and art historians continue to engage with these issues.

FURTHER READING

There is a huge amount of material written on feminism and feminist perspectives on art history. Of particular note are the recent anthologies detailed earlier in this chapter. The most recent of these, by Carol Armstrong and Catherine De Zegher, *Women Artists at the Millennium* (Cambridge MA and London, 2006), provides a thorough survey with key texts and contemporary viewpoints from Linda Nochlin and feminist artists.

A foundational text is Griselda Pollock's *Vision and Difference: Feminism, Femininity and Histories of Art* (London and New York, 2003 [1988]) which sets out the theory as well as considering female artists and art which engages with feminist issues.

The Open University book on *Gender and Art* edited by Gill Perry (New Haven CT and London, 1999) provides accessible studies on a range of gender issues in art with guidance for exploring specific works and topics.

The visually annotated work in the Icon series, *Postfeminism* by Sophia Phoca and Rebecca Wright (Duxford, UK and New York, 1999), is a good introduction. It sets out the connections between the different strands of critical theory and contemporary feminist thought.

For an introduction to recent approaches to gender studies and queer theory, Judith Butler's *Gender Trouble* (London and New York, 1999 [1990]) and Vicki Kirby's *Judith Butler: Live Theory* (London and New York, 2006) provide a good grounding on a complex subject. Also Hilary Robinson's *Reading Art Reading Irigaray* (London and New York, 2006) explores the implications of Irigaray's work for subjects such as art, gender and culture.

EXPLORING
POSTMODERNITIES

INTRODUCTION

> Nobody is happy with 'postmodernism'. We use the word with a bad
> conscience, knowing it is not up to the job.
>
> (Wood 2004: 16)

This provisional and ambivalent testimonial by an art historian is
not untypical of many critical responses to postmodernism, the
postmodern and *postmodernity*. The sheer ubiquity of these concepts
has prompted commentators to variously associate them with a
political system (Heller and Féher 1988), a cultural epoch (Jameson
1991), the *aesthetic* landscape of Las Vegas (Venturi 1972) or of
Disneyland (Baudrillard 1994). The idea of the postmodern has
been invoked to explain the processes of geographic and global
integration (Soja 1989); and likened to the presence of God – some-
thing which is 'everywhere and nowhere' (Heartney 2001: 6). The
only point of agreement in all of this seems to be that we are some-
where – or somehow – in it.

This chapter explores the postmodern and postmodernism as
they are used to differentiate art and *culture* in the late twentieth
and early twenty-first centuries. It also discusses various attempts

to characterise the nature of postmodernity as a broader-based period or epoch. To what extent can both be used to situate twentieth-century art and its development? If we describe aesthetic practice as postmodern, what do we actually mean? Is it a positive or negative attribute? And what does it tell us about art, aesthetics and global culture?

THE POSTMODERN AND POSTMODERNITIES

The terms postmodern and postmodernism have been used to characterise a range of aesthetic practices, including the use of installations, performance, lens-based *media*, video, and land-based art, which emerged from the mid- to late 1960s (Wood et al. 1993: 237). Much of this activity, and the critical *discourse* which has accompanied it, can also be characterised as having a particular stance in relation to some of the *Modernist* art and theories explored in Chapter 2.

If we understand one form of *modernism* as being concerned with what aesthetic practice should be, then the postmodern can be interpreted as a more or less conscious reaction to this. For example, a design-based example of modernist thinking might be the linear machine aesthetic of the Bauhaus, which advocated standardisation, uniformity, balance, and the use of iron, glass, steel and concrete, rather than wood or stone (Bayley 2006: 1). In contrast, postmodern design neither defines an integrated set of aesthetic values nor limits the range of media used.

In relation to the visual arts, we might also understand modernism (sometimes capitalised) as a set of critical beliefs and assumptions about culture and style, some of which were associated with Clement Greenberg and his advocacy of a largely painting-based *abstract* art – see Chapter 2. Against this critical landscape the postmodern, literally understood, suggests either a passing beyond such ideas and aesthetic tastes, or a revision of them. For instance, critics have pointed to the melding and cannibalisation of historic styles and vernacular traditions, such as Tudor or Georgian, in contemporary (postmodern) architecture as evidence of the move beyond a modernist sensibility.

In a parallel but connected discourse, the term postmodernity has been used to categorise a distinct social, economic and historic period. Disagreement continues, however, as to exactly when this

started and how long it will be with us. As Appignanesi and Garratt note (1995: 6), the suggestive ambiguity of the term postmodern starts with its grammar, which literally means 'after' (post) 'just now' (from the Latin stem *modo*). Naturally enough, we tend to mark off time in relation to where we perceive ourselves to be, so the idea of something being 'after just now' is problematic both in its relativity and potentially indefinite duration.

Further confusion can arise because the term is used as a vague adjective or qualifier without reference to an identifiable context or object. Both narratives – the emergence of postmodern culture from modernism and of postmodernity from *modernity* – are closely interconnected, but also divergent (Connor 1989: 27). Describing the former, Wood suggests that 'postmodernist art spoke a different language' in the last third of the twentieth century (2004: 25). To extend the metaphor, for us to translate this language requires that we not only look at the narratives of postmodern culture, but that we consider the social, political and economic context of postmodernity itself. By exploring these issues, this chapter considers some of the complexities and interactions of the postmodern in relation to art.

ART AS COMMODITY AND CONCEPT

Consider **Three Ball Total Equilibrium Tank (Two Dr Silver Series, Spalding NBA Tip-off)**, 1985 (**Figure 23**, p. 168), by Jeff Koons, an American artist whose work came to notice in the mid- to late 1980s. Let us consider how we might describe what we see and discuss how this work illustrates the postmodern.

Total Equilibrium is a three-dimensional *installation* comprising three basketballs held in a water-filled plexiglass vitrine. Koons has taken objects associated with an American contact sport (and a specific consumer brand), and re-presented them in a particular way. Held in stasis and weightless, the three basketballs are de-familiarised and functionless – they have no practical use, other than as objects of aesthetic display.

'Equilibrium' (1985) was the name of the exhibition in which this installation was first displayed. A major interest which Koons had at this time was advertising and the ways in which sporting activities were connected with brands which in turn used shorthand signatures and motifs for advertising consumer goods (Kellein

2002: 37). A former commodities trader, Koons became one of the highest-paid and most well-known American artists of his generation. His visible success and the use of consumer objects as art seemed to fit the 1980s *zeitgeist*.

We might see in this example and in other installations by Koons, a comment on the idea of the commodity fetish – the ways in which objects are given disproportionate cultural status and value (Wood 2004: 30). Additionally the use of a plexiglass vitrine recollects an eighteenth-century cabinet of curiosities or even a reliquary in which sacred objects are displayed. But instead of a church, crypt or even a designer shop window display, this installation belongs to the Tate Modern, where its display alludes to these cultural connotations. With this example Koons estranges the familiar, reminding us that much recent and contemporary art is as much about concepts and ideas as it is about aesthetic effects.

This installation also marries otherwise ordinary objects from contemporary culture (that of sport) with the idea of 'art', rather than keeping the two separate. As mentioned in Chapters 1 and 2, from around 1912, avant-garde artists like Picasso and Braque started to incorporate fragments of newspapers, tickets, wallpaper, and text from advertising flyers in their work (Richardson 1996: 225). This frequently emphasised the actuality of the painted surface as a physical object, and their collages made explicit the connection with modernity – what it meant to live within an urbanised and metropolitan society.

Around the same time the French avant-garde artist Marcel Duchamp (1887–1968) re-presented entire objects such as bottle-racks and bicycle wheels as readymades (Gaiger 2003: 57–63). In **Total Equilibrium** Koons is also 're-presenting' an object as opposed to a 'representation', as in a painting or sculpture. Like much of the avant-garde art of the 1960s, our awareness of its difference partly arises from a culturally based knowledge of what preceded it – hundreds of years of art as mimesis. Discussing **Total Equilibrium** and similar works, Koons has acknowledged the influence and example of Duchamp. Duchamp's (unsuccessful) submission of **Fountain**, an unplumbed urinal signed 'R. Mutt', for exhibition in 1917 exemplified his belief in art as 'concept' rather than as mimesis or formalist. Duchamp is also widely regarded as having provided the paradigm for the assumptions and ideas which

became prevalent within avant-garde art practice from the mid-1960s onwards.

Although Koons has taken this idea further, this work of art nevertheless underlines points of similarity and difference between avant-garde art 'then' and 'now'. The idea that art can be about concepts (as well as aesthetic effects), and that it can reference, adapt or use everyday objects, should be kept in mind when exploring ideas about the postmodern. This example is neither a painting or a sculpture, but a mixed-media installation which occupies three-dimensional space, albeit in a way suggestive of earlier avant-garde art.

Total Equilibrium can be interpreted in various ways. It might be understood as a comment on consumer culture and how the seemingly banal can be made less – or more so. For example, we may experience in this work a kind of depthlessness – that it remains impossible to move beyond our sense of what we are actually viewing (Taylor 1995: 92; Hassan 1992: 196–97). Whatever the

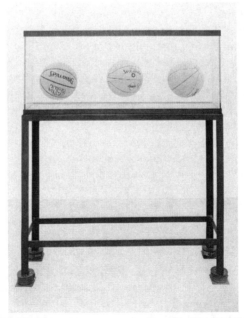

Figure 23 *Three Ball Total Equilibrium Tank (Two Dr J Silver Series, Spalding NBA Tip-Off)*, Jeff Koons, 1985, glass, steel, sodium chloride reagent, distilled water, 3 basketballs, 62 1/2 × 48 3/4 × 13 1/4in., © Jeff Koons © Tate, London, 2006.

reading of the installation, we are not suggesting that there is a specific or particular meaning which should be 'understood.' There is no necessarily 'correct' interpretation.

We might choose to read what Koons had to say about the exhibition in the belief that this would provide a rationale behind its making. The exhibition in which this work featured explored the themes of achievement, life and death. According to Koons, the basketballs symbolised the possibility of gaining fame and fortune from sporting prowess, although their suspension in liquid stasis also signified being and nothingness (Kellein 2002: 19). *Total Equilibrium* might therefore be understood allegorically, as having a meaning or narrative which is concealed or indirect. However, its meaning is also incomplete – we may be aware of what one commentator has described in a similar context as 'continuous punning' – some of the symbolic and historic associations of the installation's components, without being entirely sure of whether (or what) they actually mean overall (Connor 2004: 86–87).

Of course, we don't have to accept any particular evaluation of the work. We might read a monograph on the artist, look at the press reviews, or simply reach our own conclusions. But whatever our personal response, *Total Equilibrium* can be interpreted as posing questions about the ways in which different media, juxtapositions and methods of presentation can be used to communicate cultural and aesthetic ideas.

DEATH OF THE AUTHOR

In 1966 the French literary critic and semiologist Roland Barthes (1915–80) first announced 'the death of the author'. Barthes believed that the creator of a text (or work of art) should not have the monopoly over its interpretation and that other readings were equally tenable. When discussing this period, one commentator described art as making viewer-inclusive 'propositions' (Popper 1975: 11). As with the *Total Equilibrium* installation, the response and engagement of an active viewer, rather than a passive spectator, became a central aspect and assumption of avant-garde art practice from the mid-1960s onwards.

Recognising the validity of such multiplicity of meaning was a marked change from previous traditions within artistic production.

As noted in Chapter 1, these had tended to be either *mimetic* or formalist in origin, and both had situated aesthetic practice against particular values and purposes. Identifying this new trend as one of the metaphors of postmodern art, the critic Hal Foster suggested that the artist increasingly became 'a manipulator of signs and symbols . . . and the viewer an active reader of messages rather than a passive contemplator of the aesthetic' (1985: 99–100).

Barthes was not alone in pointing to the difficulty of establishing stable meanings within art. In his book *The Truth in Painting* (1978) the French philosopher Derrida asserted the impossibility of secure meanings within cultural discourse. Contrary to the arguments made by structuralism (Chapter 4), Derrida asserted that meaning is in a constant process of evolution since signs are only provisional, taking their meaning from traces of other contexts and linguistic associations (Sim 2003: 97). For Derrida, the best that we could do was to talk 'around' the subject, conceding our contingent experience of the art-object.

POSTMODERN ART AND THEATRICALITY

Unless an installation is cantilevered off the gallery wall, a spectator is usually able to view it in the round, rather than being pre-positioned by the dictates of the gallery hang. In 1967, the Modernist critic Michael Fried wrote what became a highly influential article entitled 'Art and Objecthood'. He suggested that a participative viewing experience was one of the fundamental differences between an increasing range of installations and performance-based practices (subsequently typified by the early work of Gilbert & George) and Modernist art.

For Fried, rather than the immediate and instantaneous grasping of aesthetic impact offered by Modernist art ('presentness'), the sheer physicality of installations and similar object-based art demanded a different response. Fried believed that such 'literalist' encounters, dependent on the duration of the viewer's engagement, were orchestrated and inauthentic, eliminating the critical importance of the aesthetic in reaching judgements about quality and meaning. This prompted the dismissive suggestion that such experiences were instances of mere 'theatricality'. Fried's intervention has become pivotal in underlining the apparent difference between a Greenberg-

sponsored Modernism, largely concerned with flat, abstract paintings, and the diverse range of art practices associated with postmodernism, which became widespread from the mid-1960s.

POSTMODERNITY AND 'DOUBLE-CODING'

We can now consider the idea of the postmodern in the broader sense as relating to the direction of cultural forms within the late twentieth century. Adapting a formulation from Ernest Mandel's (1923–95) book, *Late Capitalism* (1978), the social theorist Fredric Jameson (b. 1934) claimed postmodernism as the cultural equivalent of a global capitalism which has characterised the latter decades of the twentieth century. As a Marxist, Jameson has linked successive styles of art to stages in the development of the Western economic system. So, for example, naturalistic and realistic art is situated within the world of early and developing capitalism; modernism within the dynamic period of international or monopoly capitalism, and postmodernism within what Jameson optimistically describes as the multinational stage of late capitalism (Jameson 1991: 35).

Within today's global capitalism, Jameson argues that art, culture and society have become 'schizophrenic' – of the present, but self-consciously re-working past categories and typically using blank quotation to do so. Driven to innovate by the imperatives and fashions of the global marketplace, postmodern culture is one of *pastiche* or copying, and random cannibalisation (Jameson 1991: 17–18). History is self-consciously re-appropriated and re-fashioned into new forms – 'neo-conservatism', 'neo-Georgian' houses or 'neo-Expressionism' as a return to a 'sort of' painting. For Jameson, these apparent differences within postmodern culture are superficial, since postmodernism is understood not as a single style but as a 'cultural dominant' within which other 'subordinate features' coexist (Jameson 1991: 4).

Charles Jencks (b. 1939) has described this de-historicised or unanchored quotation of past styles as an example of 'double-coding' (1989: 7). To take an architectural example, contemporary houses that incorporate and hybridise earlier styles – *classical* pillars, window frames and pediments, etc. – frequently do so in a way which feels self-consciously 'added on', as if they had been selected from a style sheet rather than being an integral part of the conception, design and build from the outset.

As an example of this self-conscious referencing of past styles, consider **Study for Capriccio**, 2005 (**Figure 24**, p. 172), by the British artist Gerald Laing (b. 1936). 'Capriccio' is the Italian word for fantasy or imaginative invention. Laing elaborates it as:

> a sudden start, motion or freak. A free, fantastic style, a prank, trick or caper. A thing or work of fancy.
>
> (http://www.geraldlaing.com)

Figure 24 *Study for Capriccio*, Gerald Laing, 2005, 91 × 81cm, © the artist, © photograph Ewen Weatherspoon.

The broader context of this image will be discussed in Chapter 8, although its inspiration is the globally televised images of the prisoner abuses which took place at Abu Ghraib in Iraq. Describing the work, Laing writes:

> This painting is full of paradox and ambiguity. . . . Thus it becomes possible to avoid thinking about the surreal arrangement of the human figures, and the internal life of the prisoner. Formal concerns become a sort of anaesthetic, or at least a way of re-composing the reality of Abu Ghraib.
>
> (http://www.geraldlaing.com)

Although its subject matter is powerful and compelling, Laing's image is also a pastiche. It is an example of 'double-coding' which uses the familiar *iconography* and techniques of Pop art (of which Laing was an original exponent), whilst referencing the inhumane treatment of prisoners during the recent occupation of Iraq.

The art critic and philosopher Arthur Danto (b. 1924) has suggested that one of the principal definitions of postmodern culture has been this very 'transformation of past styles into subject matter' (Danto 1998: 198). Others have seen in such free-floating *appropriation* confirmation that the global culture of Western capitalism has largely lost any meaning other than what the market chooses to give it (Eagleton 1996).

The initial sections of this chapter have briefly sketched the postmodern as a cultural ethos and sensibility which has generated differing approaches to the making and meaning of art. The parallel term of postmodernity has been suggested as referencing a distinct historical period. In the sections which follow, we will explore some of the characterisations and step-changes which Jameson and other theorists claim are symptomatic of postmodernity.

HOW SOON IS 'NOW'?

In attempting to differentiate historical periods, commentators often look for patterns or 'changes' in human behaviour which may be traceable to specific technological innovations and developments. For instance, we might think of the Industrial Revolution, the invention of the internal combustion engine and the rise of the

internet as culturally and historically significant moments in human history: the first example because it established new modes of mechanised production and exchange; the second because it afforded the prospect of individual transport and mass mobility; and the last because it was a major step in information-availability and, in one sense at least, global integration.

Both separately and collectively, these were developments of fundamental importance, even if their significance was not always initially realised. The early years of the twentieth century – at least in the heavily industrialised parts of Europe and America – were instances where technological and scientific changes appeared to mesh with cultural and artistic innovation. For example, the painting styles of the French Impressionists in the later decades of the nineteenth century were an attempt to record the *spectacle* and flux of the modern world and the experience of living in dynamic metropolitan centres like Paris and London. Braque and Picasso, and their followers such as Fernand Léger (1881–1955) and Gris, sought new ways of capturing the total experience of modernity – often using, as we have noted, actual objects such as newspapers, advertising bills and fabrics in their collages. Other avant-garde artists like Robert Delaunay (1885–1941) painted the Eiffel Tower, as an 'icon of modernity' and as a source of national pride (Gaiger 2004: 149).

We might see some of the social, technological and artistic changes sketched above as indicative of Western modernity – secular, metropolitan and increasingly mechanised. However, in the last fifty years, globalised scientific and media technologies have increased the scope and velocity of these shifts, creating a world which appears ever more integrated and proximate. More recently, computer technology and biotechnology have been among those techno-scientific changes which appear to underline an epochal shift (Heise 2004: 137). This period, from the mid- to late twentieth century onwards, is the point at which Western culture begins to coalesce with the globalised capitalism of postmodernity.

ART AND 'PARADIGM SHIFTS'

In 1962 the science historian Thomas Kuhn (1922–96) published *The Structure of Scientific Revolutions*. It was Kuhn who devised the term 'paradigm shift' to describe significant moments in human

history when scientific understanding changes and we perceive things differently. For example, the proof of a heliocentric solar system with the earth orbiting the sun rather than the other way around, contradicting the beliefs upheld by the Roman Catholic church, was profoundly important both for the status of scientific discourse and for human self-understanding more generally. The idea of a heliocentric solar system had been the subject of Kuhn's first book, *The Copernican Revolution* (1957).

The greater importance of this insight, however, was that traditional science (what Kuhn calls 'normal science') was far from a neutral and objective activity, based on rationally chosen frameworks (Sardar 2000: 26–28). Rather, Kuhn interpreted it as a more subjective undertaking in which the questions and experiments which scientists explored were typically set by the existing paradigm. It is only when a new paradigm challenged the ideas which underpin existing research assumptions that scientists look for new evidence or adapt the research techniques themselves. The principle of a paradigm shift is a useful way of understanding the changing priorities of successive avant-garde movements which accompanied the onset of modernity and the increasingly mechanised and technologically driven relationship between human society and the wider environment.

DUCHAMP'S READYMADES

The mid-twentieth century is generally understood as signifying the 'paradigm shift' from modern to postmodern visual culture. However, as we have already noted, Duchamp's far earlier readymades – including snow shovels, bicycle wheels, bottleracks and, most famously, an unplumbed urinal – are widely understood as having anticipated some of the major aesthetic trends which became widespread in the 1960s. His mixed-media installations, incorporating previously functional objects, established the principle that art could be about concepts and ideas (whether playful or ironic), rather than mimetic or formalist concerns. Duchamp's work has been accorded iconic postmodern status because he believed that the artist should decide what art was, a legacy which has influenced successive twentieth-century avant-garde movements – from Dada, Surrealism, and Russian Constructivism, to Pop, neo-Dada, and the

neo-conceptualism of the 1960s. More recently, the installation-based practice of 'Brit Artists' like Gavin Turk (b. 1967) has drawn on Duchamp's legacy (Stallabrass 1999: 45).

Duchamp's work and approach proved formative in many respects, but he did not challenge or question the *hegemony* of the galleries. His readymades were typically submitted to galleries for exhibition and display, as were other examples of avant-garde art. In practice, it was the gallery which provided the final authentication of the art work. Although Duchamp subverted the aesthetic assumptions under which art had operated, the achievement was nevertheless mediated through an established gallery system which played a significant part in sustaining his reputation, many years after he had (apparently) renounced art to play chess. As de Duve notes, the object-centred idea of art and its 'institutionalised value' were among those aspects of Duchamp's legacy which conceptual art deconstructed (1998: 413). The 'dematerialization of the art object' – various strategies to escape the *fetish* of the exhibited object and to resist the powerful institutional role and politics of the gallery – has become a central priority of many American and European artists since the 1960s and 1970s (Lippard 1973).

THE INSTITUTIONAL THEORY OF ART

Duchamp challenged conventional ideas about art and aesthetic judgements – how we evaluate the art we see. As explored in earlier chapters, for art to have been historically accepted, it had been subject to certain expectations and standards – initially set by the church, then by the *academy* and subsequently by an avant-garde expectation of continual innovation.

Acknowledging Duchamp and the diverse range of objects and practices which have subsequently claimed aesthetic status, the American philosopher and writer George Dickie (b. 1936) formulated the 'institutional theory of art' (Dickie 1974). According to this theory, for art to be art it has to meet two criteria. First, an object or artefact has to have been changed by human agency or intervention, and second, the resulting object has to be acknowledged as art through formal exhibition or display, though not necessarily in a gallery context. For Duchamp, for example, the mere act of selection technically met the first criterion, with the objects meeting the

second criterion through their subsequent display. For 'land art', which we discuss shortly, the creation of an art work away from the gallery still meets the criteria through the presentation or re-presentation of the work to an audience often through photographs. Dickie's theory has proved to be highly influential – and widely quoted. It provides convenient, philosophical justification for the diverse range of installation- and performance-based practice and other *hybrid* forms prevalent since the 1960s.

LIMITATIONS OF THE INSTITUTIONAL THEORY

Dickie's theory greatly expands the definition of art (to the obvious benefit of artists, curators and gallery owners) but it does not tell us whether the art chosen is actually good or bad – it is simply classifi-catory. For some critics this alone disqualifies it as a meaningful theory. By contrast, you may recall from Chapter 2 that the attempt to define the quality (and hence the standing) of abstract painting was central to Greenberg's Modernist theory.

A second objection to Dickie's theory is whether the art world actually has the unified authority and recognised procedures to confer the status of art in the first place. As Graham observes (1997: 157), the art world is hardly a corporate entity typified by overall agreement on what art is or should be. For example, much of the routine scepticism which greets the annual announcement of the Turner Prize shortlist is arguably not just about the art works as such, but is a comment on the institutional politics and perceived credibility of the art world itself.

However, despite its drawbacks, Dickie's theory recognises post-modern art as a culturally relative phenomenon rather than as a 'timeless canon' of particular works (Warburton 2004: 156). His theory moves us on from limited discussions about whether such and such an object is 'art' to more intellectually useful questions about interpretation and the communication of meaning.

AMERICAN HEGEMONY AND A NEW ORDER

Duchamp's rediscovery by a new generation of post-war American artists, including Claes Oldenburg (b. 1929), Jasper Johns (b. 1930), Rauschenberg and Warhol, underscored the increasing popularity of

installation, performance and other hybrid art practices throughout America and Europe in the mid-1960s to 1970s. These new art forms can also be seen as a conscious reaction to the largely painting-based *abstraction* advocated by Greenberg and other Modernist critics. However, this reaction was also part of a broader political and social counterculture, some of the origins of which can be traced back to the new world order which emerged after 1945.

Whilst America's population had largely escaped the privations experienced by its wartime allies in Europe and the Soviet Union, figurative art was linked in the public mind to the economic depression of the 1930s and the attempts by the Roosevelt administration to alleviate unemployment and social hardship. Much of the urgent social purpose behind figurative painting had derived from the political need for a cohesive national identity at a time of political unrest abroad and high unemployment at home. But as one of the main beneficiaries of the post-war settlement and with a robust and expanding economy, America's global status seemed assured. Throughout the later 1940s and 1950s, the abstract art associated with Barnett Newman (1905–70), Jackson Pollock (1912–56), Mark Rothko (1903–70) and David Smith became iconic of an influential, Americanised avant-garde.

The end of the Second World War confirmed American and Soviet hegemony. The older *imperial* and *colonial* powers like Italy, France and Great Britain saw their political and economic influence curtailed in a re-ordered world. The rise of American abstraction and the dominance of Greenberg's Modernist theory were due in no small part to these underlying realities. However, there were other reasons behind abstraction's post-war popularity. Figurative and naturalistic art had been widely employed as propaganda by the totalitarian regimes of Germany, Italy and Soviet Russia. Whilst many artists had continued in a recognisably figurative tradition after 1945, others felt that abstraction was a way of re-asserting art's integrity as a culturally independent practice (Harris 1994: 35). Particularly in America, abstraction was seen as part of a new and distinct national identity, and as a highly visible confirmation of the freedoms which social democracy gave to its citizens.

To subsequent generations on both sides of the Atlantic, however, American abstraction became a restrictive orthodoxy, not unlike the overtly politicised figurative art which had preceded

it. The very different art practices of Warhol, Oldenburg, Johns and Rauschenberg used the iconography of consumer culture, frequently parodying ideas of originality, authorship and the expressive, existential concerns of abstract art. Similarly, their work subverted the previously dominant paradigm of the strongly *masculine*, heterosexual artist (Butt 2004: 315–37). There were other reasons, however, for the shift from modernism which became increasingly apparent and discussed during the late 1960s and 1970s.

LYOTARD AND THE DEATH OF THE 'GRAND NARRATIVES'

In *The Postmodern Condition: A Report on Knowledge* (1979) the French philosopher and theorist Jean-François Lyotard attempted to characterise what he perceived to be the significant post-war changes and their consequences. Lyotard claimed that the various promises made by communist, liberal democratic and socialist ideologies had been illusory. With their origins in the progressive civic ideals of the *Enlightenment*, these influential interpretations of the world – 'metanarratives' or grand narratives – had simply not delivered. In consequence, aspirations for a progressive politics had been replaced by a widespread scepticism and distrust of all-embracing political theories and the promises they made. For example, as discussed in Chapter 3, the fortunes of Soviet communism (one of the grand narratives Lyotard had in mind) had a major effect on its political and cultural credibility in the West – among the reasons for the enhanced post-war status of an apparently apolitical abstract Modernism.

If we look to contemporary art, the apparent loss of Enlightenment reason and discourse is among the themes referenced by Jake and Dinos Chapman. The recurrent use of work and iconography derived from the Spanish painter Goya, such as **Disasters of War**, 1993, is a direct reference to his ambiguous association and implication within these broader historical narratives. Interviewed by Kirsty Wark (*Newsnight Review*, BBC2, 15 December 2006), Dinos Chapman stated that 'Goya points out this removal from the state of grace'; and elsewhere (*Front Row*, BBC Radio 4, 14 December 2006) that his work was a 'euphemistic jab at a certain kind of modernity'.

Arising from this interpretation of postmodernity, Lyotard proposed the idea of the 'differend' – of difference. The formulation

can be seen as an argument for cultural relativism and the absence of absolute truths – ideas and values could simply be different, but valid on their own terms. Whilst this might not eliminate all conflict, Lyotard believed that adherence to such a principle would at least reduce its occurrence. The theory of Modernism and the abstract practice which it helped to shape were understood as just another 'metanarrative', which imposed its own brand of stylistic conformity (abstraction) throughout much of the twentieth century. As an apparent antidote to this, Lyotard stressed the idea of the 'event' – an 'experience of the immediate which is conceived always to be open and undetermined' (Sim 2003: 200). For Lyotard, among the failings of 'metanarratives' like Modernism was their tendency to be closed off from the 'event' – what might be possible and innovative, rather than prescribed and set.

Applying Lyotard's ideas to the possibilities of aesthetics might suggest an approach to art making based on difference and an open-ended sense of meaning or interpretation – apparent with Duchamp's readymades or the installation by Koons. Dickie's Institutional Theory also echoes Lyotard's sense of event and difference – keeping an open mind on the processes of art making and varying interpretations as to its meanings. Similarly, the 1960s vogue for situationism – the belief in the spontaneous aesthetic moment with a politically oppositional message – can be seen as a direct engagement with Lyotard's identification of the 'differend' and of the 'event'.

. . . 'THE END OF ART' . . . A NEW COUNTERCULTURE FOR THE 1960s AND 1970s

The fracturing of the old-style political consensus which Lyotard referred to became apparent with increasing cultural awareness of the political dimension to *gender* difference, ethnicity and ecological issues. In America, the war in Vietnam and the burgeoning civil rights movement again focused attention on the social role and responsibilities of art practice and the neutralising effects of private and institutional patronage. In 1968, student-led demonstrations and dissent in several European capitals attacked market capitalism and what was seen as a new neo-colonial West. Revised forms of Marxist theory came to prominence (as they had in the 1930s), but the cultural and global landscape described by Lyotard had also

changed. The focus of these ideas was less along the old battle lines of class and economics, but was increasingly directed at issues of identity, cultural reproduction and originality. How was this reflected in the art practice of the period?

One aspect of a revised cultural politics concerned the exploration of ecology and landscape. Although aesthetic interest in the landscape was not new, either in America or Europe, from the later 1960s the *genre* of 'land art' engaged with the materiality of the landscape which became the object of aesthetic attention. American artists like Robert Smithson (1938–73) and Michael Heizer (b. 1944), and in Britain, Ian Hamilton Finlay (1925–2006), Hamish Fulton (b. 1946), Richard Long (b. 1945) and Andy Goldsworthy (b. 1956), moved their work beyond the immediate confines of the gallery system, both as a critique of such institutions and as a response to the perceived limitations of a painting-based avant-garde and its associated Modernist theory.

Practitioners and land artists like Smithson saw their work as part of a broader critique of art's commodification by the commercial gallery system (Hopkins 2000: 172). There was also an ecological angle to these interventions. It may seem strange in our environmentally more conscious times that a carbon-hungry engineering project like Smithson's **Spiral Jetty**, 1970 – a 1,500ft sandstone sculpture in Utah's Great Lakes – could sustain such readings. But Smithson's work reflected a fascination with the idea of 'entropy' – the gradual slowing down and eventual stasis of all natural phenomena. At a time when corporations and mainstream political interests were scarcely conscious of ecological balance, Smithson was exploring an ultimately finite natural environment as the product of geology and time (http://www. robertsmithson.com).

From gallery-based installations to performance, photographic and land-based operations, a *hybridised* range of objects appeared as art in the 1960s and 1970s which were typically dissimilar from flat, abstract painting. Applying ideas from semiotics (see Chapter 4), one critic and art historian has suggested that what all these ostensibly different kinds of art had in common was a reliance on the indexical sign or photograph (Krauss 2003 [1976]). What had shifted were the criteria upon which this new art could be understood and through which it could be rendered intelligible (Wood 2004: 25).

The exploration of art as a three-dimensional, conceptually driven activity was also being undertaken by a range of minimalist artists like Carl Andre (1935–2007), Hesse, Dan Flavin (1933–96), Donald Judd (1928–94) and Sol LeWitt (1928–2007) (Batchelor 1997: 6–13). Writing in 1984, Danto identified both Pop art and Minimalism as having a distinct place in what he termed the 'end of art'. He was not referring to the literal end of 'art making', but the close of a particular narrative of art, understood as a visual rather than a conceptually driven activity (Danto 1998: 115–28). The experience of seeing Warhol's plywood **Brillo Boxes**, 1964, 'so precisely like the cartons of Brillo in the supermarket' symbolised for Danto the end of art understood as successive acts of self-definition – the dynamic which had underpinned earlier avant-garde practices (Danto 1990: 343). It followed that if the difference between art and non-art was no longer visually apparent, artists were now free from attempting to define their practice. For Danto, art's philosophical liberation has characterised its 'post-history', resulting in a plurality of practices, apparent from the mid-1960s onwards.

PHOTOGRAPHY AND CULTURAL REPRODUCTION

Aesthetic concerns with originality and opposition to narrative in art had been used by Modernist critics to justify the exclusion of photography and its practitioners from serious artistic consideration. By the 1970s, photography had moved in from the margins, becoming integral to conceptual art and other hybrid practices (Edwards 2004: 137). Photography was not only used as an aesthetic medium in its own right, but was employed in various ways to document and record otherwise transient or inaccessible examples of land- and installation-based art for display and publication.

Photography and photographic montage had been widely used by the Surrealist and Russian Constructivist avant-gardes throughout the 1920s and early 1930s, and was associated with a particular tradition within *critical theory*. Walter Benjamin's essay 'The Work of Art in the Age of Mechanical Reproduction' (1936) had explored how photographic technology had fundamentally changed the status of the art object and its wider cultural meaning.

According to Benjamin a work of art possessed a particular 'aura' – a presence and value arising from its uniqueness and originality. But what if the original could be endlessly reproduced by photography, film or lithography – the technologies of Benjamin's time? Reproduction would enable any number of copies to be purchased and circulated to a mass audience. For Benjamin, the mere fact of art's reproducibility, its particular production for such purposes, offered not only the possibility of new types of art, but the prospect of an entirely different form of cultural politics. The experience, ownership and – crucially – the use of art would no longer be restricted to a social or political elite. (These associations informed Kennard's nuanced *photomontage* commemorating the half-centenary of Benjamin's death – see **Figure 14**, p. 82.)

Writing in the 1930s, Benjamin underestimated the extent to which various political systems would be able to use photographic technology for their own ends rather than for the potentially liberating purposes he had envisaged. Despite developments in digitised technology which Benjamin could not have envisaged, original works of art have continued to be fetishised by the international art market (Meecham and Sheldon 2000: 204). The value of 'brand identity' was most recently underlined by the $140 million auction record set by one of Jackson Pollock's early drip paintings, ***No. 5, 1948***. However, Benjamin was entirely correct in identifying originality and a culture based on photographic *simulacrum* – or copies – as intrinsic to modernity. For instance, Warhol's subsequent depiction of mass brands – Campbell's soup cans, Coke bottles and screen idols like Marilyn Monroe and Elvis Presley, confirmed consumer culture's saturation with advertising images and spectacle.

As Connor notes (1989: 99), among the characteristics of recent photographic practice and theory have been both its implication in and resistance to, Modernist ideas of purity and individuality, and its engagement with the expanded field of postmodern art. Practitioners including Victor Burgin (b. 1941), Sherrie Levine (b. 1947), Silvia Kolbowski (b. 1953) and Kruger (**Figure 16**, p. 107) have explored the *ideological* role of photographic representation, foregrounding issues of gender, ethnicity, sexuality and the changing dynamic of cultural politics.

BAUDRILLARD AND THE FOUR ORDERS OF THE SIMULACRA

Benjamin's ideas on cultural reproduction have proved influential for other social theorists. Using the idea of the simulacrum or *copy*, Jean Baudrillard has explored the 'hyperreality' of contemporary culture. Applying the idea of the simulacra to the development of the image, Baudrillard (1994: 6) has suggested that it has undergone four successive historical phases, each of which can be used to explain different historical periods – from the *Renaissance* through to postmodernity.

The first order of the simulacrum is where an image attempts to represent a given reality. We might think of a still life depicting a basket of fruit or an arrangement of flowers. If it is created with sufficient *naturalism*, we can imagine the textures and smells of what is represented. The second phase accompanies art's increasing commodity status as an object to be bought and sold. As such it can potentially represent any number of ideologies or ways of seeing the world. For example, as we noted in Chapter 3, within a few years of its appearance, David's **Horatii** was indexed to the secular ideals of the French Revolution. Typically, art no longer represented a religious or even *hegemonic* world view, but could convey partic-ular agendas and interests according to patronage and the varying contexts of its production.

Baudrillard's third order of the simulacrum is where art actually conceals 'the absence of a basic reality' (Baudrillard 1994: 6). Within industrialised society the most immediate source of the visual is no longer art, but a mass culture of reproduction and spectacle based upon television and other technologies. Like Warhol's silkscreens of multiple icons, art as a cultural 'brand' merges with the global spec-tacle of commodity advertising and its electronic media culture.

To illustrate the final order of the simulacra, Baudrillard uses the example of Disneyland which persuades us that what is outside is the actual, when in fact it is also simulated – a complete imaginary like Los Angeles and America itself (Baudrillard 1994: 6). Here, the image ceases to have a relationship to anything other than its own simulation – its own simulacra. The film *The Truman Show* (1998) or Bill Murray's travails in *Groundhog Day* (1993) exemplify this scenario – an entirely simulated and ever repeated present.

The interplay between advertising, text and context has been a central concern in the work of the American artist Barbara Kruger. Consider her poster-size photomontage, **We Don't Need Another Hero**, 1987 (**Figure 16**, p. 107). A former art director in women's magazines, Kruger uses the tone and voice of her trademark black and white captions and straplines to manipulate and subvert the original meaning of the photographic image. For some of the gendered and political issues arising from this work, see Chapter 6. Keeping in mind Baudrillard's characterisation of how reality is simulated by consumer advertising, we might interpret the strapline as exposing its ideological role in constructing this complete imaginary – and the efforts of the consumer industry in making us complicit with the objectification of social and gender roles.

Baudrillard's analysis suggests that a seamless web of advertising and consumer spectacle has not only enfolded art, but has actually re-defined our world, replacing it with a series of simulations and fictions. From Disneyland to Las Vegas, to the new yet 'traditional' village of Poundbury, Dorset, sponsored by HRH Prince Charles, we increasingly experience the present through a series of retro-fashions, quotations and pastiche.

Some critics have accused Baudrillard of pessimism for his refusal to formulate more positive alternatives to this bleak scenario (Wakefield 1990: 140–42). Others have seen a deliberate strategy of mocking exaggeration aimed at contemporary commodification and the excesses of the culture industry. Refusing this apparent denial of human agency, Jameson looks to the yet unrealised power and cultures of the developing world for new forms of cultural and aesthetic resistance (1991: 417). Some of the aesthetic and cultural issues arising from *globalisation* will be explored in the final chapter of this book.

CONSERVATIVE POSTMODERNISM: A RETURN TO PAINTING?

As we have seen, among the characteristics of postmodern art has been a range of practices which have questioned or moved away from the dominance of painting and a parallel belief in the viewer as some kind of disembodied 'eye' engaged only with the pictorial. An influential anthology edited by Hal Foster and initially published

in America under the title *The Anti-aesthetic* (1983) has described these as 'anti-aesthetic' strategies – typified, as we have seen, by a conceptually driven approach to the art object and to the process of its production. Although a figurative tradition continued throughout the modern period, the 1960s and 1970s saw the dominance, and eventual institutionalisation, of *neo-avant-garde* conceptual art throughout America and Europe (Wood 2004: 26).

The start of the 1980s, however, saw a major upswing in figurative art, buoyed by a recovering art market and increasing corporate and curatorial interest. In 1981, London's Royal Academy hosted a major retrospective by European and American artists entitled 'A New Spirit in Painting'. It featured work by a range of American, British, German, Italian and Scottish practitioners, some of whose work was described as 'Neo-Expressionist' in recognition of the highly painterly and apparently expressive use of pigment, but usually with idiomatic differences which became 'signatures' of the artists themselves. This category included work by Anselm Kiefer (b. 1945), Francesco Clemente (b. 1952), Georg Baselitz (b. 1938) and Julian Schnabel (b. 1951).

The figurative painting style of the Italian artist Carlo Maria Mariani (b. 1931) has been associated with this trend in postmodern art as it has with Jameson's earlier characterisation of the schizophrenic nature of postmodernity. Mariani's belief in the continuing relevance of figurative painting and the cult of the expressive artist is seen by Heartney as evidence of a nostalgia for pre-modernity (2001: 13). Similarly, Mariani's pastiche of classical imagery and ironic quotation from dead styles has been read as symptomatic of a 'conservative' postmodern art motivated by a need to connect with broader human concerns and audiences.

As various commentators noted at the time, institutional and curatorial support for big, bold and frequently colourful canvases was not unconnected to a new consumer zeitgeist and a resurgent commodities market which had seen little merit in the apparently esoteric themes and priorities of neo-conceptualism (Hopkins 2000: 203). A recent example of figurative painting which appears to share this ethos is the large oil on canvas painting, ***An Enduring Offering***, 2005, by Jago Max Williams (**Figure 25**, p. 187). Like some of Mariani's work, this figurative painting is a classical pastiche, reminiscent of the humanistic concerns of pre-modernity and the

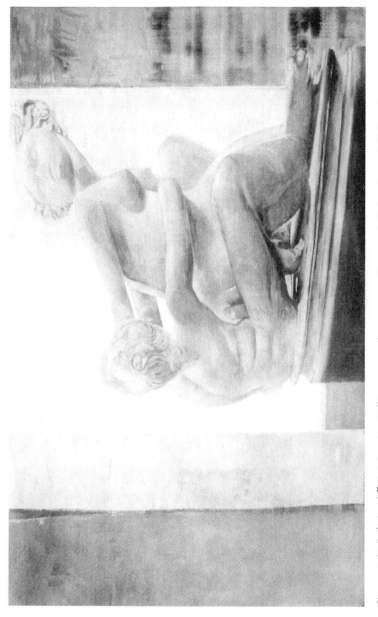

Figure 25 *An Enduring Offering*, Jago Max Williams, 2005, oil on canvas, 128 × 191cm (private collection). © the artist.

priorities of expressive painting. Both artists appear to quote from dead styles and a Renaissance heritage, but with *An Enduring Offering*, the explicit bodily iconography is both self-conscious and possibly ironic.

AN OPPOSITIONAL POSTMODERN CULTURE

A second strand within postmodern art has been identified as 'critical pluralist' in orientation (Connor 1989: 88). Unlike the eager institutionalisation sought by neo-Expressionism, its practitioners were engaged in 'oppositional' postmodern art which relied upon what Foster called 'anti-aesthetic' practices like photography, film and text as ways of deconstructing representation and identity. Its adherents variously claimed their work as a continuation of a radical, 'authentic' and comparatively marginalised postmodern tradition stretching back to Dada, Cubism, Surrealism and the Soviet Constructivists. These avant-gardes had been described as having attempted the re-connection of visual representation with politics and the 'praxis of life' (Bürger 1984: 109). Artists associated with this 'critical' postmodernism included John Baldessari (b. 1931), Jenny Holzer (b. 1950), Kruger (**Figure 16**, p. 107), Richter, Sigmar Polke (b. 1941) and David Salle (b. 1952). But as Heartney has noted (2001: 40), by the mid- to late 1980s, it appeared that the art market had successfully co-opted these interventions, as it had neo-Expressionism. What these interventions have underlined is the extent to which there are continuities as well as differences between postmodern art and various antecedent avant-gardes.

FUKUYAMA AND THE END OF HISTORY

The End of History and the Last Man (1992) was authored by the American social historian Francis Fukuyama. Published in the period following the collapse of the Berlin Wall and the Soviet Union's disintegration, it was seen by many on the political right as confirmation of the global dominance of the social, political and economic values of Western society. According to Fukuyama, the various social and political ideas which had their origins in the European Enlightenment had now reached their logical end-point. The collapse of the 'grand narratives' described by Lyotard had, so it

was argued, culminated in the total system of consumer-based capitalism. History had reached its objective – liberal democracy and a free market economy. Seen from such a perspective, postmodern culture was at best complicit in such a system of values, or was otherwise mutely resistant, yet dependent upon it.

The events of 9/11, the Madrid train bombing and the United Kingdom's 7/7 were, however, reminders – if any were really needed – that America and Europe are only part of the world – not *the* world. There remain ideologies in conflict with a Westernised neo-liberalism, and it is by no means clear if the latter template will be enthusiastically adopted by the developing world, Asia and the Middle East. Some of the artistic and cultural aspects of the new millennium's emerging global order will be explored in the final chapter. However, it is worth noting here that what has been described as the 'degree zero' of contemporary postmodern culture has frequently meant in practice the imposition of (Western) cultural norms and assumptions upon the developing world.

Postmodern art, however, has achieved a prominence and purchase on the popular imagination that even an institutionalised Modernism struggled to attain. The popularity of London's Tate Modern, and the iconic (and increasingly syndicated) presence of museums and galleries across the globe, suggest more than just the presence of private and commercial sponsorship – powerfully operative as such influences may seem. Artists and their audiences retain the capacity to demonstrate agency and judgement; to think and to act beyond – or in spite of – a prevailing commodity culture. Although frequently themed by the homogenising concerns of a Westernised culture industry, postmodern art also delineates the less palatable aspects and fictions of a globalised polity. In this sense, like some of its avant-garde antecedents, postmodern art signifies an open-ended testament to possibility.

SUMMARY

This chapter has introduced ideas and themes which have been used to characterise the postmodern. It has been suggested that we might understand the postmodern not only as a particular sensibility and as an approach to making art, but as a distinct economic and political period. A

case has been made for identifying the mid- and later 1960s as the point at which abstract Modernist art increasingly gave way to a range of conceptually based practices, largely indifferent to issues of medium-specificity or flatness. This chapter has suggested that such a paradigm shift coincided with wider political, social and economic step-changes which have played a tangible part in re-orientating aesthetic concerns and subject matter.

However, despite the tidy linear narrative just outlined, postmodern themes have been with us for some time, possibly since Duchamp's *Fountain* (1917). Understood like this, it could be argued that the institutionally powerful theory of Modernism (explored in Chapter 2) was instrumental in simplifying the development and reception of modernist art practices in such a way that earlier avant-garde challenges were marginalised in order to privilege a specific reading of artistic development.

When we identify an apparent return to figuration in the 1960s, the use of photography, an installation-based Minimalism, and far more politicised avant-garde art forms, as allegedly symptomatic of the postmodern, we should also be aware that similar concerns typified much of the modern art of the 1920s and 1930s. However, the recently recovered legacy of these so-called 'historic avant-gardes' such as Dada, Surrealism and Constructivism reminds us that the art of the last few decades can equally be understood as the partial re-continuation of an incomplete modernity, and that obituaries of the latter's passing are premature. Rather than identify an entirely distinct postmodern sensibility or period, perhaps we should also recognise a late – and still salvageable – modernity.

FURTHER READING

The available reading on postmodernity and related subjects is extensive. Useful and accessible guides through aspects of the postmodern labyrinth include *Introducing Postmodernism* by Richard Appignanesi and Chris Garratt (Duxford, UK, 1995); *Postmodernism* (Movements in Modern Art Series) by Eleanor Heartney (London, 2001); and *The Art of Today* by Brandon Taylor (London, 2005).

The Cambridge Companion to Postmodernism, edited by Steven Connor (Cambridge, 2004), provides an insightful and incisive introduction to some of the diverse aspects of postmodern thought

and culture. The introduction to the anthology of essays includes a useful genealogy on the development of postmodernism.

Themes in Contemporary Art by Gill Perry and Paul Wood (eds) (New Haven CT and London, 2004) is one of a series authored for the Open University course, 'Art of the Twentieth Century'. It provides an excellent and highly readable introduction to the range and contexts of art practice from the later 1960s onwards.

After Modern Art 1945–2000 by David Hopkins (Oxford, 2000) offers a succinct and well-illustrated account of the postmodern period, with a focus on European and American developments in art.

Journals and magazines which are concerned with the art and theory explored in this chapter include *Art Monthly, Artforum, Art in America, Flash Art, October Magazine* and *Studio International*.

GLOBALISED PROXIMITIES AND PERSPECTIVES

INTRODUCTION

> The first proposition I make ... is that our members should be banned for saying that *culture is a weapon of struggle*. ... Allow me, as someone who has for many years been arguing that art should be seen as an *instrument of struggle*, to explain why suddenly this affirmation seems not only banal and devoid of real content, but actually wrong and potentially harmful.
>
> (Sachs 1990: 187; 1991: 10)

This assertion, by Albie Sachs, Justice on the Constitutional Court of South Africa, was printed in the *Art from South Africa* exhibition catalogue (June 1990–July 1991). It was made soon after Nelson Mandela's release from Robben Island and the lifting of the ban on the ANC. Although the catalogue discussed these issues, it also highlighted the status and the role of art in a *postcolonial* and globalised world.

This chapter explores the implications of postcolonialism, *globalisation* and postcolonial studies for contemporary art and art history. It also foregrounds themes and subjects which have been explored by contemporary artists in relation to postcolonialism and globalisation.

GLOBAL AND LOCAL PERSPECTIVES

What does *globalisation* mean to you? Fair Trade coffee? Call centres in India? Aid for disaster victims? International involvement in the Middle East? Cheap manufactured goods from China? A McDonald's or sushi bar on every high street? Or perhaps exhibitions of contemporary art from South Africa ('Art from South Africa', 1990–91), Argentina ('Argentina 1920–1994', 1994) or the Middle East ('Word into Art: Artists of the Modern Middle East', 2006)? All these have global implications but what do they really signify to the people involved? Is globalisation about economic advancement or exploitation; individual freedoms or shared responsibilities; *fusion* or separation?

There is a common thread running through this subject. At every level of engagement, postcolonialism involves recognising different people's perspectives. This might include local and indigenous communities or members of diasporas – effectively every group, nation or region in the world. Many factors frame these multiple and different perspectives – ethnicity, class, *gender*, identity, tradition, *modernity*, history and place. These frequently centre on concerns for equitable treatment, economic security and autonomy. Visualising the reactions of and interactions between different individuals and groups, we can perhaps grasp some of the problems and complexities of the postcolonial world (Young 2003: 1–8).

How does all this impact upon art and art history? It raises questions about the historically Westernised perspective of art history and its engagement with *non-Western* art. It provides new themes for artists who respond to the issues arising from postcolonialism and globalisation. And it challenges art historians to engage with new horizons in art. But before exploring these points further, we need to define globalisation and postcolonialism.

GLOBALISATION

Globalisation is characterised by increasing interaction, communication and trade between all parts of the developed and developing world. It has become increasingly prominent as an issue since the decolonisation of Western European *imperial* territories from the late 1940s and since the end of the Cold War in the 1980s.

Globalisation is frequently associated with increasingly international corporate power and the relocation of services to areas of cheap labour and poor employment standards. Radical responses to global trade negotiations and the perceived power of multinationals to exploit this situation are frequently televised. Conversely, increasing prominence is also given to ethical trade and production arrangements. All of these circumstances engage with a growing awareness and recognition that local needs should be respected around the world (Renton 2001: 4–8; Young 2003: 129–37).

Politically and culturally, globalisation is sometimes equated with Westernisation, capitalisation or Americanisation (Gaiger and Wood 2003: 289). This viewpoint argues that the end of the Cold War left only one superpower – the United States of America – whose political ethos (capitalism) and Western *culture* (television, music and fashion) dominates and populates the rest of the world. However, this general characterisation conceals more complex interactions. It does not adequately register internal tensions in developed countries, for example, those associated with black culture in the USA (Hall 2003 [1992]: 291–92). It does not acknowledge the strength and impact of some non-Western cultural forms, for example music and dance (Young 2003: 69–79). In art, globalisation encompasses many different forms of Western and non-Western engagement which result in *fusion* or *hybridisation,* but which can also involve new perspectives on traditional art making, meaning and display (Maharaj 2003 [1994]: 298–304; Butler 2003 [1998]: 305–19).

POSTCOLONIALISM AND POSTCOLONIAL STUDIES

Where globalisation is a rather nebulous headline term, postcolonialism has more specific meanings. *Postcolonialism* seeks to redress the bias and manipulations of Western European and US *colonial* and imperial enterprises. Its goal is equal status in the world for non-Western societies and as such it champions their cause. It has been characterised as the struggles of colonised peoples for 'material and cultural well-being' against the context of past and present colonial and imperial impositions (Young 2003: 2).

Postcolonial theory is about the study of the impact of European colonial activities on the rest of the world since they began around the eighteenth century (Ashcroft and Ahluwalia 2001: 15). The

term postcolonial is sometimes taken to mean the situation in the world since the decolonisation of Western empires from the late 1940s, but can more broadly be taken to encompass the impact of colonial and imperial activities since the eighteenth century.

It is difficult to see a line between these two subjects but it is perhaps best to see globalisation as one way of looking at the situation in the world today and postcolonialism as the response to that situation.

ORIENTALISM

The world situation has changed radically since 1945. We have witnessed the end of Western European imperial and colonial systems and the end of the Cold War. We can also register shifts away from political systems of oppression in some places (for example, the Civil Rights Movement in the USA and the end of apartheid in South Africa). The interpretation of the global situation has also been changed through the work of the Palestinian academic Edward Said (1935–2003). In *Orientalism* (1978), Said explored how Western Europe systematically constructed the concept of the Orient – the East, the *other* – to support its self-perception and its powerbase.

The terms orient and occident are alternative words for east and west (from the Latin words *oriens* and *occidens* signifying the rising and setting of the sun). Orientalism emerged as an academic subject from the study of Eastern languages and their relationship to Western languages in the late eighteenth century. It has been argued that the discipline was built on the assumption that 'Western civilisation was the pinnacle of historical development' (Ashcroft and Ahluwalia 2001: 53).

In *Orientalism*, Said outlined how Western institutions, cultural structures and modes of thought had constructed the concept of the Orient since the eighteenth century. He argued that in defining the Orient, Western Europeans had created a homogeneous other which was subordinated to, and controlled by, Western powers.

Western encounters with non-Western cultures have been characterised by colonial, imperial and economic imperatives. Within these interactions, art has portrayed the Orient as fantastical, exotic, different, dangerous, sexually provocative or inspirational. In each case the Western eye has sought to subsume and rationalise unfamiliar

visual cultures within Western art. Said's analysis, however, goes far beyond culture to reveal the roots of Western colonial and imperial exploitation and its manipulation of non-Western political, social, economic and military circumstances.

Said argued that inasmuch as the Orient is a fabrication, a myth, of European and latterly American making, so Western writers, historians, economists and administrators have variously constructed a perception of the West based on its existence. This perception is one of superiority and domination – of civilisation; of social and political structures; of culture and of values (Said 1978: 1–9).

Robert Irwin (b. 1946) has recently written a rebuttal to Said's characterisation of Orientalists and the academic disciplines which involve the study of Islamic, Arabic and Middle Eastern languages, history and culture (2006). Irwin argues that Orientalists through history have largely been motivated by a quest for knowledge rather than a desire for cultural *hegemony*. He asserts that such a legacy has the positive potential to bridge differences between Western and Islamic cultures.

HISTORICAL PERSPECTIVES WITHIN ART HISTORIES

We can see such Western European bias by taking a quick look at 'key' moments in art history. Vasari wrote in Italy about Italian *Renaissance* artists. Winckelmann was German and wrote about the *Classical* Greek heritage of art in Western Europe in the eighteenth century. The Impressionists emerged in France and the radical changes of *avant-garde* art that followed spread across much of Western Europe. Karl Marx was a German living in Britain and Clement Greenberg was an American writing in New York. And Brit Art is, well, British. The list could go on.

You might say, yes, but what about the European fascination with Chinese and Indian art? What about the impact of Japanese, native African or Oceanic visual forms on artistic developments in the late nineteenth and early twentieth centuries? What about Gauguin in Tahiti? You would be right to say that non-Western art has been involved in Western art and art history, but you would be wrong to think that art history has been 'about' non-Western art, at least until relatively recently. In each of these historical cases non-

Western art was perceived and mediated through the prism of Western ideas and artistic values.

BOUNDARIES AND ART HISTORIES

Starting with the *Enlightenment* period, the Western European quest for knowledge sought to identify and categorise the known world. This was as true for art and art history as for the study of any branch of the human or natural world. Preziosi even dates the definition of the Western concept of art to this period (2003). This enterprise involved judging art's qualities and defining classifications and hence boundaries in relation to the Western European tradition.

These periodisations and classifications have become the standard way of separating and comparing artistic forms and changes. For example, boundaries are perceived between the Renaissance and the High Renaissance (defined by Vasari 1991 [1568]: 277–83); the avant-garde from its predecessors; or *Modernism* from postmodernism. Comparisons are made between avant-garde art in France, Britain and Italy. Classifications and boundaries help identify differences, focus research and aid understanding of a vast subject. The old imperial adage of divide and rule seems appropriate.

The comparison of periods and classifications considers and defines the relationships between them such as influence, *appropriation*, innovation, *difference*, development, decline, evolution or revolution. These comparisons involve value judgements which set one art form against another and define differences in qualitative terms. In this way oppositions are established which can be understood within the processes of *semiotics* (see Chapter 6). For example, the analysis of the style of an art work is often described with reference to another work – 'A' is more/less naturalistic than 'B'; 'Y' handles colour or light more/less vibrantly than 'Z'; 'C' is more/less figurative than 'D'. The language of art history sets up and exploits oppositions as a way of understanding the nuances of artistic forms.

Classifications and boundaries exist within Western art, but there has also always been a boundary around Western art. This boundary is a more nebulous thing, not related to developmental change or a geographical border, but signifying more fundamental oppositions. It is this boundary that, Said argued, was constructed to

differentiate Western Europe from the rest of the world. In relation to art, it has been used to assert Western cultural superiority.

EAST AND WEST

Oh, East is East, and West is West, and never the twain
 shall meet,
Till Earth and Sky stand presently at God's great
 Judgment Seat;
But there is neither East nor West, Border, nor Breed,
 nor Birth,
When two strong men stand face to face, tho' they
 come from the ends of the earth!
(Rudyard Kipling, 'The Ballad of East and West')

Said proposed a form of reading – called contrapuntal reading – which revealed the perspective of the colonised and the 'constitutive power of imperialism' within a text (Ashcroft and Ahluwalia 2001: 92–96). In his reading of Kipling's *Kim*, Said revealed the deep-seated perceptions of the efficacy of British rule in India as well as the 'love for and fascinated attention to [India's] every detail' (Ashcroft and Ahluwalia 2001: 101–4; Said 1993: 195). In the above poem, we can read Kipling's revelation of the incompatibility of and the perceived empathy between East (India) and West (the British). For Said, East and West were concepts developed within Western thought which differentiated Europe from its historical other – its geographic east. In semiotic terms, they are signifiers with evolving signifieds, which do not simply mean regions on a map.

The two opposed concepts of East and West have a long history. As with so much of Western thought, the germ of the idea can be traced to classical times. Histories and legends from Classical Greece detail the separation, conflicts and wars between the Greeks in Europe and the barbarians and Persians in Asia (Herodotus 1972: 41–43). Herodotus' description of the Persian army crossing the Hellespont, the sea straits between Europe and Asia, symbolises the divide (Herodotus 1972: 456–65). Now in modern Turkey, this geographic location continues to mark one of the psychological boundaries of Western Europe, more recently witnessed in the debates over Turkey's entry into the European Union.

Claims supporting Western European hegemony followed the perception that Classical Greece was peopled by races of European origin. For generations of scholars, Classical Greece was the foundation of Europe – conceptually, philosophically, artistically and anthropologically. This viewpoint was challenged by Martin Bernal's book *Black Athena: The Afroasiatic Roots of Classical Civilization* (1987). He contended that the origins of Western culture were actually Egyptian and Asian rather than northern European (or Aryan). Bernal argued that scholars had concealed this association and that Greece had in fact drawn its culture from Egypt. This polemic was challenged by scholars for its speculation and its perceived exaggeration of racial and cultural interdependencies (Lefkowitz and Rogers 1996). However, Bernal's contentions were not new and had been argued previously by Afrocentric scholars. This debate is ongoing – see for example Bernal (2001).

ARTISTIC INTERACTIONS ACROSS THE EAST/WEST BOUNDARY

Artistic forms have crossed the boundary between East and West since classical times. Art forms from Classical Greece spread as far as the Black Sea (Cormack 2006: 13–17) and the Gandhara region, around the northern border between modern Afghanistan and Pakistan (Dehejia 1997: 79–100). From late antiquity until the Renaissance, the East–West division was characterised by increasing differentiation between Western Europe and the Byzantine Empire, which had emerged from the western and eastern parts of the Roman Empire. During the Crusader period, Byzantine and Western art fused on the eastern borders of Europe, creating *hybrid* forms such as the *icon* of **St George**, mid-thirteenth century, in the British Museum (**Figure 26**, p. 200) (Cormack 2000: 179–92).

Interactions and appropriations of artistic forms across boundaries were often related to power dynamics. Venice, for example, drew upon Byzantine art and architecture in the basilica of San Marco and developed relationships with Byzantium's successor, the Ottoman Turks. The 'Bellini and the East' exhibition in London and Boston, MA, illustrated Venice's use of art in building relationships with the new Eastern power (Howard 2005: 12–31).

As contact between Western powers and Asia expanded, artists responded to the desire for the exotic. Trade with Asia brought porcelain, textiles and other goods from the East, sometimes made specifically for the Western market. From the seventeenth century, European manufacturers responded to the demand for Chinese and Oriental styles with their own designs, such as the hugely successful willow pattern (Jacobson 1993: 198–99). The style of Chinoiserie incorporated fantastical scenes of the East, including exotic motifs such as dragons, imaginary landscapes, views, birds, buildings and costumes (Jacobson 1993). It was the idea of the exotic East which captured the imagination, rather than the reality. A comparison between Chinoiserie and art from contemporary China (Quing dynasty, 1644–1912) illustrates this (see for example Jacobson 1993: 39, 100–107; and Krahl 2005: cat. no. 181–82).

Interest in India grew as the subcontinent succumbed to British imperial hegemony from the late eighteenth century. The Royal

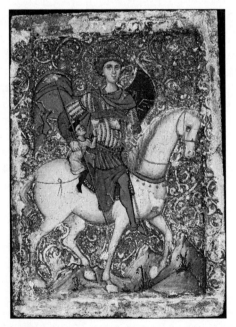

Figure 26 *St George*, icon, mid-thirteenth century, 26.8 × 18.8cm, © copyright the Trustees of The British Museum.

Pavilion built by the Prince Regent in Brighton (1815–22), with its Indian architectural forms and Chinese interior decorations, provides an extreme view of the early nineteenth-century perception of the East (Jacobson 1993: 177–207). But Britain was not the only Western European country to expand its colonial interests around the world. Spain, Portugal, the Netherlands, France and Belgium all had colonial territories by the beginning of the twentieth century.

PERCEPTIONS OF NON-WESTERN ART

The predominant view of non-Western art within Western European thought has been of an exotic other; a fascination with non-European forms, imaginary and fantastic peoples, lives and landscapes. As travel between Europe and the rest of the world grew through the nineteenth century, more Europeans came into direct contact with non-Western societies. The colonial and imperial structures maintained Western hegemony and supported the idea of Western superiority in all aspects of culture (Ashcroft and Ahluwalia 2001: 50–54).

Artists drew upon direct encounters in the East, portraying it as exotic but also inferior. Words used to describe the other were often diminishing or derogatory even when they sought to praise, for example 'noble savage'. The term *civilisation* came to encapsulate the West's self-perception in opposition to the rest of the uncivilised world.

The Pre-Raphaelite artist William Holman Hunt (1827–1910) travelled in the Middle East and painted images of the region which juxtaposed the civilised Westerner against the exotic native. A close study of *A Street Scene in Cairo: The Lantern-Maker's Courtship*, c.1854–60 (**Figure 27**, p. 202) (Barringer 1998: 118–33), reveals these oppositions. A traveller in Western top hat and frockcoat in the lower right of the image struggles with a local pedlar whilst the boy and girl in the foreground are courting. The Westerner is astride a donkey, placing him in a position of power, but the nature of his transport signifies the problems of travel in the region. The boy in the foreground looks hopefully at the girl; he tries to pull off her veil while she demurs, but the posture of her feet suggests relaxed enjoyment of the attention. Although the couple are ostensibly dressed in Middle Eastern clothing, the implication of the

action is a Western construct. The boy's idleness, the fascination with the veil, the girl's acquiescence and the unfamiliar locale characterise the Eastern other as lazy, sexually provocative, exotic and alien. In contrast the Western traveller brings the prospect of civilisation to this alien world.

Other artists such as Jean-Léon Gérôme (1824–1904) created a fantasy on a more intimate level (see for example Benjamin 1997). Gérôme painted semi-erotic scenes of an Eastern world dominated by harems, bathhouses and slave markets which reinforced the idea of an exotic and subversive East (Nochlin 1989: 33–59).

WESTERN CULTURAL APPROPRIATIONS

In the second half of the nineteenth century in France and Britain, Impressionist and Post-Impressionist artists responded to non-Western

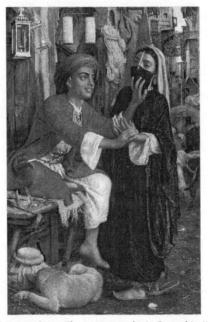

Figure 27 *A Street Scene in Cairo: The Lantern-maker's Courtship*, William Holman Hunt, c.1854–60, oil on canvas, 54.6 × 34.9cm, © Birmingham Museums and Art Gallery.

art. In 1854, Japan was forced to open its borders to trade with the West for the first time in more than 200 years. The appearance of Japanese art and artefacts in the West inspired artists such as Monet, Manet, Edgar Degas (1834–1917), van Gogh and Henri de Toulouse-Lautrec (1864–1901) to incorporate Japanese motifs and formal qualities into their works (see for example Rubin 1999: 71–76; Evett 1983: 82–106). When Paul Gauguin settled in Tahiti in 1891 he painted the local people, using the vibrant colours of the tropical island within his own language of religious, sexual and symbolic meanings (Brettell 1999: 147–50; Shackelford and Frèches-Thory 2004: 168–203).

From the early twentieth century native artefacts from Africa, Oceania and Asia provided stimulus to artists such as Matisse, Picasso and the abstract sculptor Brancusi (see for example essays in Hiller 1991). The non-naturalistic forms of these objects encouraged artists to explore similar idioms in their own works. For many decades this development has been called primitivism in reference to the art that influenced it. As a central component of early *abstraction*, native art forms were removed from their original context and use, frequently homogenised into a *primitivist* style. It was not until an exhibition at the Museum of Modern Art in New York in 1984 entitled '"Primitivism" in Modern Art: Affinities of the Tribal and the Modern', that controversy arose over this characterisation of non-Western art and the elision of its own cultural significance (Hatt and Klonk 2006: 231).

POSTCOLONIAL STUDIES

Said's work fundamentally changed the way Western academics perceived and approached cultural and historical studies. The term East, with its historically loaded significance, is now often avoided, being replaced by non-Western. This term acknowledges the separate perspectives of Western and non-Western societies without involving a value judgement.

As we have noted, Said's concept of the other is linked to semiotic theory. Chapter 4 considered the idea of oppositions and how they are used in Derridean *deconstruction* to reveal the hidden assumptions and tensions within a text or *discourse*. The chapter also outlined Foucault's theories relating to the control of knowledge and strategies of power within societies. *Postcolonial studies*

have drawn on these approaches for exploring subliminal attitudes to non-Western cultures and the underlying power dynamic of Western imperial hegemony.

A key theorist within these debates, currently at Harvard, is the scholar Homi K. Bhabha, born in 1949 in Mumbai, India. Bhabha uses, for example, Derrida and Foucault to explore the nuances of postcolonial issues. His reading of Frantz Fanon's (1925–61) writings on the postcolonial condition considers the 'dialectic of colonial space and psyche' (Bhabha in Huddart 2006: 24–31). Fanon's works, including *The Wretched of the Earth* (1961) and *Black Skin White Masks* (1952), have been widely influential within postcolonial debates (Young 2003: 121–47). Bhabha's approach to postcolonial issues not only seeks to challenge the power of the coloniser, but also proposes new ways of reading and writing which differ from the paradigms of Western knowledge systems. He is particularly concerned with the interfaces and instabilities of the colonised/coloniser relationship. Bhabha has developed influential concepts within postcolonial theory relating to the themes of the stereotype, hybridity, the *uncanny* and the nation.

Postcolonial commentators have carried out extensive studies of these issues in literature and film. These include Slavoj Žižek (Myers 2003); bell hooks (b. 1952); and Gayatri Chakravorty Spivak (b. 1942) (Sanders 2006). These studies centre on the relationships between peoples with different perspectives and how those relationships have been manipulated by the colonial and imperial systems of the West. There is concern for the subjugation and distortion of the social and cultural structures of colonised people. Studies of *translation* consider how meaning is transferred from one culture or language to another (Sanders 2006: 30–52). The different and specific circumstances of groups of people affected by colonial and imperial systems – 'native informants', diasporas, migrants, immigrants – are articulated to support the goals of autonomy, security and identity.

The diversity and complexity of the subject raises specific issues and viewpoints, for example:

- The *essentialist* view assumes an essential identity, e.g. 'black', which can be strived for. This has been questioned, and an alternative view is that hybridity can offer the opportunity to develop and define identity (Hall 2003

[1992]: 290–96). Said argued that culture is fundamental to constructing identity and therefore inherent in the influence wielded by Western imperial powers (Ashcroft and Ahluwalia 2001: 85–116).

- There are problems with moving forward in the challenges of modernity versus tradition. Modernity can be perceived as Westernisation, which risks subsuming a native culture, but tradition can also be problematic if it involves gender or other forms of oppression such as in native class and ethnic structures (Young 2003: 93–120). These problems are overlaid by the legacy and realities of a colonial past and present which can distort perspectives. Feminist art in these countries is engaging with this complex set of issues (Lloyd 1999).

- More broadly, the assertion or construction of identity in the postcolonial world can be distorted by the legacy of colonial and imperial constructs of ethnicity and nationhood (Schoenbrun 1993: 48; Finnström 1997).

- Over and above all these problems is the constant challenge to enable the oppressed groups to find a voice. Central to this debate is Spivak's essay 'Can the Subaltern Speak?' (1985). The term subaltern, coined by Gramsci, in postcolonial studies refers to marginalised and oppressed groups whose voice is often not heard or recognised (Young 2003: 925).

Other issues relate to whether postcolonial theorists have a real impact or interest in making a difference. Some claim that they are too far removed from the specificity of local circumstances and the complexities of local traditions. Postcolonial studies are particularly concerned to take account of all divisions which lead to subjugation of groups along lines of gender, race, class and identity (Young 2003: 18).

GLOBALISED ART AND MORE RECENT PERSPECTIVES

In 1996, Mark Wallinger (b. 1961) remade the Union Jack in the colours of the Irish tricolour. Titled **Oxymoron**, the work questioned what British identity actually meant. What was the status and affiliation of Ulster Unionists, or the position of expatriate Irish

communities living in mainland Britain? As Stallabrass notes, Wallinger's piece was 'an uncomfortable condensation of colonial history and current dilemma' (1999: 227). As such, **Oxymoron** drew attention to issues of identity, hybridisation and diasporas which have framed this chapter. How have artists responded to a globalised and postcolonial world?

Mumbai-born and London-based artist Anish Kapoor R.A. (b. 1954) might be seen as part of a postcolonial diaspora. A student of Hornsey College and a graduate of Chelsea School of Art and Design, Kapoor represented Britain at the 1990 Venice Biennale, taking the Turner Prize a year later. Kapoor made his name in the early 1980s with abstract, biomorphic fibreglass sculptures and installations. His signature-use of brightly coloured pigments, especially blue and ultramarine, acknowledges the mythology, temples and markets of India (Dehejia 1997: 418). Since the 1990s, Kapoor's work has become increasingly architectural in scale. He was awarded the third commission in the Tate Modern's 'Unilever series' for works to be installed in the Turbine Hall. Filling the length of the space, Kapoor's **Marysus**, 2002, was made from three steel rings joined by a PVC membrane, which Kapoor has described as like 'flayed skin' (http://www.tate.org.uk/modern/exhibitions/kapoor). In Greek mythology, Marysus was a satyr who was flayed alive by the god Apollo for his presumption.

Much of the earlier video and *installation*-based work of the Lebanese-born artist and exile Mona Hatoum (b. 1952) directly referenced political themes arising from conflict in Lebanon and the imprisonment and suffering of the Palestinian people. **Light Sentence**, 1992, was a major installation work comprising a rectangular arrangement of stacked wire mesh lockers, illuminated by a single, mobile light bulb. The moving light source constantly re-framed the throw of shadows across the gallery spaces and the installation. As various commentators have recognised, this work provokes contradictory responses: the wire lockers evoke animal cages, containment and imprisonment, but the flickering shadows create a fugitive sense of space and light which disorientates the viewer. As Perry notes of this work:

> Whatever political or domestic meanings we seek to identify, they are enmeshed with our perceptions of the work's aesthetic legacy – the

abstract patterns, the shadowy grids and strange luminous sense of flux produced by each.

(2004: 248)

Whilst the context of Hatoum's life and experience might influence a particular reading of these and similar works, they are suggested by 'association' rather than by explicit narrative (Perry 2004: 248).

Gerald Laing's recent *Iraq War Paintings* (exhibited 2004–5), including **Study for Capriccio** (**Figure 24**, p. 172), engage with the US and Britain's most recent military campaign in Iraq. Although the subject of this image is the widely publicised and inhumane treatment of Iraqi prisoners, it references the wider context of neo-imperial interventions which have characterised the early years of the new millennium. However, Western involvement in Iraq is not new and is not simply a consequence of recent global changes.

For example, Young presents the testimony of an Iraqi citizen under the title 'Bombing Iraq – since 1920' (2003: 32–44). Chronicling Britain's involvement in Iraq through the eyes of someone whose family have witnessed British bombings for four generations, the writer is candid about the losses he has experienced. Its unsentimental tone emphasises, as Laing's work does, the continuing impact of Western imperial policies on the region. Laing's oblique but symbolic inclusion of the Brillo box motif might be read as alluding to the imposition of Western values and norms. One of the reasons why this and other related images have become so iconic was the speed with which they were circulated around the world by satellite media and internet technologies – another feature of globalisation.

Just from these brief examples, it should be apparent that such work cannot, and should not, be simply read or ghettoised as metaphors for diasporas or exile. This is not to suggest that such concerns are not powerfully operative in the examples cited, or to ignore the resonance of personal experience and memory in forging either a personal identity or a body of work. It is, however, to recognise that experiences of, and exposures to, dislocation and postcolonial identities are matters of degree within a world of increasingly interconnected and hybridised cultures – and conflicts.

The British-born but Amsterdam-based artist Steve McQueen (b. 1969) came to prominence with the formal recognition given to

his work by the award of the Turner Prize in 1999. His 8mm film piece **Western Deep**, 2002, depicts the working conditions for migrant labour in South Africa's Tautoma goldmines. Influenced by the film techniques of Warhol and avant-garde cinema, McQueen uses non-linear construction, repetition, extreme noise, silence and long periods of darkness to convey the alienating and claustrophobic conditions faced by black workers mining gold for sale and export (Ratnam 2004b: 280–81). It is not that poor working conditions within developing countries are new, but more that globalisation collapses geographical distance, creating new conjunctions of exchange and transparent interdependence.

Cultural and colonial appropriation and the assumptions behind Westernised canons of high art are among the themes powerfully explored in the work of Yinka Shonibare (b. 1962). In one installation, **Mr and Mrs Andrews**, 1998, he casts the couple depicted by Gainsborough in bronze and fibreglass, but without the surrounding landscape, their heads and identity. Both figures are dressed in African batik textiles (ironically the fabric is made in Indonesia due to a past colonial intervention), a reference to the divisive realities of Britain's past and its involvement in colonial exploitation and slavery.

AND HYBRIDISED CERAMICS . . .

Taking a different *medium*, consider the melding of ideas in Grayson Perry's glazed ceramic piece **Barbaric Splendour**, 2003 (**Figure 28**, p. 209). Perry is widely known for his highly decorated earthenware and glazed ceramics, although he has produced embroidery and photography, and has more recently combined his artistic career with a regular column for *The Times*.

Barbaric Splendour and its inlay of floral cartouches evokes the shape of decorative Chinese or Japanese porcelain, although the geometric motifs on its lip suggest Greek ceramic or textile decoration. The incongruous imagery of this piece is explored in Chapter 5, but its form clearly references the ceramic culture of Asia. Describing his fascination with the 'Orient', Perry has written:

> I am a lover and plunderer of art from the East. I like to think I am a tiny part in that cultural exchange that has been going on for centuries . . .

I have always loved the artistic version of Chinese whispers that produces such wonderful hybrids.

(Perry 2006b: 16)

As he acknowledges, Perry's adoption of non-Western forms typifies a wider history of usage discussed earlier in this chapter. However, the personal inflexion and content which he brings to **Barbaric**

Figure 28 *Barbaric Splendour,* Grayson Perry, 2003, glazed ceramic, 67 × 35.5cm, courtesy of Victoria Miro Gallery, © the artist.

Splendour and pieces like it, individualise and differentiate Perry's work, suggesting an innovative example of hybridised and reflexive art.

TOWARDS A GLOBAL FUTURE: *DOCUMENTA* 2007

Documenta is widely regarded as among the most important exhibitions of contemporary art. It was established in 1955 with the aim of reconciling 'German public life with international modernity and also to confront it with its own failed Enlightenment' (http://www.documenta12.de/english/information.html). The 12th Kassel Documenta was held in 2007. Among the questions which framed its curatorial interests are these:

- Is humanity able to recognise a common horizon beyond all differences?
- What do we have to learn in order to cope intellectually and spiritually with globalisation?

Although these questions resonate beyond the boundaries of art and art history, this chapter has attempted to underscore the extent to which art and its histories are profoundly implicated in the ongoing project of late modernity and its globalised future.

A GLOBALISED ART HISTORY?

So what is art history's response to the challenge of globalisation and postcolonialism? A quick review of the syllabi of many university art history departments might suggest – not much. Still focused largely on teaching the Western *canon*, some of these departments have, however, begun to look at how non-Western art history can be integrated into the curriculum. The University of Sussex, the Open University, and Middlesex University ran the GLAADH project (Globalising Art Architecture and Design History) (2001–3) which sought to encourage departments to broaden their curriculum and incorporate globalised perspectives. The experiences of many departments involved indicate the issues and successes inherent in such a venture (see http://www.glaadh.ac.uk/info.htm). In the US similar projects have been underway for some time, but more radical revisions have also been proposed (Preziosi 2003).

The 2006 AAH conference also questioned art history's relationship with globalisation. One conference strand considered art historical engagement with the global and local perspectives of contemporary art, whilst another sought innovative approaches to the traditionally marginalised art of Oceania, Asia, Africa and the Americas. Recent publications, some included in this chapter, suggest a widening horizon covering contemporary art from non-Western cultures. Art history book series have begun to move their focus beyond Western Europe, although it predominates.

Postcolonialism and globalisation challenge art historians and artists with evolving cultural paradigms and perspectives in which Western European art is only one trajectory of many. Ultimately, art practice and art histories mediate the changing dynamic between countries and peoples; between the old colonial empires and those previously ruled; between the rising global powers and those displaced by conflict, famine and the transformations of international capital.

SUMMARY

This chapter has introduced the concepts and themes of globalisation and postcolonialism. Globalisation has been characterised as the increasingly close connections and interactions across the world made possible by recent technological and economic developments. Postcolonialism on the other hand is the response of academics and activists to past and present Western colonial hegemony, in pursuit of an ethical and equitable future. Central to both are the differing perspectives and aspirations of peoples across the world. Since the end of the Second World War, and particularly since the fall of the Berlin Wall, the USA's cultural, economic and military dominance and its relationship with the rest of the world, have foregrounded postcolonial issues and debate.

Edward Said established the theoretical foundations for postcolonial studies by identifying how the West has characterised the East as the other since the Enlightenment. In all forms of cultural endeavour and enterprise, Europeans created the concept of an inferior Orient opposed to a superior West. The boundaries between East and West have provided the locus for artistic hybrids and appropriations since classical

times. In recent centuries, non-Western art has been perceived as exotic, dangerous, erotic and primitive.

Postcolonial studies explore the relationships, issues, tensions and problems of peoples seeking to assert identity and recognition. Contemporary artists have engaged with and mediated these issues in innovative and provocative ways, creating hybridised art forms which point to these new global proximities. The Documenta exhibitions in Kassel provide a forum for these artistic interventions. Art historians are seeking ways to respond within a postcolonial and globalised world in which Western art no longer provides the only cultural narrative.

FURTHER READING

Robert J. C. Young's *Postcolonialism: A Very Short Introduction* (Oxford, 2003) offers a powerful insight into the issues surrounding this subject.

A range of works by Bill Ashcroft and his colleagues provide clear explanations of the theory of postcolonial studies. These include Bill Ashcroft and Pal Ahluwalia's *Edward Said* (London and New York, 1999, 2001); Bill Ashcroft, Gareth Griffiths and Helen Tiffin's *The Empire Writes Back: Theory and Practice in Post-Colonial Literatures* (London and New York, 2002), and Ashcroft's *The Postcolonial Studies Reader* (London and New York, 2005).

Also important are Edward Said's foundational texts, *Orientalism* (1978) and *Culture and Imperialism* (1993).

Specifically art historical engagements include *Views of Difference: Different Views of Art*, edited by Catherine King (New Haven CT and London, 1999), which explores art in pre-colonial, colonial and postcolonial contexts. Also *Critical Perspectives on Contemporary Painting: Hybridity, Hegemony and Historicism*, edited by Jonathan Harris (Liverpool, UK, 2003) and sections in *A Companion to Art Theory*, edited by Paul Smith and Carolyn Wilde (London, 2002) and *Themes in Contemporary Art*, edited by Gill Perry and Paul Wood (New Haven CT and London, 2004).

ART AND ART HISTORY: WEBSITE RESOURCES

INTRODUCTION

The internet offers extensive resources on art and art history, including search engines, encyclopaedias, specialist art sites, and information on museums and galleries. This section provides details of some relevant resources and suggestions for use in further research. A word of warning – the World Wide Web (www) is an inclusive forum, with the benefits and disadvantages this brings. Where possible, information gained from the internet should be verified from other sources. For example, art work titles and dates can sometimes be misleading or incorrect.

SEARCH ENGINES

Many internet sites have search facilities but the major providers are Google (http://www.google.co.uk), Yahoo (http://www.yahoo.com), Altavista (http://www.altavista.com) and Microsoft Windows Live Search (http://www.live.com). In addition to basic search facilities, which can be used to locate gallery sites for example, these search engines also provide directories for images. Selecting the 'Images' option in the search engine accesses images and their web location.

These search engines are primarily useful for viewing and locating art works. For example, to search for Vermeer's **Woman Reading a Letter**, *c.*1662–63, enter 'Vermeer woman', 'Vermeer reading letter' or 'Vermeer lady'. These combinations will retrieve various images, some of which will be copies of the required art work. Click on the required image to view the art work at its web location.

Different search engines produce different results, with many images linking to websites with limited additional details. It may be worth using several search engines with different word combinations to look at a range of images. Once the art work's location has been identified it may be more practical to go directly to the gallery website for further information (see below).

ENCYCLOPAEDIAS AND SPECIALIST ART WEBSITES

Many of the specialist art websites are generally targeted to the art market (sales of original art and reproductions) but they also provide extensive information and images to support research and study. Examples of these websites are Art.com (http://www.art.com), World Wide Art Resources (http://wwar.com) and Artnet (http://www.artnet.com). Some sites offer access to information about artists, their works, galleries and some art criticism, for example Artchive (http://www.artchive.com) and Web Galley of Art (http://www.wga.hu), although coverage can be quirky!

A good source for artists' dates and their works' locations is Artcyclopedia (http://www.artcyclopedia.com). It can be searched on a name basis and provides dates, examples of works and links to relevant websites of international galleries. Gallery entries usefully link to the online catalogue entries for each artist.

The free encyclopaedia Wikipedia (http://en.wikipedia.org) is increasingly prominent as a learning resource. Although entries vary in coverage and academic detail, overall this is an excellent resource for introductory information on artists, art movements, concepts and contexts.

GALLERIES AND MUSEUMS ONLINE

Increasingly the major galleries and museums world-wide have their art collections online, often providing good-quality images for study,

dates, provenance details and descriptions. The main gallery or museum website usually has a 'collection' link which leads to the online collection webpage or website where art works can be viewed. Here is a list of some of the websites of major international collections:

- Tate, London, Liverpool and St Ives – http://www.tate.org.uk
- National Gallery, London – http://www.nationalgallery.org.uk
- British Museum, London – http://www.thebritishmuseum. ac.uk
- V&A, London – http://www.vam.ac.uk
- National Gallery Scotland – http://www.natgalscot.ac.uk
- Louvre, Paris – http://www.louvre.fr/llv/commun/home_ flash.jsp?bmLocale=en
- Musée d'Orsay, Paris – http://www.musee-orsay.fr
- Prado, Madrid – http://museoprado.mcu.es/ihome.html
- Rijksmuseum, Amsterdam – http://www.rijksmuseum.nl/ index.jsp
- Museums and collections in Berlin – http://www.smb.spk-berlin.de/smb/sammlungen
- Pinacoteca Vaticana, Rome – http://mv.vatican.va/Start New_EN.html
- The State Hermitage Museum, St Petersburg – http://hermitagemuseum.org/html_En/index.html
- MOMA, New York – http://www.moma.org
- Metropolitan Museum, New York – http://www.metmuseum. org
- Guggenheim, New York, Bilbao, Venice, Berlin and Las Vegas – http://www.guggenheim.org
- National Gallery of Art, Washington DC – http://www. nga.gov
- Art Institute of Chicago – http://www.artic.edu/aic/index.php
- J. Paul Getty Museum, Los Angeles – http://www.getty. edu/museum

OTHER RESOURCES

The Association of Art Historians (AAH) is the professional association founded to support and promote the study of art history. Its journal *Art History*, published five times a year, is a useful source

for contemporary debates on art and art history (website: http://www.aah.org.uk).

Other art-related publications which may be of interest include:

- *Art Monthly* – http://www.artmonthly.co.uk
- *The Art Newspaper* – http://www.theartnewspaper.com
- *The Burlington Magazine* – http://www.burlington.org.uk
- *Modern Painters: International Art Magazine* – http://www.modernpainters.co.uk
- *Frieze* – http://www.frieze.com

Another specific source of information about art historians is the *Dictionary of Art Historians* (http://www.dictionaryofarthistorians.org) which provides biographical details and bibliographies.

GLOSSARY OF TERMS

abstract describes representations which do not look like objects as they appear in nature; as a verb, **abstraction** refers to the process of achieving the above.

academic art literally refers to art which follows the principles of the **academy**, historically concerned with figuration and **naturalism**; sometimes used pejoratively to suggest unimaginative or inexpressive artistic practice. **Academies** are organisations which were established to regulate, codify and professionalise the practice of art as distinct from **craft**.

aesthetic originates from the Greek term aesthesis – what is perceived through the senses. From its origin arose a concern with how we respond to what we see. In the eighteenth and nineteenth centuries, **aesthetics** concerned ideas of beauty and claims to judgements of taste. In the later part of the nineteenth century, **aestheticism** was a movement which attempted to situate art outside of context or history. More recently the word **aesthetic** is often used to refer to an artist's overall practice or style, i.e. 'Picasso's aesthetic'.

alienated estranged or out of harmony (with nature). Marx gave the term four meanings: alienation from one's intrinsic self (species being), from one's work, from peers and from society.

ancien régime the system of autocratic monarchy which governed France before the revolution of 1789.

appropriate (vb), appropriation to set aside or use for private purposes; in art, to borrow ideas or images, and to incorporate them into new representations or objects. It is frequently cited as being pervasive within **postmodern** art and **culture**. Sometimes used in Marxist and **postcolonial discourse** to describe the character of cultural interactions.

avant-garde militarily means the advance guard. Art historically, used to refer to those artists whose ideas and practices are felt to be innovative for their time. The French socialist writer Henri de Saint-Simon (1760–1825) associated such ideas with political radicalism. Painters like Courbet, Manet and Millet are variously described as avant-garde in their depiction of contemporary subject matter. In the twentieth century, the idea was given currency by the critic Clement Greenberg, who used it to characterise the formal and technical innovations deployed by the **Modernist** artists he endorsed.

Baroque is the period and style of art that followed the High Renaissance and Mannerism. Broadly dating from the late sixteenth to early eighteenth centuries, it is characterised by exaggerated, decorative forms.

canon originating from the Greek term for a measuring device, has come to refer to a judgement of value or quality. For example, Pollock is a **canonical** artist when judged from a **Modernist** perspective. That is, he demonstrates to a high or exemplary standard, those aspects which **Modernism** rates (i.e. flatness, **abstraction**, emphasis on pigment and properties intrinsic to the medium, rather than narrative). Canonical judgements were established by the **academies**, but there are various **canons**, according to who is making the judgement and when. What is judged as canonical fluctuates according to cultural and stylistic fashion.

civilisation previously used to characterise Western European society in contrast to the rest of the world.

classical has various levels of usage. Capitalised, **Classical** refers to the period of Greek history (fifth/fourth century BCE). More broadly, classical refers to art from Greek and Roman **culture** and

derivative styles, e.g. **neo-classical** of the eighteenth and nineteenth centuries.

collage from the French verb 'to stick or glue', used to refer to the practice invented by Picasso of sticking fragments of paper, board, flyers, etc. to the surface of their cubist compositions. In addition to changing the nature and texture of the painted surface, collage symbolised the introduction of everyday objects into the process of art making.

colonial refers to the activities, attitudes and ethos of European powers, for example Britain in India (the Raj); France in Southeast Asia (Vietnam) and Spain in South America (Bolivia) (see also **postcolonial**).

composition refers to the overall arrangement of a painting or drawing, including lines, forms, shapes, tones and colours. The academies formulated rules about composition, including use and choice of materials, ground preparation, the status and detail of preliminary sketches, etc.

contrapposto from the Italian meaning 'positioned opposite'. A pictorial device used to dramatise the presentation of the human body. Typically meaning the twisting of the upper and lower parts of the body in different directions, it was widely employed by artists like Titian, Tintoretto and Correggio. For an example of how this device was used, see Venus in Bronzino's *An Allegory with Venus and Cupid* (**Figure 15**, p. 91).

copy refers to the duplication of an art work or object. As part of **academy** training, artists were frequently expected to emulate the compositions and drawing techniques of the 'Old Masters'. See also **pastiche**.

craft refers to the creation of functional objects, often involving technical design, traditionally jewellery, textiles, glass and ceramics. Previously craft was distinguished from fine art, but this separation is less relevant since the 1950s as art practices have become increasingly diverse.

critical theory is a collective reference to various humanities-based interventions including **feminism, semiotics**, structuralism, post-Marxism and **postcolonialism**, prevalent since the 1960s.

culture anthropologically it refers to what people do and how they live; the general social values upheld by society. Understood in a more restricted and evaluative sense, 'high culture' describes the intellectual accomplishments (literature, art, philosophy, etc.) of an elite (Fernie 1995: 332).

deconstruction the process, associated with Jacques Derrida, for exploring the concealed meanings and opposing concepts within texts and **discourse**.

différance specifically constructed by Jacques Derrida to encompass both difference and deferral of meaning in signs. Derrida was seeking to emphasise the instability of meaning within texts and culture.

difference used within **semiotics** to signify the distinction between signs and their elements.

discourse used loosely to refer to a cohesive group of ideas or rules which govern a particular subject or theory.

ego the Freudian term given to the conscious self; see also **superego** and **id**.

(the) Enlightenment eighteenth-century ideas and beliefs, which asserted reason and individualism rather than superstition and religion, as the basis for human society and agency.

essentialist, essentialism refers to approaches and theories of philosophy and culture which assert definitions in relation to necessary and sufficient conditions. That is, we can identify core ideas and values which are intrinsic to the definition of, for example, art or **gender**.

fake a **copy** or counterfeit of an art object executed in order to be taken for the original.

female biologically related to the egg/seed-bearing sex of plants and animals, it is traditionally used to describe the sex of women.

feminine, femininity refers to socially constructed characteristics which have traditionally typified the **female**.

feminism stretching back to the eighteenth century, this movement has asserted the rights and equal status of women.

fetish, fetish object, fetishise to give an object occult or supernatural power. Marx used the idea of the **commodity fetish** to explain the allure of money, property and ownership under capitalism. The term is also used in psychoanalytic **discourse** to describe an eroticised or obsessive attachment to objects or their properties.

formalism a theory or approach which stresses art's formal components (line, colour, texture, pigment, size, **composition**, etc.) rather than narrative or subject matter. Variously popularised by Clive Bell and Roger Fry, with more sophisticated elaborations by Clement Greenberg, Rosalind Krauss and Michael Fried; **formalist** ideas were also used to justify **Modernist abstraction**.

fresco a technique for painting directly onto plaster; with true fresco, the pigment is applied to damp plaster, the resulting bond giving the durability for which the medium is famous.

fusion an alternative term to **hybridisation**, signifying the merging of styles or forms from different cultural contexts.

gaze refers to the viewer's visual engagement with the art object; prominently used in film and **gender** studies, and frequently suggestive of a power dynamic between the object and the spectator.

gender traditionally perceived as the culturally constructed sexual identity, as opposed to that which is biologically determined.

genre has dual usage: it either refers to a type of art (such as a landscape painting or portraiture) or to a representation of a scene from everyday life.

globalisation characterises increasing interaction, communication and trade between all parts of the developed or developing world.

Grand Tour an eighteenth-century custom and rite of passage whereby the wealthy travelled to centres of classical culture, especially Rome and Naples, in order to complete their social, moral and aesthetic education. The more intrepid travelled on to Sicily and Greece.

hegemonic, hegemony initially associated with the ideas of the Italian Marxist Antonio Gramsci, meaning power or control; typically

used to suggest the (fluid) power dynamic between competing groups, classes and interests.

hermaphrodite describes dual sexual features in one body, e.g. breasts and penis.

historiographer refers to someone who studies the history and development of an academic discipline; for example, Eric Fernie's *Art History* and *its Methods* (1995) is an example of art historiography.

hybrid, hybridised originally a botanical term referring to propagating one species/variety from two others, the term has been extended to describe cultural interactions and their outcomes.

icon from the Greek word for image, eikon.

iconography the study of meanings in images. **Pre-iconographic**, literally 'before the image', the first stage of Panofsky's approach, analyses the image in two parts – factual (lines and shapes) and expressional (colour and tone). The second **iconographic** stage studies the meaning of symbols, e.g. an hourglass as a metaphor of time passing or the human skull as symbolic of death. **Iconology**, the third and final level, is concerned with the **cultural** meaning of an image in relation to its overall context and history.

id the unconscious mind as understood by Freud; the origin and reservoir of human impulses.

idealist philosophy an understanding of reality and human consciousness as independent of social and economic processes.

ideological systems of beliefs and values which inform our response to the world. For example, Marxism understands ideology largely as a creation of class and the subject's position in relation to capital and the productive process.

imperial, imperialism the intentions and processes employed by European powers to exploit non-European territories, for example the British Empire; latterly the term neo-imperialism has been used to characterise the recent foreign policy of some Western powers.

installation its more generic usage refers to the hanging or arrangement of art within exhibition spaces; more specifically, it refers to site-specific art objects or ensembles of objects.

jouissance French word for orgasm (from the verb jouir, to come), originally used by Lacan in psychoanalytic theory to characterise an unbearable suffering which can also give an extreme pleasure, as in orgasm. The term jouissance is linked by the **poststructuralist feminists** Cixous and Irigaray to an essential **feminine**.

kitsch a German word used to refer to art and cultural objects judged to be in poor or bad taste.

male biologically related to the sperm/pollen-bearing sex of plants and animals, it is traditionally used to describe the sex of men.

masculine, masculinity refers to socially constructed characteristics which have traditionally typified the male.

materialism there are various definitions within philosophy and social theory. Contrary to idealism, where consciousness precedes existence, with materialism conditions of existence determine consciousness. To describe Marxist theories of art as 'materialist' is to acknowledge that cultural production, meaning and consumption are the consequences of broader social, economic and political considerations.

medium, media refers to the particular materials used in the making of art, e.g. oil, acrylics. **Mixed media** refers to the use of several different media in one **installation** or object.

metanarratives the term given by Lyotard to describe totalising belief systems which attempted to account for human progress and society, for example Christianity, the **Enlightenment**, socialism, **feminism**.

mimesis, mimetic a theory of art which places emphasis on the representational nature of painting and sculpture.

modern, modernity and modernism vary in meaning, depending upon context and subject. **Modern** derives from the Latin stem *modo* meaning 'just now' and is generally used to characterise any contemporaneous cultural activity. **Modernity** refers to the phenomena of, and internalised response to, social and technological change, especially evident in the nineteenth and early twentieth centuries. In art history **modernism** refers specifically to work executed between *c.*1860 and *c.*1960 when **avant-garde** artists began to depict and elaborate subject matter taken from contemporary society, rather than themes from **classical** antiquity or subjects suggested by the **academies**.

Modernism (when capitalised) refers to the formalist theory, and related artistic practice, associated with Clement Greenberg. This retrospectively identified a tradition in art practice which was characterised by increasing emphasis on flatness and inherent concerns of the medium. Therefore whilst art may be **modernist** in relation to its subject matter (such as Courbet), it may not be **Modernist** in relation to technique or composition.

monograph a book or study of a single artist.

naturalism, naturalist in painting and sculpture, an attempt to create life-like representations of people and objects in the world by close observation and detailed study. See also **realism**.

neo-avant-garde refers to the diverse art practices of the late 1960s and 1970s, which variously subverted the tenets of medium-specificity and **Modernism**.

neo-classical see **classical**.

(the) New Left the general term given to the resurgence of socialist and Marxist-inspired ideas in the late 1960s and 1970s.

non-Western (art and culture) typically refers to those areas outside Europe, America and Australia.

nude the objectified representation of the unclothed human body traditionally created to satisfy the needs of the male **gaze**.

objets d'art French for 'art objects', a categorisation which includes textiles, silverware, lacquer boxes, rather than the narrower definition of 'fine art'.

oeuvre a French word used to describe the collective work of an artist or workshop.

(the) other characterises non-Western peoples, societies and cultures in the context of Orientalism and **postcolonial** theory. For Edward Said, Western thought constructed the other in opposition to Western cultural paradigms.

pastiche describes an image, composition or **installation** which is made up from other sources; the deliberate adoption of a style which is that of another artist or period.

performance art popularised in the late 1960s, this art form was concerned with direct audience communication by the artist which lasted anything from a few minutes to several days. In some cases, it was conceived as a means of circumventing the institutional **hegemony** of commercial galleries as well as the aesthetic priorities of **Modernism**.

photomontage the practice derived from cubist **collage** in which artists associated with the German Dada movement and the Surrealist avant-gardes combined snippets of photographs (frequently with text) in order to make socio-political critiques.

postcolonial can mean the world situation since the decolonisation of Western empires from the late 1940s, but it is more broadly taken to encompass the impact of **colonial** and **imperial** activities since the eighteenth century. **Postcolonial studies** explore the circumstances of postcolonial societies in support of equal social, economic and political status vis-à-vis Western **hegemony**. **Postcolonialism** seeks to redress the bias and manipulations of Western colonial and imperial enterprises.

postmodern, postmodernism literally 'after just now'. These terms have been widely used to characterise aspects of art and culture from the late 1960s, and are partially understood as a reaction to the priorities of **Modernism**. **Postmodernity** has been used to describe a distinct cultural and social epoch which has paralleled some of these developments.

poststructuralism a radical questioning of the central tenets of the human subject, and the ability to derive stable meanings from cultural objects, works and texts. **Poststructuralism** asserts that meaning, if it resides anywhere, does so in the 'space between the reader and the text' (Fernie 1995: 353).

primary sources a work by an artist or perhaps a contemporary record of their activities (i.e. a diary or journal).

primitive, primitivism literally 'primary in time'; at an early stage of civilisation or undeveloped. **Primitivist** styles and motifs were adopted by **avant-garde** artists in the late nineteenth and early twentieth centuries in the belief that they signified authentic responses and feelings to the pressures of Western **modernity**. Overall, the

term had negative connotations and frequently suggested Western **stereotypes** of the **other**.

psychoanalysis refers to the study of unconscious mental processes as originated by Freud.

Queer theory ideas relating to recent developments in gender studies, arising from gay culture, proposing flexible constructs of **sex**, sexuality and **gender** identities.

realism has complex origins. From the mid-nineteenth century it was understood as an attempt to show things as they actually appear. **Social realism** has been used to describe approaches to representation that have an implicit or explicit social or political agenda, such as the paintings of Courbet or the sketches and cartoons of Honoré Daumier (1808–79). **Soviet Socialist Realism** refers to the particular artistic style (romanticised academic **genre** painting and sculpture), which became the officially sanctioned aesthetic of the Soviet Union after 1932.

Renaissance literally meaning 're-birth' and coined by Vasari, the term has been traditionally used to describe the innovations in art, culture and learning which typified the achievements of the various Italian city states from the late fourteenth to the sixteenth century. Its usage has become increasingly problematic, not least because it valorises a particular cultural paradigm at the expense of other periods and perspectives.

Rococo an aesthetic associated with the eighteenth-century French Court, representing pleasurable pastimes, often including florid curves and scrolls.

Romanticism used to collectively refer to the artistic, literary and philosophical phenomena of the late eighteenth and early nineteenth centuries which emphasised new aspects to human subjectivity, liberation of the emotions, and the cult of nature and imagination. Latterly the cohesiveness of the artistic activities it encompassed has been questioned.

salon from the seventeenth century, the Salon d'Apollon in the Louvre was the only public venue for exhibitions of art works in France. Eventually an annual event was opened to all artists, the submissions of which were jury-vetted according to academic values.

secondary sources typically refer to surveys, critical studies, monographs and anthologies on artists, movements and their work.

semiotics is the study of signs. **Semiology** was the term coined by Saussure to describe his approach to the study of signs, whereas **semiosis** is the process of exploring sign constructs used by Peirce.

sex refers to a biologically determined identity, rather than the social constructions, values and roles which constitute **gender**.

simulacrum, simulacra an image or semblance derived from an original object or image; used by Baudrillard to describe copies which are increasingly detached from the original source.

single point perspective, linear perspective the invention of the early Renaissance by which artists represented a scene as if viewed from a single point. Objects were drawn within a framework of suggested lines leading to a single vanishing point.

spectacle in generic usage a site or show which may be large scale and elaborate; used by Guy Debord (1931–94) to characterise 'pseudo-events' and commodified interactions under capitalism.

stereotypes, stereotypical simplistic characterisation of people or categories.

(the) superego the third part of Freud's tripartite characterisation of the self, concerned with the regulation of behaviour and social conduct.

symbolism generally a motif which by cultural convention or customary usage represents something else.

teleological from the Greek word telos, meaning aim or purpose.

translation in **postcolonial** theory, this relates to the problems of transferring meaning between different languages and cultural contexts.

uncanny a concept developed by Freud whereby something is perceived as both familiar and strange. This provokes a tension because of the conflicting feelings it arouses in the subject, frequently resulting in its rejection rather than a rationalisation of its cause.

zeitgeist literally, in German, means 'spirit of the times' or more colloquially, the character of a period or moment.

BIBLIOGRAPHY

Acton, Mary (1997) *Learning to Look at Paintings*, London and New York: Routledge.

Ades, Dawn (1986) 'Reviewing Art History', in A. L. Rees and Frances Borzello (eds) *The New Art History*, London: Camden Press.

Adorno, Theodor (1970) *Aesthetic Theory*, translated by C. Lenhardt, London: Routledge & Kegan Paul.

—— (1973) *Negative Dialectics*, translated by E. B. Ashton, London: Routledge.

—— (1997) 'Commitment', in Francis Frascina and Jonathan Harris (eds) *Art in Modern Culture*, London: Phaidon Press, 78–79.

—— (2001) *The Culture Industry: Selected Essays on Mass Culture*, introduction by J. M. Bernstein, London and New York: Routledge.

Adorno, Theodor, and Horkheimer, Max (1986) [1947] *Dialectic of Enlightenment*, London: Verso.

Alpers, Svetlana (1984) *The Art of Describing: Dutch Art in the Seventeenth Century*, Chicago: University of Chicago Press.

Anderson, Perry (1969) 'Components of the National Culture', in A. Cockburn and R. Blackburn (eds) *Student Power: Problems, Diagnosis,*

Action, London: Penguin Books in association with the *New Left Review*, 214–84.

—— (1984) *In the Tracks of Historical Materialism*, London: Verso.

Antal, Frederick (1966) 'Reflections on Classicism and Romanticism', reprinted in *Classicism and Romanticism with Other Studies in Art History*, London: Routledge & Kegan Paul, 1–45.

Appignanesi, Richard and Garratt, Chris (1995) *Postmodernism for Beginners*, Duxford, UK: Icon Books.

Appignanesi, Richard and Zarate, Oscar (1979) *Introducing Freud*, Cambridge: Icon Books.

Armstrong, Carol and De Zegher, Catherine (eds) (2006) *Women Artists at the Millennium*, Cambridge MA and London: MIT Press.

Ashcroft, Bill (2005) *The Post-colonial Studies Reader*, London and New York: Routledge.

Ashcroft, Bill and Ahluwalia, Pal (2001) [1999] *Edward Said*, Routledge Critical Thinkers, London and New York: Routledge.

Ashcroft, Bill, Griffiths, Gareth and Tiffin, Helen (2002) *The Empire Writes Back: Theory and Practice in Post-Colonial Literatures*, London and New York: Routledge.

Atkins, Robert (1997) *Artspeak: A Guide to Contemporary Ideas, Movements, and Buzzwords, 1945 to the Present*, London, Paris and New York: Abbeville Publishers.

Baigell, Renee and Baigell, Matthew (2001) *Peeling Potatoes, Painting Pictures: Women Artists in Post-Soviet Russia, Estonia, and Latvia: The First Decade*, New Brunswick NJ and London: Rutgers University Press/Jane Voorhees Zimmerli Art Museum.

Bal, Mieke (2005) *The Artemisia Files: Artemisia Gentileschi for Feminists and Other Thinking People*, Chicago: University of Chicago Press.

Bal, Mieke and Bryson, Norman (1991) 'Semiotics and Art History: A Discussion of Context and Senders' reproduced in Donald Preziosi (ed.) *The Art of Art History: A Critical Anthology* (1998) Oxford: Oxford University Press, 242–56.

Bann, Stephen (1986) 'How Revolutionary is the New Art History?', in A. L. Rees and Frances Borzello (eds) *The New Art History*, London: Camden Press, 19–31.

Barlow, Paul (2003) biographical and critical entry on Clement Greenberg, in Chris Murray (ed.) *Key Writers on Art: The Twentieth Century*, London and New York: Routledge.

Barringer, Tim J. (1998) *The Pre-Raphaelites: Reading the Image*, London: Weidenfeld & Nicolson.

Barthes, Roland (1972) [1957] 'Myth Today', in *Mythologies*, translated by Annette Lavers, London: Vintage Books.

—— (1966) 'The Death of the Author', *Aspen Magazine*, 5–6.

Bartra, Eli (2003) *Crafting Gender: Women and Folk Art in Latin America and the Caribbean*, Durham NC and London: Duke University Press.

Batchelor, David (1997) *Minimalism*, Movements in Modern Art Series, London: Tate Gallery Publishing.

Baudrillard, Jean (1994) *Simulacra and Simulation*, translated by Sheila Faria Glaser, Ann Arbor MI: University of Michigan Press.

Bauman, Zygmunt (1992) *Intimations of Postmodernity*, London: Routledge.

Baxandall, Lee and Morawski, S. (1977) *Karl Marx and Frederick Engels on Literature and Art*, New York: I. G. Editions.

Baxandall, Michael (1985) *Patterns of Intention: On the Historical Explanation of Pictures*, New Haven CT and London: Yale University Press.

—— (1988) *Painting and Experience in Fifteenth Century Italy*, 2nd edn, Oxford: Oxford University Press.

Bayley, Stephen (2006) *Bauhaus + BMW*, London: Design: Studio 176.

Beard, Mary and Henderson, John (2001) *Classical Art From Greece to Rome*, Oxford: Oxford University Press.

Bell, Clive (1949) *Art*, new edition, London: Chatto & Windus.

Benjamin, Roger (curator and editor) (1997) *Orientalism: Delacroix to Klee*, New South Wales, Australia: Art Gallery of New South Wales.

Benjamin, Walter (1982) 'The Author as Producer', in Francis Frascina and Charles Harrison (eds) *Modern Art and Modernism: A Critical Anthology*, London: Paul Chapman Publishing, 213–16.

Berger, John (1972) *Ways of Seeing*, London and Harmondsworth, UK: British Broadcasting Corporation/Penguin Books.

Bernal, Martin (1987) *Black Athena: The Afroasiatic Roots of Classical Civilization*, London: Vintage Books.

—— (2001) *Black Athena Writes Back*, Durham NC and London: Duke University Press.

Blake, Nigel, and Frascina, Francis (1993) 'Modern Practices of Art and Modernity', in Francis Frascina, Nigel Blake, Briony Fer, Tamar Garb and Charles Harrison (eds) *Modernity and Modernism: French Painting in the Nineteenth Century*, New Haven CT and London: Yale University Press in association with the Open University, 50–140.

Boime, Albert (1971) *The Academy and French Painting in the Nineteenth Century*, London and New York: Phaidon Press.

Boyne, Roy (2002) 'Foucault and Art', in Paul Smith and Carolyn Wilde (eds) *A Companion to Art Theory*, Oxford: Blackwell.

Brettell, Richard (1999) *Modern Art 1851–1929: Capitalism and Representation*, Oxford: Oxford University Press.

Brookner, Anita (1980) *Jacques-Louis David*, London: Chatto & Windus.

Broude, Norma and Garrard, Mary (1994) *The Power of Feminist Art: The American Movement of the 1970s, History and Impact*, New York: H. N. Abrams and London: Thames & Hudson.

—— (eds) (2005) *Reclaiming Female Agency: Feminist Art History After Postmodernism*, Berkeley CA and London: University of California Press.

Bryson, Norman (1990) *Looking at the Overlooked: Four Essays on Still Life Painting*, London: Reaktion Books.

Buck, Louisa (1997) *Moving Targets: A User's Guide to British Art Now*, London: Tate Gallery Publishing.

Bürger, Peter (1984) *Theory of the Avant Garde*, translated by Michael Shaw, Minneapolis MN: University of Minnesota Press.

Burke, Peter (1986) *The Italian Renaissance: Culture and Society in Italy*, Cambridge: Polity Press.

Butler, Judith (1999) [1990] *Gender Trouble: Feminism and the Subversion of Identity*, New York and London: Routledge.

Butler, Rex (2003) [1998] 'Emily Kame Kngwarreye and the Undeconstructible Space of Justice', in Jason Gaiger and Paul Wood, *Art of the Twentieth Century: A Reader*, New Haven CT and London: Yale University Press in association with the Open University, 304–18.

Butt, Gavin (2004) 'How New York Queered the Idea of Modern Art', in Paul Wood (ed.) *Varieties of Modernism*, New Haven CT and London: Yale University Press in association with the Open University, 315–37.

Carter, Miranda (2002) *Anthony Blunt: His Lives*, London: Pan Books.

Chandler, Daniel (2002) *Semiotics: The Basics*, London and New York: Routledge.

Chapman, Jake and Chapman, Dinos (1996) interview with William Furlong, *Audio Arts Magazine*, vol. 15, no. 3.

Chasseguet-Smirgel, Janine (1992) *Creativity and Perversion*, London: Reaktion Books.

Cherry, Deborah (2000) *Beyond the Frame: Feminism and Visual Culture, Britain, 1850–1900*, London and New York: Routledge.

Chicago, Judy (1999) 'Introduction', in Judy Chicago and Edward Lucie-Smith, *Women and Art: Contested Territory*, London: Weidenfeld & Nicolson.

Chicago, Judy and Lucie-Smith, Edward (1999) *Women and Art: Contested Territory*, London: Weidenfeld & Nicolson.

Cixous, Hélène (2001) [1975] 'The Laugh of the Medusa', in Hilary Robinson (ed.) *Feminism-Art-Theory: An Anthology 1968–2000*, Malden MA and London: Blackwell Publishers, 627–35.

Clark, Kenneth (1956) *The Nude,* Harmondsworth, UK: Penguin Books.

Clark, T. J. (1973a) *Image of the People: Gustave Courbet and the 1848 Revolution,* London: Thames & Hudson.

—— (1973b) *The Absolute Bourgeois: Artists and Politics in France 1848–1851,* London: Thames & Hudson.

—— (1974) 'The Conditions of Artistic Creation', *Times Literary Supplement,* 24 May, 561–62.

—— (1984) *The Painting of Modern Life: Paris in the Art of Manet and His Followers,* London: Thames & Hudson.

Clarke, John R. (1998) *Looking at Lovemaking: Constructions of Sexuality in Roman Art, 100 BC*

Clunas, Craig (1997) *Art in China,* Oxford: Oxford University Press.

Cobley, Paul and Jansz, Litza (1997) *Introducing Semiotics,* Duxford, UK and New York: Icon Books.

Collings, Matthew (1998) review of Florence Rubenfeld's 'Clement Greenberg: A Life' (1997), in *Tate Magazine* (winter) 72–73.

Collingwood, R. G. (1975) *The Principles of Art,* reprinted, Oxford: Oxford University Press.

Connor, Steven (1989) *Postmodern Culture: An Introduction to Theories of the Contemporary,* Oxford: Blackwell.

—— (ed.) (2004) *The Cambridge Companion to Postmodernism,* Cambridge: Cambridge University Press.

Cormack, Robin (2000) *Byzantine Art,* Oxford: Oxford University Press.

—— (2006) 'The Road to Byzantium', in *The Road to Byzantium: Luxury Arts of Antiquity,* London: Fontana, 13–19.

Cottington, David (2004) *Cubism and Its Histories,* Manchester and New York: Manchester University Press.

Craske, Matthew (1997) *Art in Europe 1700–1830: A History of the Visual Arts in an Era of Unprecedented Urban Economic Growth,* Oxford: Oxford University Press.

Craven, David (2002) 'Marxism and Critical Art History', in Paul Smith and Carolyn Wilde (eds) *A Companion to Art Theory*, Oxford: Blackwell, 267–85.

Crimp, Douglas and Kelly, Mary (1997) 'Interview', in Margaret Iverson, Douglas Crimp and Homi K. Bhabha (eds) *Mary Kelly*, London: Phaidon Press.

Crompton, Louis (2003) *Homosexuality and Civilization*, Cambridge MA and London: Belknap Press of Harvard University Press.

Daix, Pierre (1994) *Picasso: Life and Art*, translated by Olivia Emmet, London: Thames & Hudson.

Dannatt, George (2006) letter to Grant Pooke, December.

Danto, Arthur (1990) 'Narratives of the End of Art', in *Encounters and Reflections: Art in the Historical Present*, Berkeley CA and London: University of California Press, 331–45.

—— (1998) *The Wake of Art: Criticism, Philosophy, and the Ends of Taste*, Amsterdam: G+B Arts International.

Davis, Whitney (1996) 'Gender', in Robert S. Nelson and Richard Shiff (eds) *Critical Terms for Art History*, Chicago and London: University of Chicago Press, 220–33.

De Duve, Thierry (1998) *Kant After Duchamp*, Cambridge MA and London: MIT Press.

Deepwell, Katy (2004) *Dialogues: Women Artists from Ireland*, London and New York: I. B. Tauris.

Deepwell, Katy (ed.) (1998) *Women Artists and Modernism*, Manchester, UK: Manchester University Press.

Dehejia, Vidya (1997) *Indian Art*, London: Phaidon Press.

Derrida, Jacques (1976) *Of Grammatology*, translated by Gayatri Chakravorty Spivak, Baltimore MD: Johns Hopkins University Press.

—— (1987) [1978] *The Truth in Painting*, translated by G. Bennington and Ian McLeod, Chicago and London: University of Chicago Press.

—— (1994) *Spectres of Marx*, London: Routledge.

Dews, Peter (1987) *Logics of Disintegration: Poststructuralist Thought and the Claims of Critical Theory*, London: Verso.

Dickie, George (1974) *Art and the Aesthetic*, Ithaca NY: Cornell University Press.

Dreger, Alice Domurat (1998) *Hermaphrodites and the Medical Invention of Sex*, Cambridge MA and London: Harvard University Press.

Eagleton, Terry (1977) *Marxism and Literary Criticism*, London: Methuen.

—— (1990) *The Ideology of the Aesthetic*, Oxford: Blackwell.

—— (1996) *The Illusions of Postmodernism*, Oxford: Blackwell.

—— (2000) *Ideology: An Introduction*, London and New York: Verso.

Eco, Umberto (1976) *A Theory of Semiotics*, Bloomington IN: Indiana University Press and London: Macmillan.

Edwards, Steve (1999) *Art and Its Histories*, New Haven CT and London: Yale University Press in association with the Open University.

—— (2004) 'Photography out of Conceptual Art', in Gillian Perry and Paul Wood (eds) *Themes in Contemporary Art*, New Haven CT and London: Yale University Press in association with the Open University, 137–80.

Elkins, James (ed.) (2006) *Art History Versus Aesthetics*, New York and London: Routledge.

Elliott, David and Alkazi, E. (eds) (1982) *India: Myth and Reality: Aspects of Modern Indian Art*, Oxford: Museum of Modern Art.

Emerling, Jaye (2005) *Theory for Art History*, London: Routledge.

Evett, Elisa (1983) 'The Late Nineteenth Century European Critical Response to Japanese Art: Primitivist Leanings', *Art History*, vol. 6, no. 1, March, 82–106.

Fer, Briony (1993) 'Introduction: Surrealism and Difference', in Briony Fer, David Batchelor and Paul Wood, *Realism, Rationalism, Surrealism*, New Haven CT and London: Yale University Press in association with the Open University, 171–82.

Fer, Briony (1993), in Francis Frascina, Nigel Blake, Briony Fer, Tamar Garb and Charles Harrison (eds) *Modernity and Modernism: French Painting in the Nineteenth Century*, New Haven CT and London: Yale University Press in association with the Open University.

Fernie, Eric (1995) *Art History and Its Methods*, London: Phaidon Press.

Figes, Orlando (2003) *Natasha's Dance: A Cultural History of Russia*, London: Penguin Books.

Finnström, Sverker (1997) 'Postcolonial and the Postcolony: Theories of the Global and the Local', *Working Papers in Cultural Anthropology*, no. 7.

Foster, Hal (1985) *Recodings: Art, Spectacle, Cultural Politics*, Port Townsend WA: Bay Press.

Foucault, Michel (1971) *Madness and Civilisation: A History of Insanity in the Age of Reason*, translated by Richard Howard, London: Tavistock.

—— (1977) *Discipline and Punish: The Birth of the Prison*, translated by Alan Sheridan, New York: Pantheon.

—— (1980a) *The History of Sexuality, Volume 1: An Introduction*, translated by Robert Hurley, New York: Vintage Books.

—— (1980b) *Power/Knowledge: Selected Interviews and Other Writings 1972–77*, with a preface by Colin Gordon, Leo Marshall, John Meplam and Kate Soper (eds), Brighton, UK: Harvester Press.

—— (1980c) 'Introduction', in *Herculine Barbin: Being the Recently Discovered Memories of a Nineteenth-century French Hermaphrodite*, translated by Richard McDougall, Brighton, UK: Harvester Press.

—— (1983) *This Is not a Pipe*, translated and edited by James Harkness, Berkeley CA and London: University of California Press.

Frascina, Francis (1993a) 'The Politics of Representation', in Paul Wood, Francis Frascina, Jonathan Harris and Charles Harrison (eds) *Modernism in Dispute: Art Since the Forties*, New Haven CT and London: Yale University Press in association with the Open University, 77–166.

—— (1993b) 'Realism and Ideology: An Introduction to Semiotics and Cubism', in Charles Harrison, Francis Frascina and Gillian Perry (eds) *Primitivism, Cubism and Abstraction: The Early Twentieth Century*, New Haven CT and London: Yale University Press in association with the Open University.

Frascina, Francis (ed.) (1985) *Pollock and After: The Critical Debate*, London: Harper & Row.

Frascina, Francis and Harrison, Charles (eds) (1982) *Modern Art and Modernism: A Critical Anthology*, London: Paul Chapman Publishing in association with the Open University.

Frascina, Francis and Harris, Jonathan (eds) (1992) *Art in Modern Culture: An Anthology of Critical Texts*, London: Phaidon Press in association with the Open University.

Frascina, Francis, Blake, Nigel, Fer, Briony, Garb, Tamara and Harrison, Charles (eds) (1993) *Modernity and Modernism: French Painting in the Nineteenth Century*, New Haven CT and London: Yale University Press in association with the Open University.

Freud, Anna (1937) *The Ego and Mechanisms of Defence*, London: Institute of Psychoanalysis.

Freud, Sigmund (1963) [1910] *Leonardo and a Memory of his Childhood*, translated by Alan Tyson with an introduction by Brian Farrell, Harmondsworth, UK: Penguin Books.

Freud, Sigmund and Breuer, Josef (1960) [1895] *Studies in Hysteria*, translated with an introduction by A. A. Brill, Boston MA: Beacon Press.

Fried, Michael (1967) 'Art and Objecthood', *Artforum*, vol. 5. no. 10, 12–23, June; reprinted in Charles Harrison and Paul Wood (eds) (2003) *Art in Theory 1900–2000: An Anthology of Changing Ideas*, Malden MA and Oxford: Blackwell, 835–46.

Friedländer, David (1975) *From David to Delacroix*, Cambridge MA: Harvard University Press.

Fuller, Peter (1988) [1980] *Art and Psychoanalysis*, London: Hogarth Press.

Gaiger, Jason (2004) 'The Idea of Abstract Art', in Paul Wood and Steve Edwards (eds) *Art of the Avant-gardes*, New Haven CT and London: Yale University Press in association with the Open University,

Gaiger, Jason (ed.) (2003) *Frameworks for Modern Art*, New Haven CT and London: Yale University Press in association with the Open University.

Gaiger, Jason and Wood, Paul (eds) (2003) *Art of the Twentieth Century: A Reader*, New Haven CT and London: Yale University Press in association with the Open University.

Galassi, Peter and Sherman, Cindy (2003) in David Frankel (ed.) *Cindy Sherman: The Complete Untitled Film Stills*, New York: Museum of Modern Art and London: Thames & Hudson.

Garlake, Margaret (2005) catalogue introduction, *George Dannatt: Paintings, Drawings and Constructions: A Retrospective*, exhibition 1 September–1 October 2005, London: Osborne Samuel LLP.

Glover, Edward (1956) 'Sublimation, Substitution and Social Anxiety', in *Selected Papers on Psycho-analysis, Vol. 1: On Early Development of Mind*, London: Image Publishing.

Gombrich, Ernst (1978) 'Introduction: Aims and Limits of Iconology', reprinted in *Symbolic Images: Studies in the Art of the Renaissance*, London: Phaidon Press.

—— (1984) *The Story of Art*, 14th edn, London: Phaidon Press.

Gould, Carol (2003) 'Clive Bell: British Critic and Art Historian', in Chris Murray (ed.) *Key Writers on Art: The Twentieth Century*, London and New York: Routledge.

Graham, Gordon (1997) *Philosophy of the Arts: An Introduction to Aesthetics*, London: Routledge.

Greenberg, Clement (1986) [1939–44] *The Collected Essays and Criticism: Perception and Judgement, 1939–1944*, ed. John O'Brian, Chicago and London: University of Chicago Press.

—— (1988) [1945–49] *The Collected Essays and Criticism: Arrogant Purpose, 1945–1949*, ed. John O'Brian, Chicago and London: University of Chicago Press.

Greer, Germaine (1979) *The Obstacle Race: The Fortunes of Women Painters and Their Work*, London: Secker and Warburg.

—— (2006) speaking on BBC2's *Newsnight Review*, 15 December.

Habermas, Jürgen (2003) [1980/81] 'Modernity – An Incomplete Project', in Charles Harrison and Paul Wood (eds) *Art in Theory 1900–2000: An Anthology of Changing Ideas*, (2003), Malden MA and Oxford: Blackwell, 1123–30.

Hall, James (2000) *Dictionary of Subjects and Symbols in Art*, London: John Murray.

Hall, Stuart (2003) [1992] 'What Is This "Black" in Black Popular Culture?', in Jason Gaiger and Paul Wood (eds) *Art of the Twentieth Century: A Reader*, New Haven CT and London: Yale University Press in association with the Open University, 290–96.

Harris, Jonathan (1994) 'Abstract Expressionism and the Politics of Criticism', in Paul Wood, Francis Frascina, Jonathan Harris and Charles Harrison (eds) *Modernism in Dispute: Art Since the Forties*, New Haven CT and London: Yale University Press in association with the Open University, 42–64.

—— (2001) *The New Art History: A Critical Introduction*, London: Routledge.

—— (2003) biographical and critical entry on T. J. Clark, in Chris Murray (ed.) *Key Writers on Art: The Twentieth Century*, London and New York: Routledge.

—— (2006) *Art History: The Key Concepts*, London and New York: Routledge.

Harris, Jonathan (ed.) (2003) *Critical Perspectives on Contemporary Painting: Hybridity, Hegemony and Historicism*, Liverpool, UK: Liverpool University Press.

Harrison, Charles (1981) *English Art and Modernism*, London: Allen Lane and Indianapolis: Indiana University Press.

—— (1985) 'Modernism and the Transatlantic Dialogue', in Francis Frascina (ed.) *Pollock and After: The Critical Debate*, London: Harper & Row.

—— (1997) *Modernism*, Movements in Modern Art Series, London: Tate Gallery Publishing.

Harrison, Charles and Wood, Paul (eds) (2003) *Art in Theory 1900–2000: An Anthology of Changing Ideas*, Oxford: Blackwell.

Hassan, Ihab (1992) 'Pluralism in Postmodern Perspective', in Charles Jencks (ed.) *The Post-Modern Reader*, London: Academy Editions and New York: St Martin's Press, 196–207.

Hatt, Michael and Klonk, Charlotte (2006) *Art History: A Critical Introduction to Its Methods*, Manchester, UK and New York: Manchester University Press.

Haxthausen, Charles W. (ed.) (2002) *The Two Art Histories: The Museum and the University*, New Haven CT and London: Yale University Press.

Haynes, Deborah J. (2002) 'Bakhtin and the Visual Arts', in Paul Smith and Carolyn Wilde (eds) *A Companion to Art Theory*, Oxford: Blackwell.

Heartney, Eleanor (2001) *Postmodernism*, Movements in Modern Art Series, London: Tate Gallery Publishing.

Heise, Ursula (2004) 'Science, Technology, and Postmodernism', in Steven Connor (ed.) *The Cambridge Companion to Postmodernism*, Cambridge: Cambridge University Press, 136–67.

Held, Jutta (1988) 'How do Political Effects of Pictures Come About? The Case of Picasso's *Guernica*', *Oxford Art Journal*, vol. 11, no. 1, 33–39.

Heller, Agnes and Féher, Ferenc (1988) *The Postmodern Political Condition*, Cambridge: Polity Press in association with Blackwell.

Hemingway, Andrew (2006a) 'Introduction', in Andrew Hemingway (ed.) *Marxism and the History of Art: From William Morris to the New Left*, London: Pluto Press, 1–8.

—— (2006b) 'New Left Art History's International', in Andrew Hemingway (ed.) *Marxism and the History of Art: From William Morris to the New Left*, Pluto Press: London, 175–95.

Herodotus (1972) *The Histories*, translated by Aubrey de Sélincourt, Harmondsworth, UK: Penguin Books.

Heyer, Elfriede and Norton, Roger (trans.) (1987) 'Introduction' to J. J. Winckelmann, *Reflections on the Imitation of Greek Works in Painting and Sculpture*, La Salle IL: Open Court Publishing, ix–xxiii.

Hill, Roger (2006) conversation with Grant Pooke at the artist's studio, Robertsbridge, East Sussex, UK, November.

Hiller, Susan (ed.) (1991) *The Myth of Primitivism: Perspectives on Art*, London and New York: Routledge.

Hilton, Timothy (1996) *Picasso*, London: Thames & Hudson.

Hjelmslev, Louis (1961) *Prolegomena to a Theory of Language*, translated by Francis J. Whitfield, Madison WI: University of Wisconsin Press.

Holborn, Mark (2003) 'Introduction' to *Hell* by Jake and Dinos Chapman, London: Jonathan Cape in association with the Saatchi Gallery.

Holly, Michael Ann (1984) *Panofsky and the Foundations of Art History*, Ithaca NY and London: Cornell University Press.

Hood, Stuart and Crowley, Graham (1999) *Introducing Marquis de Sade*, Duxford, UK: Icon Books.

Hopkins, David (2000) *After Modern Art, 1945–2000*, Oxford: Oxford University Press.

Howard, Deborah (2005) 'Venice, the Bazaar of Europe', in Caroline Campbell and Alan Chong (eds) *Bellini and the East*, London: National Gallery, 12–31.

Huddart, David (2006) *Homi K. Bhabha*, Routledge Critical Thinkers, London and New York: Routledge.

Hughes, Robert (1991) [1980] *The Shock of the New: Art and the Century of Change*, London: Thames & Hudson.

Hyman, John (1989) *The Imitation of Nature*, Oxford: Blackwell.

Irwin, Robert (2006) *For Lust of Knowing: The Orientalists and their Enemies*, London: Penguin Books.

Isaak, Jo Anna (1996) *Feminism and Contemporary Art: The Revolutionary Power of Women's Laughter*, London and New York: Routledge.

Istrabadi, Juliet Graver (2004) biographical and critical entry on Erwin Panofsky in Chris Murray (ed.) *Key Writers on Art: The Twentieth Century*, London: Routledge, 221–28.

Jacobson, Dawn (1993) *Chinoiserie*, London: Phaidon Press.

Jagose, Annamarie (1996) *Queer Theory*, Carlton South, Victoria: Melbourne University Press.

Jakobson, Roman and Halle, Morris (1956) *Fundamentals of Language*, The Hague: Mouton.

Jameson, Fredric (1991) *Postmodernity, or The Cultural Logic of Late Capitalism*, London: Verso.

Jencks, Charles (1989) *What is Post-Modernism?*, London: Academy Editions and New York: St Martin's Press.

Johnson, Dorothy (1993) *Jacques-Louis David: Art in Metamorphosis*, Princeton NJ and Chichester, UK: Princeton University Press.

Jones, Amelia (2001) [1990] '"Post-feminism": A Remasculinisation of Culture', in Hilary Robinson (ed.) *Feminism-Art-Theory: An Anthology 1968–2000*, Malden MA and London: Blackwell, 496–506.

—— (ed.) (2003) *The Feminism and Visual Culture Reader*, London and New York: Routledge.

Joseph, Jonathan (2006) *Marxism and Social Theory*, Basingstoke, UK: Palgrave Macmillan.

Kellein, Thomas (ed.) (2002) *Pictures: Jeff Koons 1980–2002*, New York: Distributed Art Publishers.

Kempers, Bram (1992) *Painting, Power and Patronage: The Rise of the Professional Artist in Renaissance Italy*, London: Allen Lane the Penguin Press.

Kernberg, Otto (1992) 'Foreword' to Janine Chasseguet-Smirgel, *Creativity and Perversion*, London: Reaktion Books, vi–ix.

King, Catherine (ed.) (1999) *Views of Difference: Different Views of Art*, New Haven CT and London: Yale University Press in association with the Open University.

Kirby, Vicki (2006) *Judith Butler: Live Theory*, London and New York: Continuum International Publishing Group.

Kite, Stephen (2003) biographical and critical entry on Adrian Stokes in Chris Murray (ed.) *Key Writers on Art: The Twentieth Century*, London and New York: Routledge.

Krahl, Regina (2005) Catalogue no. 181–82, in Evelyn S. Rawski and Jessica Rawson (eds) *China: The Three Emperors 1662–1795*, London: Royal Academy of Arts.

Krauss, Rosalind (2003) [1976] 'Notes on the Index, Part I', in Charles Harrison and Paul Wood (eds) *Art in Theory 1900–2000: An Anthology of Changing Ideas*, Malden MA and Oxford: Blackwell, 994–99.

—— (1988a) 'Sculpture in the Expanded Field', in *The Originality of the Avant-Garde and Other Modernist Myths*, Cambridge MA: MIT Press, 276–90.

—— (1988b) *The Originality of the Avant-Garde and Other Modernist Myths*, Cambridge MA and London: MIT Press.

Kristeva, Julia (2003) [1980] 'Powers of Horror: An Essay on Abjection', in Charles Harrison and Paul Wood (eds) *Art in Theory 1900–2000*, Oxford: Blackwell in association with the Open University, 1137–139.

Kultermann, Udo (1993) *The History of Art History*, New York: Abaris Books.

Laing, Dave (1978) *The Marxist Theory of Art: An Introductory Survey*, Brighton, UK: Harvester Press and New Jersey: Humanities Press.

Lakoff, George and Johnson, Mark (1980) *Metaphors We Live by*, Chicago: University of Chicago Press.

Lanham, Richard A. (1969) *A Handlist of Rhetorical Terms*, Berkeley CA: University of California Press.

Leader, Darian and Groves, Judy (1995) *Introducing Lacan*, Cambridge: Icon Books.

Lechte, John (1994) *Fifty Contemporary Thinkers: From Structuralism to Postmodernity*, London and New York: Routledge.

Lee, David (1999) *David*, London: Phaidon Press.

Lefkowitz, Mary R. and Rogers, Guy MacLean (1996) *Black Athena Revisited*, Chapel Hill NC and London: University of North Carolina Press.

Leighten, Patricia (1990) 'The White Peril and *l'art nègre*: Picasso, Primitivism, and Anticolonialism', *The Art Bulletin*, vol. LXXII, no. 4, 609–30.

Leja, Michael (2002) 'Peirce's Visuality and the Semiotics of Art', in Paul Smith and Carolyn Wilde (eds) *A Companion to Art Theory*, London: Blackwell.

Lévi-Strauss, Claude (1974) [1962] *The Savage Mind*, London: Weidenfeld & Nicolson.

Lippard, Lucy (1973) *Six Years: The Dematerialization of the Art Object*, London: Studio Vista Books.

Lloyd, Fran (1999) *Contemporary Arab Women's Art: Dialogues of the Present*, London: Women's Art Library.

Lukács, Georg (1978) [1967] quoted in Dave Laing, *The Marxist Theory of Art: An Introductory Survey*, Brighton, UK: Harvester Press and New Jersey: Humanities Press.

Lynes, Barbara Buhler (1999) *Georgia O'Keeffe: Catalogue Raisonné*, New Haven CT and London: Yale University Press.

Lyons, John (1977) *Semantics*, vol. 1, Cambridge: Cambridge University Press.

Lyotard, Jean-François (1979) *The Postmodern Condition*, translated by Geoffrey Bennington and Brian Massumi (1984), Minneapolis, MN: University of Minnesota Press and Manchester: Manchester University Press.

—— (1986) [1983] *The Differend: Phrases in Dispute*, translated by George ven den Abeele, Minneapolis MN: University of Minnesota Press and Manchester, UK: Manchester University Press.

McAfee, Noelle (2004) *Julia Kristeva*, London: Routledge.

McLellan, David (1975) *Marx*, London: Fontana.

MacLagan, David (2001) *Psychological Aesthetics: Painting, Feeling and Making Sense*, London: Jessica Kingsley.

Maharaj, Sarat (2003) [1994] 'Perfidious Fidelity: the Untranslatability of the Other', in Jason Gaiger and Paul Wood (eds) *Art of the Twentieth Century: A Reader*, New Haven CT and London: Yale University Press in association with the Open University, 297–303.

Malvern, Jack (2006) 'Take a Stand for Art', *The Times*, times2, 26 June, 4–5.

Mandelbaum, Maurice (1995) 'Family Resemblances and Generalisations Concerning the Arts', in Michael Neill and Aaron Ridley (eds) *The Philosophy of Art: Readings Ancient and Modern*, New York and London: McGraw-Hill, 193–210.

Marcuse, Herbert (2002) *One Dimensional Man*, London: Routledge.

Marquis, Alice Goldfarb (2006) *Art Czar: The Rise and Fall of Clement Greenberg*, Aldershot, UK: Lund Humphries.

Martin, Bronwen and Ringham, Felizitas (2006) *Key Terms in Semiotics*, London and New York: Continuum.

Marx, Karl (1975) Extract from the *Critique of Political Economy* (1859), quoted in David McLellan *Marx*, London: Fontana, 40.

—— (2001) [1844] 'Estranged Labour', in Dave Renton (ed.) *Economic and Philosophical Manuscripts*, quoted in *Marx on Globalisation*, London: Lawrence and Wishart, 111–24.

Marx, Karl and Engels, Friedrich (1998) [1848] *The Communist Manifesto*, introduction by Eric Hobsbawm, London: Verso.

Meecham, Pam and Sheldon, Julie (2000) *Modern Art: A Critical Introduction*, London and New York: Routledge.

Meskimmon, Marsha (2002) 'Feminisms and Art Theory', in Paul Smith and Carolyn Wilde (eds) *A Companion to Art Theory*, Oxford: Blackwell, 380–96.

Morris, Lynda and Radford, Robert (1983) *The Story of the Artists International Association 1933–53*, Oxford: Museum of Modern Art.

Mulvey, Laura (1989) [1975] 'Visual Pleasure and Narrative Cinema', in *Visual and Other Pleasures*, Basingstoke, UK: Macmillan.

Murray, Chris (ed.) (2002) *Key Writers on Art: From Antiquity to the Nineteenth Century*, London and New York: Routledge.

—— (2003) *Key Writers on Art: The Twentieth Century*, London and New York: Routledge.

Murray, Peter and Murray, Linda (1985) *Dictionary of Art and Artists*, Harmondsworth, UK: Penguin Books.

Myers, Tony (2003) *Slavoj Žižek*, Routledge Critical Thinkers, London and New York: Routledge.

Nash, Steven A. (1985) 'Naum Gabo: Sculptures of Purity and Possibility', in Steven A. Nash and Jörn Merkert (eds) *Naum Gabo: Sixty Years of Constructivism*, Munich, Germany: Prestel-Verlag, 11–46.

Nash, Steven A. and Merkert, Jörn (eds) (1985) *Naum Gabo: Sixty Years of Constructivism*, Munich, Germany: Prestel-Verlag.

Nead, Lynda (1992) *The Female Nude: Art, Obscenity and Sexuality*, London and New York: Routledge.

Neill, Alex and Ridley, Aaron (1995) *The Philosophy of Art: Readings Ancient and Modern*, New York and London: McGraw-Hill.

Néret, Gilles (2003) *Kazimir Malevich 1878–1935 and Suprematism*, Cologne, Germany and London: Taschen.

Nochlin, Linda (1988a) [1971] 'Why Have There Been no Great Women Artists?', first published in *Art News*, vol. 69, no. 9 (January 1971), reprinted in *Women, Art, and Power and Other Essays*, London: Thames & Hudson and New York: Harper & Row, 147–58.

—— (1988b) 'Women, Art, and Power?', in *Women, Art, and Power and Other Essays* (1988), London: Thames & Hudson and New York: Harper & Row, 1–36.

—— (1989) 'The Imaginary Orient', in *The Politics of Vision: Essays on Nineteenth-Century Art and Society*, London: Thames & Hudson.

—— (2006) *Bathers, Bodies, Beauty: The Visceral Eye (Charles Eliot Norton Lectures)*, Cambridge MA and London: Harvard University Press.

Olin, Margaret (1996) 'Gaze', in Robert S. Nelson and Richard Shiff (eds) *Critical Terms for Art History*, Chicago and London: University of Chicago Press, 208–19.

Ormond, Richard and Kilmurray, Elaine (2003) *John Singer Sargent: Complete Paintings*, vol. 3, New Haven CT and London, published for the Paul Mellon Centre for Studies in British Art by Yale University Press.

Orton, Fred (1996) 'Action, Revolution and Painting', in Fred Orton and Griselda Pollock, *Avant-Gardes and Partisans Reviewed*, Manchester, UK: Manchester University Press, 177–203.

Orton, Fred and Pollock, Griselda (1996) 'Memories Still to Come ... An Introduction', in *Avant-Gardes and Partisans Reviewed*, Manchester, UK: Manchester University Press, i–xxi.

Ostrow, Saul (2001) 'Introduction – Aloïs Riegl: History's Deposition', in *Framing Formalism: Riegl's Work*, Richard Woodfield (commentary), Amsterdam: G+B Arts International.

Paglia, Camille (1990) *Sexual Personae: Art and Decadence from Nefertiti to Emily Dickinson*, New Haven CT and London: Yale University Press.

Panofsky, Erwin (1972) [1939] *Studies in Iconology: Humanistic Themes in the Art of the Renaissance*, New York and London: Harper & Row.

—— (1993) [1940] 'Introduction: The History of Art as a Humanistic Discipline', first published in T. M. Greene (ed.) *The Meaning of the Humanities*, Princeton NJ: Princeton University Press, 89–118. Reprinted in Erwin Panofsky, *Meaning in the Visual Arts*, London: Penguin Books, 23–50.

Parker, Rozsika and Pollock, Griselda (1981) *Old Mistress: Women, Art and Ideology*, London: Routledge & Kegan Paul.

Parris, Matthew (2006) 'Are You Gay or Straight? Admit It: You Are Most Likely an In-between', *The Times*, times2, 5 August, 17.

Peirce, Charles Sanders (1931–58) *Collected Writings* (8 vols) eds Charles Hartshorne, Paul Weiss and Arthur W. Burks, Cambridge MA: Harvard University Press.

Perry, Gillian (1999) *Gender and Art*, New Haven CT and London: Yale University Press.

—— (2004) 'Dream Houses: Installations and the Home', in Gillian Perry and Paul Wood, *Themes in Contemporary Art*, New Haven CT and London: Yale University Press in association with the Open University, 231–75.

Perry, Gillian and Wood, Paul (eds) (2004) *Themes in Contemporary Art*, New Haven CT and London: Yale University Press in association with the Open University.

Perry, Grayson (2006a) 'When Will Art Celebrate the Ordinary Man?', *The Times*, times2, 26 July.

—— (2006b), 'When East Meets West', *The Times*, times2, 1 November, 16.

Phoca, Sophia and Wright, Rebecca (1999) *Introducing Postfeminism*, Duxford, UK: Icon Books.

Plato (1987) *The Republic*, translated by Desmond Lee, London: Penguin Classics.

Pointon, Marcia (1997) *History of Art: A Students' Handbook*, 4th edn with assistance from Lucy Peltz, London and New York: Routledge.

Pollock, Griselda (1988) *Vision and Difference: Femininity, Feminism and the Histories of Art*, London and New York: Routledge.

—— (1996) 'Looking for Difference or what Greenberg Did Not Say', in Griselda Pollock and Fred Orton, *Avant-Gardes and Partisans Reviewed*, Manchester, UK: Manchester University Press, 245–52.

Pooke, Grant (2006) 'Pregenitality and the Singing Sculpture: The Anal-sadistic Universe of Gilbert & George', in Brandon Taylor (ed.) *Sculpture and Psychoanalysis*, Aldershot, UK: Ashgate Press in association with the Henry Moore Institute, 139–59.

Pooke, Grant and Whitham, Graham (2003) *Teach Yourself Art History*, London: Hodder & Stoughton.

Popper, Frank (1975) *Art – Action and Participation*, London: Studio Vista.

Potts, Alex (1994) *Flesh and the Ideal: Winckelmann and the Origins of Art History*, New Haven CT and London: Yale University Press.

Prettejohn, Elizabeth (1998) *Interpreting Sargent*, London: Tate Gallery Publishing.

—— (2005) *Beauty and Art 1750–2000*, Oxford and New York: Oxford University Press.

Preziosi, Donald (2003) 'Grasping the World: Conceptualizing Ethics After Aesthetics', paper given at the GLAAHD conference, September.

Putnam, James (2006) 'Polymorphous Perverse', exhibition text.

Pütz, Catherine (2002) *Jacques Lipchitz: The First Cubist Sculptor*, London: Paul Holberton Publishing in association with Lund Humphries.

Ratcliff, Carter (1982) *John Singer Sargent*, New York: Abbeville Press and Oxford: Phaidon Press.

Ratnam, Niru (2004a) 'Dusty Mannequins: Modern Art and Primitivism', in Steve Edwards and Paul Wood (eds) *Art of the Avant-Gardes*, New Haven CT and London: Yale University Press in association with the Open University, 157–83.

—— (2004b) 'Art and Globalisation', in Gillian Perry and Paul Wood (eds) *Themes in Contemporary Art*, New Haven CT and London: Yale University Press in association with the Open University, 277–313.

Rawlinson, Mary (2006) 'Beauty and Politics', in James Elkins (ed.) *Art History Versus Aesthetics*, London and New York: Routledge, 128–43.

Read, Richard (2002) *Art and Its Discontents*, Aldershot, UK: Ashgate Press.

Reckitt, Helena and Phelan, Peggy (2001) *Art and Feminism*, London: Phaidon Press.

Rees, A. L. and Borzello, Frances (eds) (1986) *The New Art History*, London: Camden Press.

Renton, David (ed.) (2001) *Marx on Globalisation*, London: Lawrence & Wishart.

Richardson, John (1996) *A Life of Picasso: 1907–1917: The Painter*

of Modern Life, vol. 2, London: Jonathan Cape.

Richter, Gerhard (1993) quoted in Charles Harrison and Paul Wood, 'Modernity and Modernism Reconsidered', in Paul Wood, Francis Frascina, Jonathan Harris and Charles Harrison (eds) *Modernism in Dispute: Art Since the Forties*, New Haven CT and London: Yale University Press in association with the Open University.

Ridley, Aaron (1998) *R. G. Collingwood: A Philosophy of Art*, London: Phoenix Books.

Robinson, Hilary (2006) *Reading Art Reading Irigaray*, London and New York: I. B. Tauris.

Robinson, Hilary (ed.) (2001) *Feminism-Art-Theory: An Anthology 1968–2000*, Malden MA and London: Blackwell.

Rose, Gillian (1978) *The Melancholy Science: An Introduction to the Thought of Theodor W. Adorno*, London: Macmillan.

Rubin, James H. (1999) *Impressionism*, London: Phaidon Press.

Rycroft, Charles (1977) *A Critical Dictionary of Psychoanalysis*, Harmondsworth, UK: Penguin Books.

Sachs, Albie (1990) 'Preparing Ourselves for Freedom: Culture and the ANC Constitutional Guidelines', *TDR* (1988–), vol. 35, no. 1 (spring), 187–93; reprinted 1991 in *Art from South Africa*, Oxford: Museum of Modern Art, 10.

Said, Edward (1978) *Orientalism*, London: Penguin Books.

—— (1993) *Culture and Imperialism*, London: Chatto & Windus.

Sanders, Mark (2006) *Gayatri Chakravorty Spivak: Live Theory*, London and New York: Continuum.

Sanderson, Colin and Lodder, Christina (1985) 'Catalogue Raisonné of the Constructions and Sculptures', in Steven A. Nash and Jörn Merkert (eds) *Naum Gabo: Sixty Years of Constructivism*, Munich, Germany: Prestel-Verlag, 193–272.

Sardar, Ziauddin (2000) *Thomas Kuhn and the Science Wars*, Cambridge: Icon Books.

Saussure, Ferdinand de (1983) [1916] *Course in General Linguistics*, translated by Roy Harris, London: Duckworth.

Schama, Simon and Saville, Jenny (2005) *Jenny Saville*, New York: Rizzoli.

Schnapper, Anton (1980) *David témoin de son temps*, Fribourg: Office du Livre.

Schneider Adams, Laurie (1993) *Art and Psychoanalysis*, New York: Icon Editions.

—— (1996) *The Methodologies of Art: An Introduction*, Oxford and Boulder CO: Westview Press; New York: Icon Books.

Schoenbrun, David L. (1993) 'A Past Whose Time Has Come: Historical Context and History in Eastern Africa's Great Lakes', *History and Theory*, vol. 32, no. 4 (December), 32–56.

Schor, Mira (1997) *Wet: On Painting, Feminism and Art Culture*, Durham NC and London: Duke University Press.

Scruton, Roger (1981) 'Adrian Stokes', in *The Politics of Culture and Other Essays*, Manchester, UK: Carcanet Press, 148–51.

Sebeok, Thomas Albert (1972) *Perspectives in Zoosemiotics*, The Hague and Paris: Mouton.

Sellers, Susan (1996) *Hélène Cixous: Authorship, Autobiography and Love*, Cambridge: Polity.

Shackelford, George T. M. and Frèches-Thory, Claire (2004) *Gauguin Tahiti*, Boston MA: MFA Publications.

Sheppard, Anne (1987) *Aesthetics: An Introduction to the Philosophy of Art*, Oxford and New York: Oxford University Press.

Sim, Stuart (1992) 'Marxism and Aesthetics', in Oswald Hanfling, *Philosophical Aesthetics*, Oxford: Blackwell in association with the Open University.

—— (2003) biographical and critical entry on 'Jacques Derrida', in Chris Murray (ed.) *Key Writers on Art: The Twentieth Century*, London and New York: Routledge, 96–102.

—— (ed.) (1998) *Post-Marxism: A Reader*, Edinburgh: Edinburgh University Press.

Snowman, Daniel (2002) *The Hitler Émigrés: The Cultural Impact on Britain of Refugees from Nazism*, London: Chatto & Windus.

Soja, Edward (1989) *Postmodern Geographies: The Re-assertion of Space in Critical Social Theory*, London and New York: Verso.

Sokal, Alan D. and Bricmont, Jean (1998) *Intellectual Imposture: Postmodern Philosophers' Abuse of Science*, London: Profile Books.

Sörbom, Göran (2002) 'The Classical Concept of Mimesis', in Paul Smith and Carolyn Wilde (eds) *A Companion to Art Theory*, Oxford: Blackwell, 19–28.

Spargo, Tamsin (1999) *Foucault and Queer Theory*, Duxford, UK: Icon Books and New York: Totem Books.

Spindlow, Pamela (2003) 'Sadomasochism in the Art of the Post Modern Era', unpublished thesis, University of Kent, UK.

Spivey, Nigel (1996) *Understanding Greek Sculpture: Ancient Meanings, Modern Readings*, London: Thames & Hudson.

Stallabrass, Julian (1999) *British Art in the 1990s*, London and New York: Verso.

—— (2001) *High Art Lite: British Art in the 1990s*, London and New York: Verso.

Stirton, Paul (2006) 'Frederick Antal', in Andrew Hemingway (ed.) *Marxism and the History of Art: From William Morris to the New Left*, London: Pluto Press, 45–66.

Sutherland Harris, Ann and Nochlin, Linda (1977) *Women Artists 1550–1950*, Los Angeles CA: Country Museum of Art and New York: Alfred A. Knopf.

Taylor, Brandon (1992) *Art and Literature under the Bolsheviks, Vol. 2: Authority and Revolution 1924–1932*, London and Colorado: Pluto Press.

—— (1995) *The Art of Today*, London: Everyman Art Library.

—— (2006) Foreword to *Sculpture and Psychoanalysis*, Aldershot, UK: Ashgate Publishing and Henry Moore Institute.

Thesander, Marianne (1997) *The Feminine Ideal*, translated by Nicholas Hills, London: Reaktion Books.

Tickner, Lisa (1987) *The Spectacle of Women: Imagery of the Suffrage Campaign 1907–14*, London: Chatto & Windus and Chicago: University of Chicago Press.

Trotsky, Leon (1925) reproduced in *Literature and Revolution*, translated from the Russian by Rose Strunsky (1957), New York: Russell and Russell, 183.

Turner, Richard A. (1997) *Renaissance Florence: The Invention of a New Art*, London: Laurence King.

Vasari, Giorgio (1991) [1568] *The Lives of the Artists*, Oxford: Oxford University Press.

Vaughan, James C. (1973) *Soviet Socialist Realism*, London: Macmillan.

Vaughan, William and Weston, Helen (eds) (2000) *David's The Death of Marat*, Cambridge: Cambridge University Press.

Venturi, Robert (1972) *Learning from Las Vegas: The Forgotten Symbolism of Architectural Form*, Cambridge MA and London: MIT Press.

Vergine, Lea (2000) *Body Art and Performance: The Body as Language*, Milan, Italy: Skira Editore and London: Thames & Hudson.

Voloshinov, Valentin N. (1973) *Marxism and the Philosophy of Language*, translated by Ladislav Matejka and I. R. Titunik, New York: Seminar Press.

Wakefield, Neville (1990) *Postmodernism: The Twilight of the Real*, Winchester MA and London: Pluto Press.

Wallach, Alan (1998) *Exhibiting Contradiction: Essays on the Art Museum in the United States*, Amherst MA: University of Massachusetts Press.

Walsh, Linda (1999) 'Charles Le Brun, Art Dictator of France', in Gillian Perry and Colin Cunningham, *Academies, Museums and Canons of Art*, New Haven CT and London: Yale University Press in association with the Open University, 86–123.

Warburton, Nigel (2003) *The Art Question*, London and New York: Routledge.

—— (2004) *Philosophy: The Basics*, London and New York: Routledge.

Warner, Marina (1976) *Alone of All Her Sex: The Myth and Cult of the Virgin Mary*, London: Vintage Books.

Waugh, Evelyn (1982) [1954] *Brideshead Revisited*, Harmondsworth, UK: Penguin Books.

Williams, Raymond (1988) *Keywords: A Vocabulary of Culture and Society*, London: Fontana.

Winnicott, David (1953) 'Transitional Objects and Transitional Phenomena', *International Journal for Psychoanalysis*, vol. 34, 89–97.

Wollheim, Richard (1991) [1971] *Freud*, London: Fontana.

Wood, Jon (2006) 'Re-staging Freud's Sculpture', in Jon Wood (ed.) *Freud's Sculpture*, Henry Moore Institute Gallery 4, 22 February–23 April 2006, 6–18.

Wood, Paul (2004) 'Inside the Whale: An Introduction to Postmodernist Art', in Gillian Perry and Paul Wood (eds) *Themes in Contemporary Art*, New Haven CT and London: Yale University Press in association with the Open University, 5–43.

Woodfield, Richard (2002) 'Gombrich and Psychology', in Paul Smith and Carolyn Wilde (eds) *A Companion to Art Theory*, Oxford: Blackwell, 426–35.

Young, Robert J. C. (2003) *Postcolonialism: A Very Short Introduction*, Oxford: Oxford University Press.

Zangwill, Nick (1999) 'Feasible Aesthetic Formalism', *Nous*, vol. 33, 610–29.

INDEX

CPSIA information can be obtained at www.ICGtesting.com
Printed in the USA
BVOW02s1736010915

415973BV00004B/6/P